# DIALOGU

## ON

# ART

Edward Roditi

/50

# DIALOGUES
## ON
## ART

Edouard Roditi

Ross-Erikson
Santa Barbara
1980

# Contents

# Illustrations

# Preface to the
# Revised American Edition

THE interviews now reprinted here without any additions or amendments were originally drafted, from notes of conversations held with the artists, some twenty years ago. Both the English and the American edition of the original printing have long been out of print. Only a German translation of my book is still available in European bookstores; it is published in the prestigious Bibliotek Suhrkamp edition of modern classics that includes such authors as André Gide, Franz Kafka, Thomas Mann and Albert Camus. It was a copy of this German translation that chanced to fall into the hands of the late Carl G. Jung. In *Man and his Symbols*, which Jung conceived and edited shortly before his death, my interview with Marino Marini is thus quoted at considerable length. One can read there that "A good deal may be learned from a conversation that took place in 1958 between Italian sculptor Marino Marini and the writer Edouard Roditi." And Jung's book then concludes that "The conversation . . . explains the transformation of *sensory* art into abstraction that should be clear to anyone who has ever walked open-eyed through an exhibition of modern art."

Some critics in England and America have nevertheless tended to view my collection of interviews with some misgivings, though the late Harold Rosenberg once defined my book, in the *New York Times*, as "the best of its kind" and most of my interviews, long before their first publication in book form, had previously been published with success in a number of periodicals. Four of these interviews had indeed been first published as full-page features in London's widely read weekly newspaper *The Observer*.

The main concern of such "carping" critics appears to have been my choice of artists. Instead of concentrating their attention on the interest of the testimony of the artists with whom I had

chanced to converse, these few critics have generally glanced at the names of the artists interviewed and then objected to some of my choices, regardless of the significance of their testimony, whether from the point of view of the history of art in our own age or from that of the philosophy of art in general. I have thus been asked why I chose to include Paolozzi, who was young and still relatively unknown when my book was first published, or Gabriele Münter, whose name and work, as a companion of Kandinsky at the time of his decisive shift from figurative art to his earliest and more Expressionist style of abstraction, were still scarcely known, except to a few specialists, beyond the frontiers of Western Germany. Why too had I included Josef Herman or Fahrunnissa Zeid, but failed to interview Picasso or any of the Americans, such as Sam Francis, who were then accessible to me in Europe?

My reply has always been to point out that my interview with Miro, who is certainly one of the more famous artists represented here in my *Dialogues,* proved to be, however entertaining as a piece of sheer journalism, by far the least informative of these twelve conversations, whereas Fahrunissa Zeid brings us interesting information about the emancipation of women, for instance, in an Islamic country, and Josef Herman reaffirms certain beliefs in the social responsibility of the artist which had scarcely been touched upon by any of the other artists interviewed here.

The most newsworthy or famous artists are not necessarily the most eloquent or profound when they try to express themselves in words rather than in visual terms. When I tried, for instance, to interview Picasso, he proved to be so boastfully and disconnectedly garrulous that I preferred never to submit for publication a final draft of my notes of our conversation. When I likewise tried to interview Hans Arp, he was very sick and uncommunicative; actually, he died a couple of months later.

Though responsible for the final choice of interviews included in each edition, the publishers of the original English and American editions of my book and then of the subsequent German and French translations all expressed different opinions concerning the choice of artists who, in their view, should have been included or omitted. When I first submitted my manuscript to my London publisher, it included an interview with the veteran Italian painter Carlo Carrà, one of the only surviving original members of the

historic Futurist group, and one with the Russian-born Paris artist
Ossip Zadkin, who had been one of the few pioneer Cubist
sculptors. Though *The Observer* had already agreed to publish as a
series, four weeks running, my interviews with the sculptors Bar-
bara Hepworth, Henry Moore, Paolozzi and Zadkin, my London
publishers insisted on dropping Zadkin and Carrà from my book
as "relatively unknown" artists, and on my now including, in their
stead, two London artists, Josef Herman and Fahrunissa Zeid,
whom they believed to be more newsworthy. My New York pub-
lishers then expressed surprise and some misgivings about the
inclusion of these last two artists, but finally accepted the book as it
stands because they thereby reduced very considerably the cost of
producing the American edition.

When my German publishers subsequently began to consider
translating my *Dialogues* for publication in Western Germany,
they insisted on dropping Barbara Hepworth, Josef Herman,
Paolozzi and Fahrunissa Zeid, regardless of their testimonies, but
gladly accepted to include both Carrà and Zadkin. I was asked
moreover to consider now including, for the convenience of my
German readers, two additional German artists. Fortunately, I
had meanwhile interviewed Hannah Höch, one of the founders
of the Berlin Dadaist group in 1917, so that this interview was
immediately accepted, after its successful periodical publication
in *Der Monat,* for inclusion in the German edition of my *Dialogues.*
I then agreed with my German publishers to interview the Ger-
man Abstract Expressionist painter Ernst Wilhelm Nay too.

A French publisher later suggested that I translate into French
my interviews with Chagall and Miro and perhaps the one with
Marino Marini too. Though he likewise insisted that I now in-
clude, for a French version of my book, more Paris artists, he
could never abide for more than a week by any agreed choice of
those to be included. Finally, I submitted to him a new and very
lengthy and detailed interview with Max Ernst which has never
yet been published in English. The French version of my
*Dialogues* thus went to press with only three interviews: Chagall,
Ernst and Miro. All this only goes to prove how difficult it was to
get any two publishers to agree on the choice of artists to be
included in my book. Each publisher, it seems, had a different
idea about artists whose names would be famous enough to "sell"
the book. Only my German publisher actually paid much atten-

tion to the contents of the interviews as sources of information on certain aspects of the history or the theory of contemporary European art.

Critics and friends have often accused me too of deliberately spoofing Miro by not seeking to offer a less flippant or snide version of our original conversation. When I translated my interview with Miro for publication in French, I therefore added to the introduction a quotation from a similar interview written and published in Spanish and with which I had meanwhile become acquainted. This interview was written by the great Spanish writer Don Camilo Jose Cela, of the Royal Academy of Spain, who happens to be, on the Balearic island of Majorca, one of Miro's neighbors and closest friends. In order to justify the contents and tone of my own conversation with Miro, I now quote here, in translation, this Spanish interview which was originally published in the periodical *Papeles de Son Armadans.* It proves conclusively that the most famous artists are not necessarily the most brilliant or profound conversationalists, and that it was through no fault of my own that Miro failed, when I interviewed him in Paris, to come up to the expectations of some of my readers and critics.

In Don Camilo Jose Cela's Spanish text, one indeed finds Miro making even more commonplace or absurd remarks than in my interview. Among other subjects of vital importance to an understanding of his art, Miro discusses at length with Cela the various vegetables and herbs that grow in his Majorcan garden, as if his listener were a visitor from another planet now hearing about onions, for instance, for the first time in his life. "There used to be onions," Miro reminisces, "in my father's garden." After which he goes on to explain how useful onions can be. Every vegetable or herb that Miro grows is then discussed in turn, each time with a detailed account of how Miro himself raises, prepares and eats it.

But the most breathtaking part of this whole conversation is Miro's highly personal theory of the miracle of an artist's inspiration. The floor of his new Majorcan studio, he carefully points out, consists of beaten earth, so that inspiration, surging from Mother Earth, can rise to the artist's mind through his feet and legs. Miro neglected, however, to tell Cela whether he stands there bare-footed when he works. Floor boards, tiles, stone paving, linoleum and carpeting too must all hinder, it seems, the process of inspiration by preventing the direct contact of the artist's feet

with Mother Earth, his only true source of inspiration. But how about leather or rubber soles? On this vital subject, we are left in the dark. I now seriously regret that I somehow failed to encourage Miro to make any such revelations to me.

Edouard Roditi
Santa Barbara
August 1978

# Acknowledgments

To the editors and publishers of *Arts* (New York), *Encounter* (London), *Der Monat* (Berlin), and *The Observer* (London), thanks are due for their kind permission to reprint individual dialogues which had first been published in these periodicals.

Thanks are likewise due to the following, for their kind permission to reproduce the works of art and the photographs which illustrate these twelve dialogues: MARC CHAGALL *Crucifixion Against Paris Background,* 1968 (Courtesy: Galerie Maeght, Paris); MARINO MARINI *Horseman,* 1949 (By kind permission of the artist. Courtesy: Kunstverein, Düsseldorf, Federal Republic of Germany. Aurelio Amendola, photographer); GIORGIO MORANDI *Still Life with Bottle* (Collection: Alexander and Nadia Blokh, Paris); JOAN MIRO *Woman Standing before the Sun,* 1950 (Courtesy: Galerie Maeght, Paris); OSKAR KOKOSCHKA *Portrait of the Composer Baron Jacques de Menasce as a Boy* (By kind permission of the artist. Courtesy: Nationalgalerie, Staatliche Museen Preussischer Kulturbesitz, West Berlin. Jörg P. Anders, photographer); BARBARA HEPWORTH *Pelagos,* 1946 (Courtesy: The Tate Gallery, London); PAVEL TCHELITCHEW *Toby,* 1943 (Collection: Princess Gourielli); GABRIÈLE MÜNTER *Kahnfahrt,* 1910 (Courtesy: Leonard Hutton Galleries, New York. Otto Nelson, photographer); EDUARDO PAOLOZZI *Cyclops* (By kind permission of the artist. Courtesy: The Tate Gallery, London); JOSEF HERMAN *Peasant with Hat,* 1959 (By kind permission of the artist. Collection: Vernon Eagle, New York); HENRY MOORE *Madonna and Child,* 1943 (Courtesy: Fischer Fine Art Ltd., London); FAHR-EL-NISSA ZEID *Vision of New York* (Private Collection).

# Introduction

EXPRESSING themselves in the less familiar medium of language rather than visual images, and in words rather than colours, forms or textures, the painter and the sculptor may seem, as they discuss their art, less explicit, more impersonal, than many a creative writer. Yet a recent collection of interviews of leading contemporary authors, *Writers at Work*, has proved that many authors are sheer determinists or defeatists, scarcely more conscious of the nature or purpose of their literary activity and of the tools and devices of which they dispose than electronic brains or chimpanzee painters. William Faulkner, for instance, seemed unwilling to see himself, in his creative activity, as anything but a pawn in the hands of a mysterious blind force. He has been chosen at random for the task of writing tales which someone else might just as well have written and which would inevitably have been written, sooner or later, had he refused, like the prophet Jonah, to accomplish his mission. On the technical aspects of his work, Faulkner is even less explicit. He accomplishes his tasks only with luck and the help of some whisky:

"Bourbon, you mean?"

"No, I ain't that particular. Between Scotch and nothing, I'll take Scotch."

Among the painters and sculptors interviewed in the present volume, only Fahr-el-Nissa Zeid has described the creative process in terms as fatalistic. Treading on the less familiar ground of verbal expression, she has refrained, however, from Faulkner's spoofing, which is obviously that of an experienced performer in this act of mystifying the critic and the reader. But Faulkner proved, among the authors interviewed in *Writers at Work*, to be one of the few who are courageous enough to admit the impor-

1

tance, in their creative life, of such legally authorized stimulants as alcohol, tobacco or coffee. Only in France, it seems, or among the American poets and novelists of the "beat generation", is one still likely to find, as one did so frequently a hundred years ago, writers and artists who openly flaunt their addiction to opium, hashish, marihuana or other such keys to an artificial paradise. In America, Aldous Huxley recently offered himself as a guinea-pig, in the interests of science, for experiments on the effects of mescalin. In France, Henri Michaux conducted similar experiments on himself, with infinitely more interesting results which, however, have been less widely publicized. Fun, it seems, must now accept the limitations imposed on us by the law, or must find its justification as scientific research.

The successful writer or artist is no longer, as so often he was some time ago, an outcast, an enemy of Society, a *poète maudit* like Baudelaire, a *peintre maudit* like Modigliani. Oscar Wilde and even Soutine, in our generation, would be anachronisms. Too prejudiced to exhibit them in public as hideous warnings, we would condemn them to the mental home, to the concentration-camp, to the self-imposed retirement of monastic life. Dylan Thomas, while still alive in our midst, was a pain in the neck; one almost wonders how he escaped the fate of Antonin Artaud and Ezra Pound. Those whom one threatens to intern, during their lifetime, in mental homes may well be revered, once dead, as saints, and Dylan Thomas and Antonin Artaud have thus become, in recent years, the objects of a public cult.

Most contemporary writers and artists play safe, when they discuss their work, and prefer to speak as if it were a craft, involving but the manual skills of an honest artisan. They can talk at great length about the kind of room where they feel at ease to create, about whether they walk up and down as they think, whether they prefer to scribble their ideas in bed, on the back of unanswered mail, or in the cheap copy-books of schoolchildren on the terrace of a Left-Bank Paris café. In the case of a writer, such a discussion of the fads and superstitions of his particular *cuisine littéraire* may sound ingratiatingly familiar. The reader, similarly afflicted with all sorts of tics and inhibitions when it comes to mere letter-writing, will tend to forget that a writer achieves distinction as an artist in spite of such finicky bad habits which he may share with others who are not called upon to create. An artist's

genius consists to some extent in his ability to transcend bad habits, to overcome handicaps; a discussion of the clay feet on which the whole monument may rest, however insecurely, cannot teach us much about it as a whole. The artist is indeed human, all too human, like our humble selves, but he should be gifted with some complementary daemonic powers that others generally lack.

The painter and the sculptor are handling materials and tools that are more cumbersome and less widely used than the writer's pen and paper or than the typewriter to which countless readers are likewise chained, eight hours a day, in their office-work. One cannot imagine Barbara Hepworth chipping away at a large block of marble in her bed, with her tray of morning coffee thrust negligently aside, though Truman Capote may well be able to write a whole novel in his dyspeptic morning moods, between breakfast in bed, phone-calls and the long-delayed moment when he finally plucks up enough courage to plunge into his bathroom before sauntering forth to face an alien or hostile world. Far more than any bedroom or study, the studio is a workshop, and the working habits of a painter or a sculptor are those of a craftsman, imposed on him by the nature of his tools and materials. A discussion of these working habits would lack the human interest of a similar discussion of a writer's working habits, its tone degenerating too easily into that of a "do it yourself" technical manual, full of useful hints about mixing colours of two different brands, or about welding techniques.

Nor has an artist's or a writer's ability to explain his working habits or his philosophy of art any necessary connection with the quality of his work. Of the *cuisine littéraire*, the working habits and philosophy of art of some of the greatest writers of all times, we know nothing, partly because such topics have become popular only within the last hundred and fifty years, partly too because, even today, many writers are more interested in creating than in observing the workings of the creative process. Paul Valéry, throughout his life as a writer, devoted several hours a day to the meditations which filled his journal and his notebooks. In France, this self-imposed discipline, even on such a scale, scarcely provoked much comment. But not a single Turkish writer of the past fifty years has been known to keep a journal, and one is surprised when one discovers, in America, the notebooks of Francis Scott Fitzgerald. Do we know how much wine Catullus had to drink

before he could compose one of his lyrics? How Virgil organized his days while he worked on the *Aeneid*? Did he write his *Georgics* in bed, or in odd moments of respite as he administered his own farms?

Among the great artists of the past, even Rembrandt, one of the most introspective of all self-portraitists, has neglected to leave us anything in writing but a few laconic letters in which he dunned a recalcitrant patron who had failed to pay the agreed sum for a completed commission. Sir Joshua Reynolds, on the other hand, has left us a literary *œuvre* that reveals unsuspected complexities of aesthetic theory in his seemingly simple art; and Eugène Delacroix, as a writer, deserves inclusion in any study of the philosophy of Romanticism. Camille Pissaro, in his letters, discusses at length the scientific and social principles on which he founded, to a great extent, his own impressionism. The few letters of Jean-François Millet offer us a complete theory of Socialist Realism. The letters of Vincent Van Gogh are like the submerged part of an iceberg, revealing much that he refrained from expressing in his actual painting. The interviews published in the present volume seek to elucidate these broader aspects of each painter's or sculptor's beliefs rather than the more picturesque or gossipy details of their working habits. Some of the artists interviewed happen to be less inclined to philosophical meditation, more concerned with autobiographical explanations of their stylistic evolution.

In interviewing twelve of the leading painters and sculptors of our age, I have avoided, as far as possible, evaluating their work as "contributions" to a movement. Nor have I deliberately selected those painters and sculptors whom I personally believe to be indisputably the twelve greatest living artists. Had this been my purpose, I would of course have interviewed Picasso. These twelve interviews are rather the fruit of a series of felicitous meetings that occurred in the course of a year and a half of travel, undertaken mainly as a multilingual interpreter for international conferences. The choice of my victims was determined, to a great extent, by chance. I interviewed them in English, French, German or Italian. If their speech seems at times monotonous, their diction impersonal and devoid of those tricks and twists and catch-words that are the insignia of an individual turn of mind, this is to be attributed to my having had to translate their French, their Ger-

man or their Italian in an English style that remains inescapably
my own. Besides, I have often inflicted, as an interviewer, my own
preoccupations and terminology on those whom I was interview-
ing. A question inevitably determines, to a great extent, the
terminology of the answer. Had a different interviewer ap-
proached each one of these twelve artists, the whole book might
have offered a greater variety of points of view, but it would also
have lost much of its present unity.

Nor is this unity accidental, I mean that of a series of inter-
views in which a somewhat pedantic or monomaniac critic may
have frustrated every attempt of his victims to transcend his own
limited or compulsive preoccupations. My purpose, in attempting
this task, was at first to clarify certain historical developments in
the evolution of the art of our century. In interviewing Chagall,
for instance, I was more interested in elucidating the facts of his
Russian background and in discovering, at long last, how much
credit should be attributed to the influence and the teachings of
certain distinguished Russian painters of the turn of the century
or of the Revolutionary era, than in hearing again about Chagall's
evolution as a painter of the School of Paris. I knew that the
artistic *avant-garde* of St Petersburg, so little known today, had
once been important, and that its painters had been in close con-
tact with the Paris Cubists, the German Expressionists of Dresden
and Berlin, the Blue Rider painters of Munich, and the Futurists
of Milan. In the case of Morandi too, I was interested in verifying
the facts of friendships and associations, so as to clarify his evo-
lution, from his earlier *pittura metafisica* to his present style of
nearly abstract still-life composition. Only by checking such facts
can one discover the true history of an individual artist's stylistic
development, obscured as this history has often been by the kind
of art-criticism which sets out to extol rather than to explain, to
sell rather than to evaluate.

But I soon began to set myself a more ambitious purpose too,
for which I remain to a great extent indebted to my friend
Tchelitchew. I found myself, as I edited his posthumous papers
in the form of a dialogue, facing a task that is perhaps unique:
that of bringing together, in one volume, a selection of the many
basic beliefs on which the philosophy of modern art is founded.
Too often, books on modern art expound but an extremist point
of view, valid only as a means of explaining or appreciating the

work of a single artist or a single school or tradition. The writings
of Mondrian and his apologists, for instance, are of no use to us
if we wish to understand and evaluate the achievements of
great Fauvist and Expressionist painters like Rouault, Matisse,
Kirchner or Kokoschka. Kandinsky's theories will likewise ap-
pear nonsensical if applied in an analysis of the evolution of Max
Ernst, and even André Breton's writings on Surrealist art are not
very helpful when it comes to explaining the workings of Paul
Klee's mind. In explaining or justifying his own innovations, each
modern artist indeed allows himself to be carried away by his
own eloquence and begins to formulate norms which are often
applicable only to his own works. I have tried, in these interviews,
to discuss the relationship of each artist's work, as far as possible,
to modern art as a general trend instead of obtaining, from each
artist in turn, a kind of unilateral statement, I mean a merely indi-
vidual creed.

At the height of the Italian Renaissance, in 1538, a Portuguese
Humanist, Francisco de Ollanda, spent some time in Rome, in the
immediate circle of Michelangelo's friends. On his return to Lisbon,
he wrote in Portuguese a series of dialogues on art wherein he
purported to expound the philosophy of the great master. For
centuries, this little book was neglected by most scholars, who
saw in it but another Renaissance pastiche of Plato's "interviews"
of Socrates. It was first published in Oporto in 1896 and only
in recent years have a few scholars, among whom my former
class-mate Professor Robert Clements, of New York University,
deserves special mention, taken the trouble to compare the
opinions attributed to Michelangelo in these Portuguese dia-
logues and those that the master expressed elsewhere, in his own
writings or in those of his Italian associates. It is now known that
Michelangelo's philosophy of art has been very completely and
faithfully expounded by his Portuguese disciple, in spite of the
formal limitations imposed by the latter's choice of as rigid a
literary genre as the neo-platonist dialogue of the Renaissance
Humanists.

The twentieth-century interview, as a literary genre, borrows
its conventions from the chatty and presumably informal journal-
ism of our daily press, our radio and television programmes. It
remains, however, a genre as inescapably literary, though less for-
mal or dramatic, as that in which Renaissance scholars once tried

to revive the dialectical tradition of Plato's dialogues. Nearly all my interviews are based on notes hurriedly scribbled in the course of actual conversations. As I redrafted these notes later for publication, I cheated no more than the average journalist who writes up his impressions of an interview. But a journalist generally cheats by high-lighting the "informality" of such an interview, whereas I have cheated by perhaps over-stressing the formal progression of our discussions. These are indeed dialogues rather than interviews, perhaps because I hoped to produce a work that might be less ephemeral than journalistic impressions of twelve meetings with painters and sculptors. Have I succeeded in writing twelve dialogues on art that might explain, in a hundred years or more, the problems, aims and beliefs of some of the artists of today?

In conclusion, I wish to thank those whom I interviewed for their patience and especially for their kindness in checking, correcting and finally approving my versions of our actual conversations. I should also thank my brother, James Roditi, and the many friends who have helped or encouraged me, throughout a year of recurrent illness and other personal misfortunes, to persevere in this task of completing my first book in ten years.

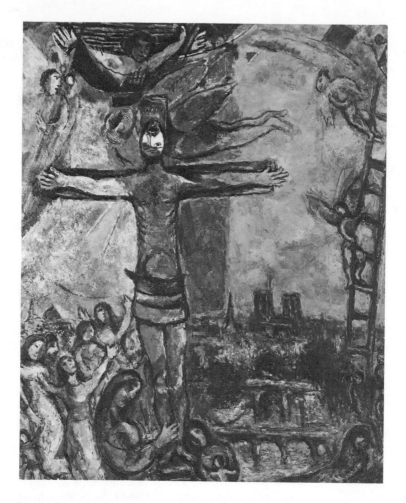

Marc Chagall
*Crucifixion Against Paris Background*

# Marc Chagall

*On the walls of the Paris apartment, in the Ile Saint Louis, that Chagall has recently acquired as a home away from home for occasional visits to the French capital, one is surprised to find, as samples of the master's work, only a few posters of recent exhibitions, pinned up here and there as in the rooms of an art-student who cannot yet afford original works of the painters whom he admires. Though I had known Chagall for many years, this is the first time that I have not been with him in a large crowd. I had met him the first time, around 1930, at a Montparnasse café table, at the Dôme. He was there with a group of artists and intellectuals from Central and Eastern Europe. Unless my memory betrays me and I have confused in a single evening my recollections of several such Montparnasse meetings, Chagall was in the company of the sculptor Ossip Zadkine, of the great Yiddish novelist Scholem Asch, of the Soviet publicist Ilya Ehrenburg, of the German film and theatre producer-director Erik Charell, whose* Congress Dances *and* White Horse Inn *were then recent successes, and of a number of others who came and went, all through an evening spent around a couple of café-tables where one spoke French, Russian, German and Yiddish. I now remember, it seems, only the celebrities among those who came and went. I was then one of the youngest contributors of* transition, *not yet twenty years old, and quite thrilled to find myself in such brilliant company.*

*Later, I met Chagall again in New York, where he was a refugee during the war years. Again, I have recollections of much coming and going, in an apartment on Riverside Drive where everyone spoke French, German, Russian or Yiddish besides English. There were painters and poets there. Zadkine was again*

9

*present, with the poets Yvan and Claire Goll, who had just begun
publishing in New York, with Alain Bosquet, the magazine* Hemi-
sphères, *to which many refugees from Montparnasse and Ameri-
can friends from Greenwich Village contributed.*

*Tonight, in the apartment on the Ile Saint Louis, I am almost
alone with Chagall. There are only five of us: Chagall, his wife
Vava, whom I had known, long before their marriage, in pre-war
Paris and Berlin, the photographer André Ostier, the art-dealer
Heinz Berggruen and myself. At first, we exchange news of old
friends who are now scattered far and wide: since 1939, each one
of us has indeed lost sight of many of those who had once been
in our pre-war Montparnasse crowd and, since 1945, of many whom
we had known later in war-time New York. After a while, Chagall
then suggests that I accompany him into the next room where I
can interview him more quietly. To be more at ease, he lies down
on a big blue divan-bed, leaving me seated almost behind him.
As he begins to answer my questions, I feel as if I were psycho-
analysing him. The flow of his memories is often so torrential that
I find it difficult to note all that Chagall says. As he speaks, he
stares at the blank white wall ahead of him, as if it were a screen
on which he can project and visualize his recollections.*

E.R.: At what age did you paint your first picture or first begin
to draw?

CHAGALL: I have never known when I was really born. Offi-
cially, I was born in 1887, which explains why my seventieth birth-
day has now been celebrated wherever I have friends, for instance
in the New York Museum of Modern Art, which staged a special
show of my graphic work on that occasion. But am I really a
septuagenarian? In spite of my grey hairs, I often feel much
younger. Besides, my parents may, as was frequently done in
those years in Tsarist Russia, have cheated about the exact date
of my birth. If they managed to prove that I was four years older
than my next brother, they could obtain my exemption from
military service by claiming that, as oldest son, I was already
contributing towards the support of my family.

*Chagall seems to be tempted to wander off into family mem-
ories such as those that he has already told us in his published
autobiography rather than answer my question more specifically.*

*Like a stubborn analyst who has met with resistance in his patient,*
*I try to bring him back to the point:*

E.R.: Did your family encourage your ambitions to become an
artist?

CHAGALL: In our little provincial ghetto, among the petty
traders and craftsmen that my family knew, we had no idea of
what it meant to be an artist. In our own home, for instance, we
never had a single picture, print or reproduction, at most a couple
of photographs of members of the family. Until 1906, I never had
occasion to see, in Vitebsk, such a thing as a drawing. But one
day, in grade school, I saw one of my class-mates busy reproduc-
ing, in drawing, a magazine illustration. This particular boy hap-
pened to be my worst enemy, the best student in the class and
also the one who taunted me the most mercilessly for being such
a *Schlemihl*, because I never seemed able to concentrate or to
learn anything in school. As I watched him draw, I was com-
pletely dumbfounded. To me, this experience was like a vision,
a true revelation in black and white. I asked him how he managed
such a miracle. "Don't be such a fool," he replied. "All you need
to do is to take a book out of the public library and then to try
your luck at copying one of the illustrations out of it, as I am
doing right now."

And that is how, *Chagall added after a pause,* I became an
artist. I went to the public library, selected at random a bound
volume of the illustrated Russian periodical *Niwa,* and brought
it home. The first illustration that I chose in it and tried to copy
was a portrait of the composer Anton Rubinstein. I was fascinated
by the number of wrinkles and lines in his face that seemed to
quiver and to live before my eyes, so I began to copy it. But I was
still far from thinking of art as a vocation or a profession. At most,
it was still but a hobby, though I already began to pin up all my
drawings, at home, on our walls.

E.R.: One of Soutine's biographers writes that this Russian-
Jewish artist's parents had been horrified and had even beaten
him when he had first expressed his ambition, as a boy, to become
a painter. Did your family and their friends, in the ghetto of
Vitebsk, react as strongly to your choice of this hobby as Soutine's
family in their small-town ghetto near Smolensk?

CHAGALL: My father was a devout Jew and perhaps understood

that our religion forbade us to create graven images and, in the opinion of the more orthodox Rabbis, even to reproduce any living creature. But it never occurred to any of us that these little pieces of paper might be what was thus so solemnly forbidden. And that is perhaps why nobody, among my relatives and my friends, was at all shocked, at first, by my new hobby.

Then, one day, another class-mate of mine, a boy who came of a family that was wealthier than ours and more cultured, dropped by, at our home, and chanced to see some of my drawings pinned to the wall of the room where I worked and slept. He was most impressed by my drawings and proclaimed enthusiastically that I was a real artist. But what did this strange word mean? I had always been somewhat lazy in my studies, a bit absentminded and unwilling to concentrate or to learn. At home, nobody ever asked me what trade or profession I might want to study. My family was very poor, and the poor cannot afford the luxury of a vocation. On the contrary, boys with a background like mine are generally glad to accept the first job that comes their way, as soon as they are old enough to work. Besides, I could scarcely imagine, at that time, that I would ever be able to do anything useful in life. At best, I might qualify for some unskilled job, like my father, who found it hard to make both ends meet on his meagre salary as a warehouseman for a wholesale dealer in pickled and salted fish. Still, this mysterious word "artist" might mean a somewhat better opening for me, in my life, and I began to ask my classmate what it meant. In his explanation he mentioned the names of the great artists of Tsarist Russia, men like Riepin and Werestchaguine, painters of portraits of famous men or of vast historical scenes that were frequently reproduced at that time in such magazines as those where I picked the models for my own drawings. But I had never paid any attention to the names of the artists whose works were reproduced in *Niwa*, and nobody in my family had ever mentioned them to me.

Be that as it may, my madness became apparent for the first time that day. I now knew that I had a vocation, even if my own father still had no idea what this profession that I had chosen might really mean. As for me, I already understood that it would at least mean my having to attend some school and obtain a diploma there. That day, my mother was baking bread in the kitchen when I interrupted her to discuss my new plan. But what

I said about being an artist made no sense at all to her, and she almost told me to go climb a tree.

E.R.: Was it in Vitebsk that you managed to obtain your first training as an artist?

CHAGALL: Yes, but it was no easy task for me to find a teacher. I had to run all over the city before I found a place where I might study my new trade. After enquiring everywhere, I finally found the studio of Pen, a provincial portrait-painter who also taught a few pupils on the side. I then begged my mother to accompany me on my first visit to the master, much as I might have asked either of my parents to come and discuss with some craftsman under what conditions he would accept me as an apprentice. But my mother preferred to consult an uncle of mine beforehand, a man who read newspapers and thus enjoyed, in our family circle, the reputation of being a cultured man of the world. This uncle then mentioned the same names, as examples of all that being an artist could mean, as my class-mate. But he also added that men like Riepin and Werestchaguine had talent, something that had never yet occurred to any of us. My mother decided, however, on the spot that she would allow me to study art if Professor Pen, who certainly knew his own business, expressed the view that I had talent. All this must have taken place in 1907 and, if I remember right, I must have then been scarcely seventeen years old.

E.R.: What were your impressions, on your first visit to Pen's studio?

CHAGALL: When we got there, my mother and I, the master was out, on some errand downtown. But we were greeted by one of his pupils, who was busy in a corner of the studio, drawing something or other. I had brought along, under my arm, a whole bundle of my own drawings, to show them to the master. When my mother saw, in Pen's studio, so many fine portraits of be-whiskered generals, their chests all bright with medals, and of the wives of local gentry, with their opulent and much bejewelled bosoms, she experienced a moment of hesitation. "My poor boy," she sighed, "you'll never manage to make the grade." She was ready to turn back and to drag me home again in her wake. I was still so timid that I held tight to my mother's skirt, whenever we left our part of town, as if I were a child and afraid of losing her in the crowd.

But my mother lingered on in Pen's studio, admiring the master's works and questioning his pupil about the chances of a future that this strange trade might offer a promising beginner. The young Bohemian answered her questions somewhat laconically, making a great show of his worldly cynicism. Art, he explained, isn't a trade that implies keeping a shop and selling any wares. At this point, Pen returned to the studio from his errands in town. Immediately, I produced my drawings and began to show them to him. My mother asked him if I had any talent. Pen answered evasively that there was "something" in my work. But these few words of appreciation sufficed to convince my mother and I was enrolled on the spot as one of his pupils.

I did not attend Professor Pen's classes very long. I soon understood that he could only teach me a kind of art that had little in common with my own aspirations. These were each day becoming more conscious and clear to me, though they still consisted in knowing what I didn't want to paint rather than what I really wanted to achieve. Still, old Pen was kind enough to realize what sacrifices my studies implied for my poor family, and he soon offered to teach me free of charge. My progress was, however, so rapid that, in 1908, I was already able to move to St Petersburg and to enrol there in the Free Academy where Léon Bakst taught.

E.R.: Wasn't Bakst already a close friend of Serge de Diaghilew and one of the most gifted and famous of the designers of sets and costumes for the Russian Ballets?

CHAGALL: Yes, Bakst was one of the leaders of a group of St Petersburg artists that was known as *Mir Iskustvo*, the World of Art.

E.R.: What was your own style of painting, when you first came into contact with Bakst and his school?

CHAGALL: All my works of this first period of my professional life as a painter are now lost. I suppose you might have called me, at that time, a Realist Impressionist, as I was still following a trend that had been introduced in Russia by a number of our teachers who, on their return from Paris, had begun to spread among their friends and pupils a few vague notions borrowed from Pissaro and Jules Adler, from Sisley and Bastien Lepage.

E.R.: How did it happen that all your early works of this period are lost?'

CHAGALL: When I first arrived in the Tsarist capital, I was very

short of money and, one day, discovered a frame-maker—his name was Antokolsky, like the famous Russian sculptor—whose shop window was full of photographs and of framed pictures that he seemed to have on sale there for various painters who were also his customers. I managed to overcome my natural timidity sufficiently to bring all my work to this man Antokolsky and to ask him if he thought he might be able to sell any of it. He told me to leave him my work and to come back in a few days, allowing him time to think it over. When I returned a week later, it was like a scene from a Kafka novel. Antokolsky behaved as if he had never seen me before and claimed that I had never left him any pictures. As for me, I had of course neglected to ask him for a receipt. I even remember his asking me: "Who are you?" In any case, I couldn't sue him in court as I was living illegally in the Russian capital, without the special permit that was still necessary for all Jews.

E.R.: It looks very much as if Antokolsky had been, in his unpleasant way, your first real patron, in fact the first to appreciate the market value of your work. He probably made a lot of money when he sold your pictures a few years later.

Chagall: Perhaps, but I have never been able to trace any of the pictures that I left with him, so I often wonder whether he ever sold them.

E.R.: Was it in St Petersburg that you finally weaned yourself away from your earlier Realist-Impressionist style?

Chagall: Yes, though not at once. One of the first pictures that I painted in the Tsarist capital was a copy of a landscape by Isaac Levitan.

E.R.: Isn't Levitan considered a great Russian Impressionist master? He was a friend, if I remember right, of the writer Anton Chekhov, who mentions him frequently in his diary and in his letters and had a Levitan landscape hanging above his desk. Chekhov is even supposed, in some of his stories and plays, to have sought inspiration from Levitan landscapes of typical Russian provincial scenes, describing them in words to create the atmosphere of *The Cherry Orchard* and *The Three Sisters*, for instance.

Chagall: Yes, we all considered Levitan a great man, in those days, and I was fortunate enough to meet in St Petersburg several of his friends and patrons as well as some friends of the

painter Serow. I saw many of the works of these two Russian Impressionist masters in private collections. At that time, being a Jew, I needed a special permit to reside in the capital and, having failed to obtain this permit, I was unable to register as a student in the National Academy of Fine Arts. That is why I had to go to the Free Academy, where I studied, among others, under Bakst and Roehrich ...

E.R.: Roehrich subsequently emigrated to the United States. I remember visiting, some twenty years ago, a Roehrich Institute in New York, on Riverside Drive. It was full of Roehrich landscapes, some of which struck me as pretty ghastly, and the whole place reeked of theosophy, or was it anthroposophy. . . ?

CHAGALL: But Roehrich had once been, in Russia, a very serious painter and a much respected innovator. It was to Roehrich that Diaghilew gave the job of designing the original sets and costumes for Stravinsky's *Rites of Spring*. At that time, Bakst, Roehrich and Alexandre Benois were the leaders of a kind of Russian *Art Nouveau* or *Jugendstil*. . . .

E.G.: Wasn't Benois the grandfather of Peter Ustinov?

CHAGALL: Yes, that whole family is very gifted, and several members of it have become famous, especially in theatrical work. When I first came to St Petersburg, Bakst, Benois, Roehrich and their friends of the *Mir Iskustvo* group were trying to achieve a synthesis of new trends, which reached them mainly from Paris and from Vienna, and of certain elements of traditional Russian folk-art, especially the somewhat more exotic or oriental folk-art of Southern Russia and of the Caucasus. They thus contributed very much towards the success of the early Russian ballets.

E.R.: Many of the Russian modernists, even Kandinsky and Gontcharowa, were at one time disciples of the *Mir Iskustvo* group. I saw last summer, in the Amsterdam Stedelijk Museum's Exhibition of Art of the year 1907, a huge painting by Kandinsky that still looked like a Bakst design for a theatre-curtain.

CHAGALL: I'm not at all surprised. But Bakst and his friends remained, on the whole, true to a very aristocratic and refined, even somewhat decadent, conception of art, whereas Levitan and even Riepin advocated a kind of Populist art that had some Socialist implications, suggesting a return to the earth and to the life of the Russian people. I felt attracted to this Populist Impressionism rather than to the pure Impressionism, after the manner of

Sisley, of some Russian painters, such as Grabar, who had studied in Paris. Still, I always had my own notions about this Populism too.

E.R.: Yes, I don't suppose anyone has ever dared to place you among those Socialist Realists whose paintings are often but illustrations to doctoral dissertations in the field of Comparative Sociology.

CHAGALL: On the contrary, I have always tried to remain within the general tradition of a kind of folk-art and, at the same time, of all great art that also appeals immediately to the less sophisticated, to the people. That is why, in Russia, I was a great admirer of the traditional art of the ikon-painters. There is often something quite magical and unreal about the plastic values and the colours of ikons. They suddenly light up before our eyes, in the darkness of a church, like flashes of lightning. One can well understand how it has been believed that many of these ancient ikons were not created by the hands of man but had appeared miraculously from heaven.

E.R.: Another Russian painter, Wladimir de Jawlensky, who was a close friend of Paul Klee, was also a great lover of the art of the ancient painters of ikons.

CHAGALL: Jawlensky? What a wonderful painter! He was one of those who encouraged me most when I was having such a hard time in St Petersburg. Later, he often wrote to me from Munich. I was so pleased, in the last few years, to see that Jawlensky's art is at last receiving the attention that it has long deserved.

E.R.: So it was in St Petersburg that you experienced your first contacts with the modern art-movement. . . .

CHAGALL: Yes, but I was also busy discovering there some of the treasures of the city's museums. And it was in St Petersburg that I began painting my first series of self-portraits.

E.R.: I have had occasion to see recently one of these self-portraits that have now become so rare. It hangs in Oxford, in the home of one of my friends. To me, it has always seemed, in its composition and colouring rather than in its actual texture, to be somewhat inspired by the early self-portraits of Rembrandt, perhaps because you depict yourself wearing a kind of beret, not unlike the one that Rembrandt wears in one of his self-portraits.

CHAGALL: How strange! I was very far, in those days, from thinking of Rembrandt. Most of the Russian painters whose work I

knew were addicted to the colour harmonies which you find so sombre. It was only later, when I came to Paris, that I learned at last, as other Russian painters did too and as Van Gogh had also learned earlier, to appreciate all the wonders of light and of colour.

E.R.: I remember reading somewhere that Bakst had already encouraged you in St Petersburg to try your hand at brighter colour harmonies and to allow yourself greater freedom as a colourist.

CHAGALL: Perhaps, but Bakst had also learned much of his art in Paris and, in any case, I began to follow his advice only after 1910, that is to say after my arrival in Paris.

E.R.: How did you manage your first trip to Paris?

CHAGALL: Bakst had originally wanted me to take on the job of his assistant Anisfeld, who helped him paint the sets for Diaghilew's ballets and was about to leave him. I don't remember how it came about that this plan did not materialize and that I somehow failed to go to Paris with Bakst and the ballet company. It was finally the lawyer Vinaver, who was also a member of the Russian Parliament or Duma, who offered me the money for my first trip. Vinaver had been, ever since my arrival in St Petersburg, my first and most faithful patron. He had several of my paintings in his collection, where I was very proud to see them hang close to works by Levitan and Serow.

E.R.: The American painter Zev tells me that his uncle had also been one of your early patrons in the Tsarist capital.

CHAGALL: Zev? Certainly. I even mention the old gentleman in my book, *Ma Vie*. But I had no idea that the nephew of my friend Zev was an American painter.

Anyhow it was Vinaver who, one day, suddenly offered to pay for my trip to Paris and to transfer to me each month a sum of forty roubles, which I used to go and collect from the Crédit Lyonnais on the Boulevards. So I left Russia all alone, and full of misgivings. I was already in love, in those days, with Bella, who lived with her parents in Vitebsk. But her family felt that I was too poor to be considered a desirable son-in-law, and even the German frontier officials, when they boarded our train to inspect our passports and our baggage, viewed me suspiciously and asked me, "*Haben Sie Laüser?*"

E.R.: What were your first impressions of Paris?

CHAGALL: I seemed to be discovering light, colour, freedom, the sun, the joy of living, for the first time. It was from then on that I was at last able to express, in my work, some of the more elegiac or moon-struck joy that I had experienced in Russia too, the joy that once in a while expresses itself in a few of my childhood memories of Vitebsk. But I had never wanted to paint like any other painter. I always dreamed of some new kind of art that would be different. In Paris, I at last saw as in a vision the kind of art that I actually wanted to create. It was an intuition of a new psychic dimension in my painting. Not that I was seeking a new means of expression, in a kind of basically Latin Expressionism like that of a Courbet. No, my art has never been an art of mere self-expression, nor an art that relies on the anecdotes of subject-matter. On the contrary, it has always been something essentially constructed, in fact a world of forms.

E.R.: Is that why you immediately associated with the Paris Cubists?

CHAGALL: No, the experiments of the Cubists never interested me very deeply. To me, they seemed to be reducing everything that they depicted to a mere geometry which remained a new slavery, whereas I was seeking a true liberation, not a liberation of the imagination or the fantasy alone, but a liberation of form too. If, in one of my pictures, I place a cow on a roof, or a tiny little woman in the middle of the body of a much larger one, all this should never be interpreted as an anecdote. On the contrary, it all seeks to illustrate a logic of the illogical, a world of forms that are *other*, a kind of composition that adds a psychic dimension to the various formulae which the Impressionists and then the Cubists have tried.

E.R.: André Breton and the Surrealists have often claimed that you had been ten years ahead of their movement, and that you had, as early as 1912, begun to obey the dictates of the kind of automatic painting that they advocated around 1920 in their earliest manifestoes.

CHAGALL: No, this argument is entirely unfounded. On the contrary, I always seek very consciously to construct a world where a tree can be quite different, where I myself may well discover suddenly that my right hand has seven fingers whereas my left hand has only five. I mean a world where everything and anything is possible and where there is no longer any reason to be

at all surprised, or rather *not* to be surprised by all that one discovers there.

E.R.: One of my friends, the Israeli art-critic Haim Gamzou, claims that you are the Breughel of Yiddish idiom and folklore, and that he has himself identified over a hundred illustrations of popular Yiddish idioms and proverbs in details of your works.

CHAGALL: But I have never consciously set out to illustrate these idioms and proverbs as Breughel once did, nor have I ever systematically composed a painting in which every detail illustrates a different proverb. All the idioms and proverbs that I may have illustrated have actually become popular because thousands of ordinary men and women use them day by day, as I too have done, to express their thoughts. If a carter uses these metaphors and similes, there is nothing literary about his language. And if I, the son of a humble worker of the Vitebsk ghetto, also use them, this is still no reason to argue that my art relies on anecdote. Does the mere fact that I have become an artist make my work literary as soon as I express myself, perhaps unconsciously, as did all those who surrounded me in my childhood?

E.R.: Not at all. But other critics have also claimed that much of your earlier work borrowed its themes, or at least many of its details, from the writings of the great Yiddish humorists Sholem Aleichem and Peretz.

CHAGALL: Of course, I had read some of the works of these writers, but I have never been much of a reader and I feel that, on the contrary, I have probably used the same sources, in popular Jewish humour and folklore, as these writers who, after all, came from communities very much like the one where I was born and spent my childhood.

E.R.: And what do you think of the critics who claim that they have detected in your works the influence of Hassidic mysticism?

CHAGALL: It is true that all my family belonged to a Hassidic community and that we even had, in Vitebsk, a famous Hassidic *Wunderrebe*, a miraculous Rabbi. But I doubt whether anyone can reasonably pretend that my work is essentially an expression of mystical faith or even of religious belief. Mysticism and religion, of course, still played an important part in the world of my childhood, and they have left their mark in the work of my mature years too, as much as any other element of the life of the ghetto

of Vitebsk. But I have now discovered other worlds too, and other beliefs and disbeliefs. . . .

E.R.: What artistic circles did you choose to frequent when you first came to live in Paris?

CHAGALL: One of my earliest and closest friends was the poet Blaise Cendrars. With Guillaume Apollinaire, the poet and leading theorist of the Cubists, I was much less at ease, though he was always very friendly and helpful. In those days, I had a studio in La Ruche, that legendary colony of broken-down studios where so many famous artists have lived. Modigliani was one of my neighbours. He was then doing more sculpture than actual painting.

E.R.: I recently saw a Brancusi painting of that period, a portrait of a model who often sat for Modigliani. It was interesting to see a painting by a great sculptor, of a model who is also known to us from the sculptures of a great painter. . . . But you must have found many other Russian artists living in La Ruche.

CHAGALL: No, I think I was then the only Russian painter there. Soutine moved in later. When I was preparing, in 1914, to go back to Russia, via Berlin, Soutine came one day to ask me if I would allow him to rent my studio as a sub-tenant while I was away.

E.R.: Was Soutine already as odd, as uncommunicative and as careless of his appearance as he has generally been described?

CHAGALL: I always found poor Soutine rather pitiful. Anyhow, I was not prepared to sublet my studio to anyone and, the day I left for Berlin, I secured the door, which had no lock, with a rope, like a parcel. I had no idea, at the time, that I would return to La Ruche only in 1922.

E.R.: What had made you decide to go to Berlin in 1914, just before the outbreak of the First World War?

CHAGALL: Apollinaire had mentioned my work several times to Herwarth Walden, the organizer of Berlin's Sturm Gallery shows. Walden often came to Paris, in those years, to pick new talents whom he could exhibit in Germany. The German poet Ludwig Rubiner and his wife Frieda had also recommended me to Walden. The Rubiners, who were wonderful and devoted friends, were then as frequently in Paris as in Berlin, and many Paris artists owed their German successes to the Rubiners, who were indefatigable propagandists for modern art. Well, one day Walden asked me to let him exhibit some hundred and fifty of my oils and

gouaches. I had already exhibited once in Berlin, in the 1913 Herbstsalon, where the collector Bernhard Koehler had purchased my *Golgotha* that now hangs in the New York Museum of Modern Art. So I went to Berlin, in 1914, to take a look at my exhibition in Walden's Sturm Gallery. Actually I stopped in Berlin only a few days, on my way back to Russia, where I planned to see Bella again and hoped to persuade her family to allow her to marry me and to return with me to Paris. We would then have stopped again in Berlin, on the way back, to collect the money that Walden might have obtained for me as a result of sales from my exhibition. But war was declared, and I was able to return to Berlin, and on to Paris, only after the War and the Russian Revolution. By that time, Walden had already sold all of my hundred and fifty paintings and gouaches, but the currency inflation was raging in defeated Germany and the money that Walden had obtained for my work was no longer worth a cent.

E.R.: So it was the second time that you had seen all your work of a whole period sold without your being able to collect any money for it. It was almost like a repetition of the Antokolsky fiasco in St Petersburg, except that, this time, your paintings did not simply disappear into thin air. If I remember right, many of the works that Walden had sold for you are now in important public and private collections. I saw some of them in Amsterdam, among those that the Stedelijk Museum exhibits in a whole room of your works.

CHAGALL: Yes, but the Stedelijk also owns many of my works that come from other sources too. But a third unpleasant surprise of this kind awaited me in 1922, when I returned to Paris and tried to go back to my studio in La Ruche. I had expected to find it exactly as I had left it, though with the dust of nearly a decade accumulated on all my pictures and other possessions. Instead I was greeted there by new tenants. In my absence, all my belongings and my works had been moved out and sold, and I was never able to salvage anything.

E.R.: In a BBC talk that was reprinted in *The Listener*, Mania Harari reported, on her return from a trip to Moscow a couple of years ago, that she had still been able to see there quite a number of works which you had painted in Russia between 1914 and 1922. During those years of war and of Revolution, were you able to concentrate much on painting?

CHAGALL: Oddly enough, those years were among the most productive of my whole career. On my return from Paris, I found the atmosphere, in Russia, much more encouraging than before 1910, especially in certain Jewish circles that I had known before my first trip to Paris. Collectors had become far more open-minded, and there were more of them too.

E.R.: I suppose you also found that, in the eyes of younger artists, you already enjoyed considerable prestige as an established master. . . .

CHAGALL: Perhaps. . . . In Moscow, I met at that time an outstanding and very successful engineer, Kagan Chabchay, who bought some thirty paintings of mine, which he planned to donate, with works by other artists too, to a Jewish Museum that he was sponsoring. But the Revolution came before this project had materialized, and Kagan Chabchay, in 1922, still owned all his private collection. It had not yet been nationalized, and he allowed me to bring back to Paris, so as to exhibit them there, all the paintings that he had purchased from me.

E.R.: Three of those pictures from the former Kagan Chabchay collection came up for sale in December 1958 in the Paris Salle Drouot. It appears that they have a somewhat curious history.

CHAGALL: Yes. On my return to Paris, in 1922, Kagan Chabchay's refugee relatives claimed that he had authorized them to sell the paintings which he had loaned to me, in order to raise money for themselves. So I allowed them to go ahead with these sales, until the Soviet authorities intervened and seized the last three pictures in order to sell them, it seems, on behalf of other heirs, who had remained in Russia, since Kagan Chabchay had meanwhile died. These three pictures, as a consequence of litigation that was then delayed by the Second World War, remained impounded by the Court for close on twenty years.

E.R.: And when they were at last sold in Paris the heirs, whether the money went to those who had emigrated or in theory to those who had remained in Russia, obtained some twelve million francs, a far larger sum than they would have obtained by selling their three pictures in 1922.

CHAGALL: But I had sold them originally to Kagan Chabchay for a sum that would amount to a few thousand francs today.

E.R.: Mania Harari also reports that she met in Moscow a private collector who owns, even today, some thirty of your works,

which he has managed to purchase more or less secretly in recent years.

CHAGALL: That is quite possible. I left many works in Russia, most of them in the homes of friends who generally owned small collections that were not nationalized. Many of these collectors or their heirs, I suppose, subsequently sold these paintings on the Free Market, which is a. kind of flea-market in Soviet Russia.

E.R.: Only recently, I was told by another traveller who had returned from Moscow that he knew of about a dozen such private collectors of modern art who had managed, even during the Stalinist era, to purchase unobtrusively on the Free Market some very valuable works by French Impressionist masters, Picasso, Matisse and other foreign artists, as well as works by yourself, by Larionow and other Russian or formerly Russian modernists who have long been banned as "formalists" by the official Soviet apostles of Socialist Realism. Still, your own work has not always been banned in Soviet Russia and, if I remember right, you even enjoyed some official support during the earlier years of the Revolution.

CHAGALL: Yes, I enjoyed the patronage of Lunatcharsky, who was the first Soviet Commissar for Education. It was he who nominated me local Commissar for Fine Arts in my native city, in Vitebsk. I was then responsible for all artistic activities in that region, and was thus able to provide Vitebsk with what I had missed there twenty years earlier, I mean a real Fine Arts Academy and a Museum.

E.R.: Were you able to attract to Vitebsk many of your fellow-artists from Moscow and Leningrad?

CHAGALL: It was fairly easy, and nearly all those whom I approached accepted to come. Food supplies were then far more plentiful in Vitebsk than in bigger cities, and I also offered all artists complete freedom. The faculty of my Academy thus included many of the great names of the Russian artistic *avantegarde*. Nearly all schools of modern art were represented there, from Impressionism through to Suprematism.

E.R.: We are not very well acquainted, in Western Europe and in America, with the various schools of contemporary Russian art, from Rayonnism to Suprematism and Constructivism. The Suprematists, I believe, were somehow connected both with

Mondrian's *De Stijl* group in Holland and with the Dadaists of Zurich, Berlin and Paris.

CHAGALL: Yes, the Suprematists and the Constructivists maintained contacts, throughout the revolutionary years, with advanced groups in Western Europe.

E.R.: But did all these artists, representing such different trends, co-operate harmoniously in your Vitebsk academy?

CHAGALL: On the contrary, our academy very soon became a veritable hotbed of intrigue. To begin with, my old friend Pen, who had been my first instructor, was mortally offended because I had neglected to offer him immediately an important position on the faculty. But I was anxious to avoid introducing, at the very start, too academic an element in our teaching. Pen got his revenge by painting a parody of a famous picture of the German Symbolist Arnold Boeklin, the author of the *Isle of the Dead*. In this parody, Pen depicted himself on his death-bed, and gave the devil who had come to fetch his soul a face that was quite recognizably mine. Later, I asked Pen to join our faculty too. But it was with the Suprematists that I had the greatest trouble.

E.R.: Was the founder of the Suprematist school, Casimir Maliewitsch, also on your faculty?

CHAGALL: Yes, but the Constructives had not yet broken away from the Suprematist group, and I thus had both Maliewitsch and El Lissitzky on the Vitebsk faculty. Even Pougny, who was also a Constructivist before he emigrated to Paris, was there with his wife: they both taught courses in applied art. But Maliewitsch was the leader of this whole group. He had started painting as an Impressionist, until 1906, and had then been one of the first Russian Fauvists.

E.R.: I saw a very fine Fauvist painting by Maliewitsch in the Amsterdam Exhibition of the art of 1907, and Larionow subsequently told me in Paris that Maliewitsch, after going through a Cubist phase too, had then exhibited in 1913, in one of the Rayonnist shows in Moscow.

CHAGALL: When I first met Maliewitsch in 1917, he had already begun to preach his Suprematist doctrines.

E.R.: The Galerie Denise René, in Paris, recently showed a few abstract works of his Suprematist period. They are very closely related to the work of Mondrian and of the Dutch abstract painters of *De Stijl*.

CHAGALL: Actually, it was Lissitzky who, among the Suprematists, gave me the most trouble. At that time, he was still relatively unknown and, before committing himself exclusively to Suprematism and later to Constructivism, had first attracted the attention of several of my own patrons by handling Jewish themes in a style that was not unlike my own.

E.R.: Some of Lissitzky's early works on Jewish themes turn up even today in German auctions. Because they are so much like early works of your own and are likewise signed, as you did too at one time, in Hebrew script, they are usually listed in German auction catalogues under your name.

CHAGALL: I suppose there are no longer many art experts in Germany who can decipher Hebrew script. But Lissitzky and I were not the only artists in Russia to handle such themes and to sign our works, at that time, in Hebrew script. There was also Issachar Ryback, who died relatively young and has left us some very fine works. He was one of the most gifted in our group of artists who were then seeking to formulate a specifically Jewish style of art. In the early years of the Revolution, the various national groups in Soviet Russia were at first encouraged to develop schools of art of their own, and quite a number of Jewish artists thus happened to pursue, for a while, the same aims. It was with Ryback, Nathan Altman, Lissitzky, Rabinowitsch and Tischler that I came to work in Moscow for the Jewish National Theatre, for the Habbimah and for the Kamerny Theatre. But most of my theatrical designs were considered too fantastic for use on the stage, and Meyerhold, Tairoff and Watchangow never used them. Only Granowsky ever had the nerve to use any of my designs. I also painted some panels to decorate the foyer of the Jewish National Theatre in Moscow.

E.R.: One of my American friends who was in Moscow last summer tells me that this theatre still owns your paintings, but that they are now stored away in the basement and shown only to foreigners and on request. He was even given to understand quite unequivocally that the present management of the theatre disapproved of such an unhealthy interest and could scarcely understand why so many foreigners came to see your pictures there. I hear besides that it would be high time they invited you to Moscow to restore these paintings, which have suffered considerable damage. But how did you manage to find time to found and

C

direct your academy and museum in Vitebsk and to work con-
currently for the theatre in Moscow?

CHAGALL: Well, as they say in Yiddish, you can't be dancing
at the same time at two different weddings, and I could scarcely
be both in Vitebsk and Moscow. As long as I was director of the
Academy, I had little spare time to paint. At all times, I was busy
raising funds to meet our expenses, scaring up supplies of all sorts,
or visiting the military authorities to obtain deferments for
teachers or pupils. So I came and went, and also inspected all
schools in the area where any art-classes were taught, and was
constantly being called to Moscow for conferences with the cen-
tral authorities. While I was away from Vitebsk, Impressionists
and Cubists, Cézannians and Suprematists, whether on the faculty
or among the students, used to engage in a kind of free-for-all
behind my back. One day, when I returned to Vitebsk from
Moscow, I thus found, across the façade of the school building, a
huge sign: *Suprematist Academy.* Maliewitsch and his henchmen
had simply fired all the other members of the faculty and taken
over the whole Academy. I was furious. I handed in my resigna-
tion at once and set out again for Moscow, in a cattle-car, as the
railroads had no other rolling-stock available even for travellers
on official business . . .

E.R.: But surely your friends in Moscow refused to accept your
resignation.

CHAGALL: On the contrary, when I called at the Ministry of the
Commissar for Education, I was told I had already been fired. A
whole file of denunciations and affidavits was produced, and I
was told that some of the Suprematists had accused me of being
authoritarian and unco-operative and of a whole lot of other crimes.

E.R.: That's an old trick of all police-states, to build up a file
of unproven accusations and gossip and then produce it at the
right moment so as to make sure that the authorities maintain the
initiative of any action. I myself have had the same experience
recently, with the Sûreté, right here in Paris. I suppose that the
Soviet authorities didn't want to allow you the initiative of resign-
ing. That's why they produced enough material to fire you.

CHAGALL: Be that as it may, reports of all this reached Vitebsk,
and the students staged a protest as a result of which I was re-
instated, though not for very long. My Suprematist colleagues
continued to intrigue against me and I then arranged to move to

Moscow, where I began to free-lance, working mainly for the Jewish Theatre until I returned to Berlin and Paris in 1922. Not only did I now have more time to paint, but I even managed in Moscow to write my book, *Ma Vie*, which was subsequently published in Paris in 1931.

E.R.: Did the Suprematists and Constructivists continue to persecute you in Moscow?

CHAGALL: From 1920 on, the various advance-guard schools of art began to feel more pressure to toe the party-line of Socialist Realism. Even David Sternberg, Falk, Altman and the other disciples of the Impressionists and of Cézanne who still headed the National Academy of Fine Arts no longer dared open their mouths when the theorists of Socialist Realism condemned as bourgeois or formalist all the styles of art which they admired.

E.R.: So you actually left Russia, in 1922, as a political refugee, since you would have been persecuted, had you remained there, as a representative of a school of art which the Stalinists had banned.

CHAGALL: Well, I had already had just as good political reasons to emigrate in 1910, so that it would be more correct to say that I left Russia, on both occasions, for purely personal and artistic reasons. I have chosen to live in France because I have always felt that France is my real home, because only in France, and especially in Paris, do I feel truly free as a painter of light and colour. I have already stated to you that Russian painters, in my opinion, have but rarely managed to develop a real sense of colour in their own country.

E.R.: Yet all of Paris and of Western Europe had raved about Bakst's sense of colour, before the First World War, and about the brilliance of the sets and costumes of Diaghilew's Russian Ballets.

CHAGALL: True, but Bakst and the other artists who worked for Diaghilew had all studied in Paris or been pupils of Russian painters who had returned to their native land after studying with the great Impressionists. Besides, there is a great difference between the use of colour in the applied arts, especially on the stage, and in easel-painting. The light, in a theatre, is not of the same kind as the light that we find in nature, or in a room where a picture hangs on a wall. That is why an artist who works for the stage can allow himself more violent contrasts of colour than on a canvas, where there is no movement of actors or of dancers to

relieve the tension of these contrasts, and no spotlights to stress suddenly a detail while leaving the rest, for the time being, in the shadow. A canvas requires a kind of harmony of light and of colour, a more integrated unity than that of a stage-set. Now that I have been working on the designs for a new production of Ravel's *Daphnis and Chloë* Ballet for the Paris Opera, I find myself constantly concerned with these problems.

E.R.: On your return to Paris, after spending all the years of the War and of the Revolution in Russia, you surely found it difficult, at first, to integrate yourself again in the Paris art-world.

CHAGALL: Perhaps. . . . But I did not come directly from Moscow to Paris. Instead, I stopped for a while in Berlin, where I found myself, in those difficult years of inflation and of the birth-pangs of the Weimar Republic, in an atmosphere that was not unlike that of the early years of the Russian Revolution. Besides, I met in Berlin a number of Russian friends, from Leningrad, Moscow and even Vitebsk, who had likewise emigrated, if only for a while.

E.R.: I suppose you saw Lissitzky again in Berlin. Your old Suprematist friend or enemy had, by that time, become one of the leaders of the Constructivist movement, with the painters Tatlin and Rodzenko and the sculptors Pevsner and Gabo. In 1920, Lissitzky organized, if I remember right, an international Constructivist Conference in Weimar, and it was attended by several leading Western European delegates from the Weimar Bauhaus, from the Dada groups in Berlin and Zurich, and from Mondrian's *De Stijl* group in Amsterdam. The Polish painter Henryk Berlewi showed me a few days ago, here in Paris, an old copy of a periodical that Lissitzky had published in Berlin, together with Ilya Ehrenburg, in 1922. It was called *Objet-Viestch-Gegenstand* and was published in three languages, French, Russian and German. When I glanced at the names of the contributors to that single issue, I was quite dazzled: Picasso, Le Corbusier, Archipenko, Ozenfant, the poets André Salmon, Wladimir Maiakowsky and Serge Essenin, the stage-directors Tairoff and Meyerhold, in fact most of the great names of that now legendary era.

CHAGALL: I'm not at all surprised. Berlin had become, right after the First World War, a kind of vast clearing-house of ideas where one met all those who came and went from Moscow to Paris and back. Later, I found for a short while a similar atmosphere on the Paris Left Bank, in Montparnasse, then again in New York during

the Second World War. But in 1922, Berlin was like a weird dream, sometimes like a nightmare. Everybody seemed to be busy buying or selling something. Even when a loaf of bread cost several million marks, one could still find patrons to buy pictures for several thousand million marks which one had to spend again the same day, in case they might become valueless overnight. In the apartments around the Bayrischer Platz, there seemed to be as many theosophical or Tolstoian Russian countesses talking and smoking all night around a samovar as there had ever been in Moscow and, in the basements of some restaurants in the Motz-strasse, as many Russian generals and colonels, all cooking or washing dishes, as in a fair-sized Tsarist garrison-town. Never in my life have I met as many miraculous Hassidic Rabbis as in inflationary Berlin, or such crowds of Constructivists as at the Romanisches Kaffeehaus.

E.R.: I'm sure that Lissitzky had already converted to Construc-tivism whole groups of German disciples of *Neue Sachlichkeit*, and that his PROUN designs, as he called them, were as well known as the MERZ constructions of the German Dadaist Kurt Schwitters. If Lissitzky had remained in Berlin, the style that he had helped to create and to popularize might well have earned him a fortune, a few years later, as an industrial designer in Western Europe and in America. But he chose to return to Soviet Russia and, after 1928, even Henryk Berlewi, who had been one of his closest friends, ceased to receive any news from him. I have been told that Lissitzky was then exiled to Siberia under the Stalinist regime and died there in the most abject poverty. Ilya Ehrenburg was more fortunate or more clever in adapting himself after his return to Soviet Russia from his years of exile in Western Europe. . . .

CHAGALL: When I was a refugee in New York during the Second World War, I often thought of all those whom I had known in Vitebsk, in St Petersburg, in Moscow, in Paris and in Berlin, all those who had been less fortunate than I and who had not managed to escape from the horrors of persecution and of war.

E.R.: There is a very poignant quality in many of the works that you painted in New York during the war. Your memories of Vitebsk and of Paris seemed to haunt you, and your visionary renderings of the past became more tragic or apocalyptic, less elegiac or humorous than those of your other periods. . . .

*At this point, Madame Chagall interrupted our conversation, reminding the master that he had an appointment with the dentist. With the agility and speed of an acrobat, he rose from the couch and was suddenly standing in the middle of the room. When Madame Chagall asked him, as he slipped into his jacket, whether he had enough money on him to pay his cab fares, he became a clown, of the same rare quality as Charlie Chaplin or Harpo Marx, felt all his pockets and replied: "Yes, yes, but where are my teeth?" Then, feeling his jaw, he added: "Oh, they are still there!" In a twinkling, he was gone.*

*Two days later, I returned, to submit to Chagall the first draft of my manuscript and check with him the many dates and details that I had hurriedly noted as he spoke. He was surprised to see how much I had recorded of all that he had said. I explained to him that my experience as a conference interpreter had taught me, without ever using shorthand, to take extensive notes while listening to a speaker. From time to time, as he read my text, he corrected a few words, added a detail, changed a date. When he had approved the whole interview, he concluded: "The poet Maiakowsky used to say to me in Moscow: 'My dear Chagall, you're a good guy, but you talk too much.' I see that I have not improved with age ..."*

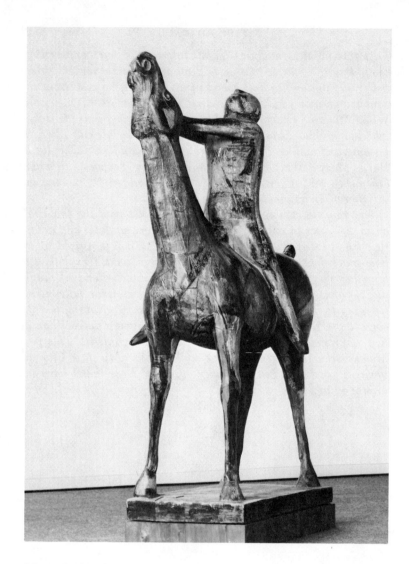

MARINO MARINI
*Horseman*

# Marino Marini

*I had noticed in recent months the sporadic publication of a number of news items and features, in the Italian press, about the progress of the huge sculpture on which Marino Marini had long been working. Each time, the reporters had tried to give their readers some new details concerning this monument. They all agreed that the great Italian disciple of the art of pre-classical antiquity and of the Middle Ages had inaugurated a new phase in the evolution of his style. The mysterious sculpture to which Marino Marini had devoted most of his time, for the past two years, was thus described by some critics as more expressionistic than his previous works, but by others as more abstract. On other details, there was less agreement. Some referred to the monument as a new bronze horse, but without the usual rider. Others affirmed that Marini was again producing an equestrian figure, but conceived according to a novel formula. Some declared that the horse would be five yards high; others, only two yards. It was sometimes said that the monument had been commissioned by the municipality of Rotterdam, sometimes by that of Amsterdam, once by that of Groningen.*

*As I happened to be for a few days on other business in Milan, I decided to investigate the matter myself and took the liberty of phoning Marini for an appointment. I was fortunate enough to find him at home. He had returned only the day before from a visit to his wife's family in Switzerland. He asked me to call the next morning at his apartment.*

*I found my way there in fog and rain, in weather more suggestive of London than of any Italian city. Marino Marini lives on one of the upper floors of a modern apartment house in the centre of the city. When the door was opened to me by the maid,*

33

*I was led into an elegant living-room, decorated and furnished in a kind of cultured 'movie-set' style, like the house of a fastidious industrial tycoon. On the walls, there were several of Marini's own paintings and drawings. On a few tables and other low pieces of furniture, some of his more famous bronzes, of which I had seen other copies in museums and galleries. It was like the home of a wealthy Swiss or Italian art-patron, with nothing that might suggest the inevitable dust and disorder of a sculptor's studio.*

*As soon as Marino Marini had joined me and greeted me, I began to ask him about his new work, quoting the discrepancies that I had noticed in the Italian press. He laughed, then began to explain to me the facts about his work.*

MARINI: It's an equestrian figure. Some papers have already published photographs of the plaster model. But a few of these pictures, as a consequence of faulty perspective, have suggested some misunderstandings. The rider is leaning back, almost lying on the horse's hindquarters. When one looks at the model from the front, the shadow of the horse's head sometimes blots out the rider, or confuses it with the horse's mane. That is why so many people have believed that the horse had no rider. As for the other details, the whole monument will be some six yards high and has been commissioned by the municipality of The Hague for one of the new "satellite cities" that are being built as suburbs of the Dutch capital.

*The business of noting Marini's explanations distracted me throughout our conversation from watching his unusually mobile expressions. His face has a sculptural quality, like that of a figure in a painting by Piero della Francesca. His forehead is broad, beneath the receding line of greying hair, but the face is still young, relaxed and open in spite of a curious sadness in the eyes, that of a prophet who has no longer any illusions rather than of an embittered or sick man. As I question him in French, Marini formulates his answers carefully in the same language, which he speaks almost faultlessly, with only a slight Italian accent. Once in a while, if he seems unable to find the right word, I encourage him to express himself in Italian. His Tuscan is unusually pure, though he speaks without that guttural quality which renders the speech of many Florentines so unmusical.*

E.R.: What difference is there between your new equestrian statue and all those that you had already created since 1945?

MARINI: I think it would be wrong to state that a clear break can be detected in the evolution of my style, in the last two years. On the contrary, the monument on which I'm now working—and I'll show you the model later in my studio downstairs—illustrates only the latest phase of this evolution, the meaning of which may already be clear to you. Each one of the equestrian figures that I have created since 1945 represents a different phase of this evolution.

*I ask Marini to explain to me his ideas about the increasingly apocalyptic character of his riders, each one of which, in turn, seems to have been struck more brutally by some catastrophe, whether as witness or as victim.*

MARINI: Equestrian statues have always served, through the centuries, a kind of epic purpose. They set out to exalt a triumphant hero, a conqueror like Marcus Aurelius in the monument that one still sees on the Capitol in Rome and that served as model for most of the equestrian statues of the Italian Renaissance. Another example is the statue of Louis the Fourteenth on the Place des Victoires in Paris. But the nature of the relationship which existed for centuries between man and the horse has changed, whether we think of the beast of burden that a ploughman leads to the drinking-trough in a painting by one of the brothers Le Nain, or of the percherons ridden by the horse-traders in Rosa Bonheur's famous picture, or again of the stallion that rears as it is spurred by one of the cavalry-men painted by Géricault or Delacroix. In the past fifty years, this ancient relationship between man and beast has been entirely transformed. The horse has been replaced, in its economic and its military functions, by the machine, by the tractor, the automobile or the tank. It has already become a symbol of sport or of luxury and, in the minds of most of our contemporaries, is rapidly becoming a kind of myth.

The artist is often a bit of a prophet and, almost a century before the invention of the automobile, some of the Romantic painters, especially Géricault and Delacroix, no longer painted their horses with the same objectivity as the portrait-painters of the eighteenth century. Especially in England, these painters had

often been more exact in their rendering of a favourite horse than in their somewhat idealized portrait of its aristocratic human owner. The Romantic painters were already addicted to a cult of the horse as an aristocratic beast. They saw in it a symbol of luxury and adventure rather than a means of transport or beast of burden.

From Géricault and Constantin Guys to Degas and Dufy, this cult of the horse found its expression in a new attitude towards sport and military life, an attitude that is best exemplified by the nineteenth-century dandy. Odilon Redon's visionary renderings of horses and later in those of Picasso and Chirico, we then see the horse become part of the fauna of a world of dreams and myths.

E.R.: All this had already struck me last summer, when I visited, in Western Germany, a special exhibition entirely devoted to the theme of the horse in the history of art. Though this exhibition had devoted almost a whole room to your own work, I left it convinced that the nineteenth century remains, from Géricault to Degas, the great age of the horse as an artistic theme.

MARINI: I suppose I came along in the immediate aftermath of this great age, after Degas, but still as a contemporary of Dufy as well as of Picasso and of Chirico. My own work has followed a general trend in its evolution, from representing a horse as part of the fauna of the objective world to suggesting it as a visionary monster arisen from a subjective bestiary.

E.R.: I don't remember ever having seen, except as photographs in catalogues and art-publications, any of your horses of the first period of your own evolution, the one you have just called objective.

MARINI: They are mostly early works, not as well known as some of my more recent sculptures. I had been fortunate in renting a studio, when I was a beginner, in Monza, near Milan, where my neighbours owned a big livery stable. I made the most of the opportunities offered me and drew and modelled horses almost every day. But these horses were still far from symbolizing to me anything subjective or apocalyptic. All my work, I mean my human figures too, remained for a long while very classical, somewhat reticent and realistic too, in its style. Until the end of the Fascist era and of the War, I continued to hark back to the sober realism of the artists of the Etruscan funerary figures, or of the

sculptors of some Roman portraits, especially the earlier ones. My own way of reacting against the imperialist pathos of official Fascist art continued, until 1944, to consist in identifying my art very consciously with my private life, so that I never allowed myself any form of expression that might seem too blatantly public. That is why I continued to produce so many portraits which may seem as anonymous as those funerary busts of unknown Romans which strike us, twenty centuries later, as human documents, stripped of all historical pathos. My nudes of that period also have, I believe, this classical quality of anonymity. I have tried to express in them no personal sensuality of my own. I wanted to exclude from them the autobiographical element that allows us to recognize, in some sculptures of Renoir and even of Maillol, the artist's own mistress or at least a particular contemporary type of feminine beauty that appealed to the sculptor more immediately than an eternal type of classical beauty.

E.R.: When I see your nudes of before 1945, I feel that I am rediscovering in them an ideal of beauty that remains perfectly anonymous and timeless, as if set beyond the frontiers of history. In some of your portraits of these earlier years, I have also felt a kind of presence that is not that of the artist but truly of his model. It is the same kind of presence as can be felt in many funerary sculptures of Roman and Etruscan antiquity. So many of them reveal to us a personality that is often nameless and whose biography remains unknown; but this personality is still complete and faces us like someone raised from the dead and answering our call: "Here I am!"

MARINI: That is just what I tried to suggest in those portraits that are founded on a different sculptural tradition. My nudes seek to revive the tradition of Greek classical sculpture. But my portraits are founded on Etruscan and Roman art, as you pointed out, and also on the realistic art of the Christian Middle Ages as we discover it in the portraits of kings and queens and bishops lying in state on their cathedral tombs, or in the equestrian statue of Bernabò da Visconti. I suppose you know that masterpiece of Bonino da Campione, here in Milan in the Castello Sforzesco Museum.

E.R.: I went to see it yesterday morning, and it again reminded me of some of your works of recent years, if only because it somehow contrasts with them.

MARINI: Bonino da Campione was still directly inspired by the figure of Marcus Aurelius on the Roman Capitol. In the Middle Ages it was venerated as a portrait of Constantine, the first Christian Emperor. But I am no longer seeking, in my own equestrian figures, to celebrate the triumph of any victorious hero. On the contrary, I seek to commemorate in them something tragic, in fact a kind of Twilight of Man, a defeat rather than a victory. If you look back on all my equestrian figures of the past twelve years, you will notice that the rider is each time less in control of his mount, and that the latter is each time more wild in its terror, but frozen stiff, rather than reared or running away. All this is because I feel that we are on the eve of the end of a whole world.

E.R.: I suppose you mean the world of the Humanism that provided the foundations of all Western art, from the romanesque Carolingian Pre-renaissance to the birth of contemporary abstract art.

MARINI: I would prefer not to develop my ideas on this subject in the form of a polemical statement. It is a feeling, deep within me, that must be related to what some Romans felt, in the last years of the Empire, when they saw everything around them, a whole world order that had existed for centuries, swept away by the pressure of barbarian invasions. My equestrian figures are symbols of the anguish that I feel when I survey contemporary events. Little by little, my horses become more restless, their riders less and less able to control them. Man and beast are both overcome by a catastrophe similar to those that struck Sodom and Pompeii. So I am trying to illustrate the last stages of the disintegration of a myth, I mean the myth of the individual victorious hero, the *uomo di virtù* of the Humanists. I feel that soon it will no longer be possible to glorify an individual as so many poets and artists have done since Classical antiquity and especially since the Renaissance. Far from being at all heroic, my works of the past twelve years seek to be tragic.

E.R.: If I understand correctly, your equestrian figures, whether in sculpture or in your drawings, began to follow this evolution around 1945. I hope you will not be offended if I compare this development to that of an animated cartoon which tells us the story of your mythical rider. I have seen, for instance, some of your drawings of the end of the war, representing your horseman standing beside a rather massive and peaceful horse, like the

horses in some of the paintings of Paolo Uccello. Then there came drawings in which your horseman mounted the horse, followed by others where we see him mounted, the man still as massive and peaceful as the horse, as in the statue of Bernabò Visconti. After that, little by little, the horseman and the horse ceased gradually to communicate to us this heroic or epic quality of classical equestrian statues.

MARINI: Yes, and this decline and fall began in my horseman of 1945, which I actually finished in 1947. It is now in Pittsburgh, in the garden of the house that Frank Lloyd Wright built there for Edgar Kaufmann. I called this statue *Resurrection*. It represents a horseman, seated on his mount with arms outstretched and staring straight ahead; it is a symbol of the hope and the gratitude that I felt shortly after the end of the war. But developments in the post-war world soon began to disappoint me, and I no longer felt any such faith in the future. On the contrary, I then tried to express, in each one of my subsequent equestrian figures, a greater anxiety and a more devastating despair.

E.R.: Is that why your horses appear increasingly tense, as if they had stopped suddenly on the brink of an abyss? And why each rider seems to have been stricken more brutally, till we now see the rider lying like a dying man who has been struck down on his horse?

MARINI: In my studio I'll show you one of my latest works, an equestrian figure with the horse prostrate on the ground, and the rider lying beside him as if they had both been suddenly overcome by a tempest of ash and of lava like the one beneath which were found the petrified victims of the last days of Pompeii. The horseman and the horse, in my latest works, have become strange fossils, symbols of a vanished world or rather of a world which, I feel, is destined to vanish for ever.

E.R.: Some critics have argued in recent years that your evolution tends towards a conception of sculpture that is less classical or archaic. It has even been said that you are becoming an Expressionist, or that your art is about to become abstract. I suppose these writers are all analysing your evolution as it can be observed from the outside, that is to say without considering what you are trying to communicate....

MARINI: As soon as sculpture is conceived on a monumental scale, larger than life, it becomes architectural and tends to

appear more abstract. But as soon as it seeks to express anxiety, sculpture also wanders away from the ideals of classicism.

E.R.: I suppose you mean that it then abandons the canons of Winckelmann in order to adopt those of Lessing's *Laocoön*.

MARINI: But I am no longer trying to formulate a stylized version of anxiety such as we find in the *Laocoön* group and in so many other sculptures of the Silver age of antiquity. I feel that these works are always a bit too melodramatic. If you really want to find the sources of my present style in antiquity, I must confess that you will find them in the remains of the life of the past rather than in those of its art. The fossilized corpses that have been unearthed in Pompeii have fascinated me far more than the *Laocoön* group in the Vatican. If the whole earth is destroyed in our atomic age, I feel that the human forms which may survive as mere fossils will have become sculptures similar to mine.'

E.R.: Your apocalyptic pessimism expresses itself in what I might call a "Hiroshima" style. But this style has much in common with that of the sculptors Giacommetti and Germaine Richier, whose human figures likewise seem to be fossils or hideously disfigured victims of a catastrophe, and also with the vision of a Decline of the West that one finds in the works of some abstract sculptors, like César in France, Paolozzi in England, and Stankiewicz in America, I mean those "near-abstract" artists who construct their sculptures out of "prefabricated" elements, odd pieces of scrap-metal and old machinery salvaged from junk-yards and then welded together....

MARINI: I expressed my whole philosophy on this subject to Pierre Matisse, my New York dealer, when I once said to him that I had been born in an Earthly Paradise from which we have all been expelled. Not so long ago, a sculptor could still be content with a search for full, sensual and vigorous forms. But in the past fifteen years, nearly all our new sculpture has tended to create forms that are disintegrating. Here in Italy, the art of the past is part and parcel of our daily life in the present. We live among the monuments of the past. I, for instance, was born in Tuscany, where the rediscovery of Etruscan art, in the past fifty years, has been something of great importance in contemporary local life. That is why my own art was at one time so often founded on themes borrowed from the past, like the equestrian figure, which remains a reminder of utilitarian relationships be-

tween man and the horse, rather than on more modern themes, like the relationship between man and the machine.

E.R.: I remember seeing in Paris a number of public monuments that can give us a good idea of what representations of the relationship between man and the machine can give in art. There is, for instance, in the Parc Monceau a wonderful Chopin monument, with the composer strumming a waltz, I presume, on a stone piano that is fortunately shown only in relief; and César Franck, in the Square Sainte Clotilde, is represented playing a stone organ. But Paris has even more wonderful statues of this kind, such as the eternally motionless stone automobiles of the monuments to Panhard and Serpolette, the one at the Porte Maillot and the other at the Place Saint Ferdinand. Before the war, at the Porte des Ternes, there was also a fabulous bronze balloon that seemed to defy all the laws of gravity as it rose into the air, from its stone pedestal, with bronze passengers gesticulating in the bronze cockpit. It commemorated, if I remember right, an incident of the siege of Paris, during the Franco-Prussian War; and that is why the Germans scrapped it during the Occupation of France. All these monuments are a bit absurd. . . .

MARINI: Of course, because machines change their style so rapidly. If one tries to reproduce them in art as realistically as man and the horse in classical art, one immediately lapses into a kind of anecdotic or documentary art, like that of old engravings representing fashions for women. A balloon or an automobile will appear, in art, as silly as a bustle. Only the stylization of a painter like Léger could integrate the machine as the subject-matter of art. Here in Italy, the Futurists, before 1914, attempted a similar integration of the machine. I don't know the work of the American sculptor Stankiewicz, but I have seen some of César's work. César creates, with elements borrowed from industry and the world of machines, sculptural fossils that appear to have survived the same kind of catastrophe as my own figures. But I would like to show you now, in my studio, my latest fossils. . . .

*Marino Marini led the way out of the apartment, down the stairs and across the yard, into his huge ground-floor studio. As we entered it, we faced the enormous plaster model of the monument commissioned by the municipality of The Hague. It is a gigantic yellowish horse, tense with horror like the horse in*

*Picasso's* Guernica. *The horseman, as if struck by lightning, falls
back. The whole sculpture is constructed in terms of planes, with
almost flat surfaces, rather than in the round, as Marino Marini's
earlier and more classical works had once been constructed.*

*At the back of his studio, he then showed me another horse
that lies on the ground, as if struck down by the same catastrophe,
with its horseman lying beside it, though not thrown off, only
fallen with the horse. Among these fossils that Marino Marini has
created in the last few years, his sculptures of before 1945 looked
like relics of another civilization.*

*As I left the sculptor's studio, I went back to the Castello
Sforzesco to think over all that he had said and to contemplate
again the statue of Bernabò Visconti. When I came out of the
Museum, I found, in the yard of the Castello, a group of English
tourists to whom a woman was explaining something. I ap-
proached them and listened.*

*Through the gate of the Castello, the guide pointed out, at the
far end of the park, the great triumphal arch that was built after
1866 to commemorate the asssistance given by Napoleon the
Third in the reunification of Italy. "As you look at this arch," she
explained, with a slight Cockney accent, "you are turning your
back on the one that you saw a few days ago in the Forum in
Rome. And if you had walked straight ahead, in a straight line,
all the way from Rome, you would have passed through the arch
in the Forum and through this gate, on through this arch here in
Milan. If you still walk ahead in a straight line, you would then
pass first under the Arc de Triomphe in Paris, and after that
through the Marble Arch in London. All four of these archways
were built by the same man. . . ."*

*This wonderful confusion of geography and of twenty centuries
of architectural history failed to elicit any protest from the guide's
listeners. Yes, Marino Marini was right. We are living on the eve
of a catastrophe, though this catastrophe may turn out to be but
the triumph of sheer ignorance and nonsense.*

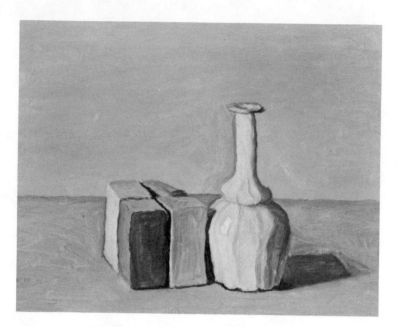

GIORGIO MORANDI
*Still Life with Bottle*

# Giorgio Morandi

*Many of the more important artists of our age, such as Picasso, Braque and the majority of the younger Abstract or non-objective masters, have generally communicated to us their subject-matter, however private or cryptic, in an idiom that is strikingly public, if not rhetorical or declamatory. Paul Klee has been, in this respect, a notable exception.*

*Among the less cryptic modern artists whose works describe a recognizably objective world, Morandi seems to be committed to a kind of modesty or privacy very similar to that of Klee. For many years, Morandi remained almost unknown, even in his native Italy. Only since 1948 has he quite suddenly acquired an international reputation. Today, collectors and dealers through-out the world must add their names to a long waiting-list for the four or five pictures that he manages to finish each year, and a veritable legend about Morandi's strangely retiring manner has spread from Bologna, where he lives, as far as California, Brazil and Japan.*

*When I met him in 1958, Giorgio Morandi was sixty-eight years old. A tall, lean, grey-haired and scholarly man, he avoids, in his dress and his manner, everything that might suggest an artist's reputedly Bohemian way of life. True to the traditions of the North Italian middle-class of the provincial cities, he leads the same kind of restricted social life as most of the older University professors and professional men of his native city, but with an additional touch of purely personal modesty, shyness and asceti-cism that marks him at once as an eccentric in his own quiet way.*

*Morandi has lived nearly all his life in the same old-fashioned apartment that was once the home of his parents, in one of the narrow arcaded streets of the ancient heart of Bologna. He has*

45

never married, neither have the three elderly sisters with whom he shares his home and whom, however experienced and respected they may be in their profession as teachers, he always treats as if they were still very young women, in constant need of his guidance and protection. To reach the room that he uses as a studio, he must go through those where his sisters sleep and spend much of their spare time. He always knocks on their door and pauses a while, to avoid disturbing them, before daring to enter his studio or to return from it to the front part of the apartment.

In his small living-room and dining-room, both furnished in a very conventional late nineteenth-century style, a few remarkably fine paintings hang on the walls: a small Jacopo Bassano, one of those scenes from the Scriptures that the Venetian master has depicted entirely in terms of the rustic life of his own region and age, and two of those studies where Giuseppe Maria Crespi, the Bolognese Baroque painter, so successful in obtaining commissions for large and melodramatic religious compositions, also proves his real talent as a precursor of Greuze and the eighteenth-century French "intimist" or "bourgeois" artists whom Diderot loved so dearly. One of Morandi's Crespi studies represents rather charmingly, in oils, a young woman, viewed from the rear as she sits at her dressing-table, with her face reflected in a mirror. The very choice of these few paintings reveals Morandi's preference for an art that is neither too aristocratic nor too public. Like the great French Impressionists, he remains committed to the standards and tastes of a stable middle-class, a firm believer in the aurea mediocritas of the poet Horace. In our age of mass culture, there is an old-world charm, in fact a certain informal courtliness, about the modesty and discretion which characterize Morandi's manner and way of life, those of a vanishing class.

There was an element of discretion, of scrupulous exactitude, even of formality, in the very manner of our interview. We faced each other, as we sat at the dining-room table in the otherwise deserted apartment, and Morandi allowed me, as we spoke in Italian, as much time as I might need to note in full what he had said. Later, he was very scrupulous too about revising the draft of my interview which I submitted to him in English, but which he asked a friend to translate into Italian before he returned it to me, many months later, with all his corrections.

*At first, I explained to him how I had already interviewed other
artists, especially Chagall.*

MORANDI: It would be difficult for me to speak to you, as
Chagall apparently did, in autobiographical terms. I have been
fortunate enough to lead, unlike Chagall, an uneventful life. Only
on very rare occasions have I ever left Bologna, my native city, and
the surrounding province of Emilia. Only twice, for instance, have
I been abroad, once when I crossed the frontier into Switzer-
land, a couple of years ago, to see an art-exhibition in a resort on
the shores of one of the Swiss-Italian lakes. Besides, I speak only
my native language, as you see, and read only Italian periodicals.

E.R.: So you are perhaps the only major living artist who has
never felt the urge to go to Paris . . .

MORANDI: Don't misunderstand me, please. When I was in my
early twenties, my highest ambition was to go abroad and study
art in Paris. Unfortunately, the material difficulties involved were
too great, and I was obliged to remain in Italy. Later, I had too
many responsibilities, with my teaching and my family, and never
managed to go abroad.

E.R.: Do you think that your evolution as a painter might have
been different, had you been able, as a younger man, to study art
in France?

MORANDI: No. If anyone in Italy, in my generation of young
painters, was passionately aware of new developments in French
art, it was I. In the first two decades of this century, very few
Italians were as interested as I in the work of Cézanne, Monet
and Seurat.

E.R.: Your interest in Seurat was revealed to me when, in the
big Seurat show at the Chicago Art Institute a few months ago,
I was surprised to see that one of the drawings shown had been
loaned by you, from your private collection.

MORANDI: They had been very anxious to borrow it from me.
But I'm not really a collector and only enjoy being able to study
at my ease, in complete privacy, a sample, however small, of the
work of an artist whom I revere.

E.R.: You seem to insist very much on this element of privacy
in your life. Is that why you have never been active in any group
or school of modern art?

MORANDI: You might think that I have deliberately avoided

every direct contact with the main currents of the contemporary art-world, but this isn't really true. I am essentially a painter of the kind of still-life composition that communicates a sense of tranquillity and privacy, moods which I have always valued above all else.

E.R.: This intimate quality of your still-life compositions has prompted several critics to call you the Chardin of Italy.

MORANDI: No comparison could flatter me more, though my favourite artist, when I first began to paint, was actually Cézanne. Later, between 1920 and 1930, I developed a great interest in Chardin, Vermeer and Corot too.

E.R.: In a book of reproductions of your works, I saw recently that some of your earlier paintings are composed in a much less personal style, in fact in a style very reminiscent of that of Cézanne and those early Cubists, especially Juan Gris, who had begun by imitating his later manner.

MORANDI: An artist's early works are nearly always five-finger exercises which teach him the principles of the style of an older generation of artists, until he himself is mature enough to formulate a style of his own. That is why you have been able to detect, in my works of between 1912 and 1916, some recognizable influences of the early Paris Cubists and, above all, of Cézanne.

E.R.: In the same book of reproductions of your works, I also noted that you then painted still-life compositions, between 1916 and 1919, with lay figures, or rather milliners' busts, like those that one also sees in some of the *Pittura metafisica* compositions of Carlo Carrà and Giorgio de Chirico.

MORANDI: But my own paintings of that period remain pure still-life compositions and never suggest any metaphysical, surrealist, psychological or literary considerations at all. My milliners' dummies, for instance, are objects like others and have not been selected to suggest symbolical representations of human beings or of legendary or mythological characters. The only titles that I chose for these paintings were conventional, like *Still Life*, *Flowers* or *Landscape*, without any implications of strangeness or of an unreal world.

E.R.: In a way, you might then be called a Purist, as the painters Léger and Ozenfant called themselves in Paris, around 1920.

MORANDI: No, there is nothing in common between any works

of mine and those of the Paris Purists. The only kind of art that has continued to interest me, ever since 1910, has been that of certain masters of the Italian Renaissance, I mean Giotto, Paolo Uccello, Masaccio and Piero della Francesca, then also that of Cézanne and the early Cubists.

E.R.: Have you always preferred to paint still-life compositions?

MORANDI: In that book, you surely saw that I also continued for a long while to paint occasional flower-pieces and landscapes too. Besides, I have also painted three or four self-portraits.

E.R.: The American "Magic Realist" William Harnett, in the latter part of the nineteenth century, seems to have shared your dislike of painting human beings. Once in a while, in a Harnett still-life, one finds a photograph of someone pinned on a wall, or a portrait of an American President on a postage-stamp or a dollar-bill, but all such representations of human beings have been reduced by Harnett to a kind of second-intentional existence as objects, so that his works never represent human beings but only representations of human beings, deprived of all the personal history and psychology that one can detect in a Rembrandt portrait. True, one of Harnett's early drawings is a study of a model, a man in Bavarian or Tyrolean costume, but this is certainly a relic of his years as a student in the Munich academies, and it struck me besides, when I first saw it, as lacking any of the psychological realism that characterizes similar drawings by Leibl or any other Munich painters who, among Harnett's contemporaries, pursued ideals similar to those of Courbet. Later, if I remember right, Harnett's only direct representations of anything human were a painting of a man's hand holding a cane, and a still-life *Memento mori* with a human skull placed among books.

MORANDI: I have never seen any of the works of Harnett, but what you now say about him interests me very much.

E.R.: He seems to have concentrated, as you have too, on painting a man-made world, but always excluding man. But some painters manage to suggest man's presence in their works by stressing his sheer absence, much as some landscape-painters, especially Rembrandt, suggest to me the presence of God, as Creator of this visible world, without actually representing Him there. Still-life painting might even be said to be a kind of religious art, but founded on a religion of man rather than on a belief in the existence of God.

MORANDI: As a definition, it would not at all apply to my work. I told you only a few minutes ago that I have always avoided suggesting any metaphysical implications. I suppose I remain, in that respect, a believer in Art for Art's sake rather than in Art for the sake of religion, of social justice or of national glory. Nothing is more alien to me than an art which sets out to serve other purposes than those implied in the work of art in itself.

E.R.: Would this mean that you disapprove of the Sacred Art of Rouault, of the Socialist Realism of Renato Guttuso, and of the Imperial Art of Sironi and of other Italian painters who once received important commissions from the State, during the Fascist Era?

MORANDI: I have never devoted any thought to this kind of problem and have never set out to illustrate anything at all programmatic in my work.

E.R.: Perhaps you have avoided ever imposing yourself, in your work, as a public speaker.

MORANDI: But I do not wish to be interpreted as disapproving of any other contemporary artist's approach to his own work. With me, it is all a matter of personal conviction, and I do not want thereby to condemn any aspect of the work of other artists. Actually, I am very interested, for instance, in the work of Rouault.

E.R.: In many of your paintings of recent years, I feel that your avoidance of any ideological or anecdotic content leads you to a kind of abstraction. In the still-life compositions of the past, especially in those of Dutch masters, of the Bergamo painter Baschenis, of Melendez in Spain, even of Chardin, the presence of man, as I said, seems to me to be often suggested quite intentionally by his sheer absence. I can remember, for instance, a still-life painting in the Louvre, by a French seventeenth-century master; it is entitled *The five senses* because each one of man's senses is represented there by an object that would appeal to our aesthetic tastes rather than to the merely sensory perceptions of an animal. Hearing is represented by a musical instrument and the sense of smell by a flower. But your compositions of bottles and other household utensils do not suggest to me the absence of man. Instead, I would say that you group the objects which serve you as models differently for each picture, with very slight variations, much as Mondrian, in his abstract compositions, varied but

slightly his arrangements of the same geometrical figures, generally painted too in the same few basic colours.

MORANDI: I believe that nothing can be more abstract, more unreal, than what we actually see. We know that all that we can see of the objective world, as human beings, never really exists as we see and understand it. Matter exists, of course, but has no intrinsic meaning of its own, such as the meanings that we attach to it. Only we can know that a cup is a cup, that a tree is a tree.

E.R.: I suppose that human beings who come from other cultural backgrounds can even fail to recognize our familiar household utensils for what we believe them to be, much as we ourselves see a work of art in what an African recognizes at once as proof of the terrifying presence of a divinity, whereas a monkey sees in it only a piece of wood, not even noticing that it has been carved by man to represent something. But I would say that, in recent years, you have tried, in your paintings, to strip familiar objects of their familiar meanings so as to reduce them to a kind of objective abstraction as opposed to the non-objective, geometrical or subjective abstraction of Mondrian. Your kind of abstraction, I feel, transcends reality, but without losing sight of the objects and forms of the world of reality. Besides, it is less disconcerting for those who still want to know what a picture represents. In America, we have had for many years a painter, Georgia O'Keefe, who transcends reality in much the same manner. Her compositions of flowers or of animal skulls are similarly stripped of all poetic or other meanings, reduced to significance only as elements in the patterns that she creates. Everything that she paints survives as pure form, and some of her later works are as geometrical, in their representation of something objective, as Mondrian's non-objective compositions. But this kind of realism, I mean yours and Georgia O'Keefe's, is quite different from the "Magic Realism" of Harnett, whom I mentioned earlier, or of the seventeenth-century still-life painters of Haarlem, who nearly all relied on *trompe-l'œil* effects to create the illusions of reality.

MORANDI: *Trompe-l'œil* has never interested me at all. I don't know any of the work of Georgia O'Keefe, but I gather, from what you say, that her case might also be different from mine. I do agree, though, that I have nothing in common with Mondrian.

E.R.: I am not surprised to hear that *trompe-l'œil* has never

interested you. After all, it is one of those tricks that can assure an artist the kind of easy popularity that I would never suspect you of seeking. In museums, one often sees the less sophisticated visitors gaping at the works of artists who have been able to imitate most realistically, as Melendez did, the grain of the wood of a table-top, or who have placed, as Crivelli did, a fly on the shining skin of an apple. Harnett had to earn his living, in nineteenth-century New York, by painting such *trompe-l'œil* compositions to decorate public bars, and it appears that he never sold a single picture, in his lifetime, to any of the important American art-collectors of his day. He did manage, however, to become a celebrity, for a while, among the Broadway journalists who frequented the bars where his paintings were exhibited. One of these happened to represent a still-life arrangement of various objects that included a dollar-bill which looked as if it could be literally lifted out of the picture and taken away in one's pocket, so that a legend, probably apocryphal, soon began to circulate about this picture. One newspaper of the period even states that the United States Government sued Harnett for counterfeiting the national currency, but that the artist then won his case in court by pointing out that his dollar-bill was painted on a board too big to fit in a man's pocket and too thick to be mistakenly accepted in lieu of paper money. I have tried to find records of this strange case in American legal literature, but without any success. I suppose we must accept it as a modern variant of the legend of the bird which tried to peck at the fruit painted by the Greek painter Apelles in antiquity.

MORANDI: I have never intended to give the objects in my still-life arrangements any particularly familiar meanings, and I doubt whether my work of recent years really has much in common with that of any of these other painters whom you have so far mentioned, except of course Chardin. But Chardin was also, in my opinion, the greatest of all still-life painters, and he never relied on *trompe-l'œil* effects at all. On the contrary, with his pigments, his forms, his sense of space and his *matière*, as French critics call it, he managed to suggest a world that interested him personally.

E.R.: I believe that Chardin's quality of *matière* is the fruit of a very intense kind of observation and feeling, not an end in itself as it has become in the works of some younger Abstract Expres-

sionists. A loaf of bread, in a Chardin still-life, has an appetizing quality quite alien to the illusionism of *trompe-l'œil*, and I would even say that a Chardin painting appeals to our senses and our emotions in much the same way as the objects which he depicts appealed to his own senses and emotions in the real world when he painted them. I find the same quality of creative magic rather than of trickery in the still-life paintings of Courbet and, of course, though with a greater sensuality, in those of Renoir. I find it in Cézanne too, but intellectualized. It is a very mysterious quality, almost impossible to explain in words, without quoting specific examples. I seem to detect it in the still-life details of some of Caravaggio's compositions with figures, but not in those of Carlo Crivelli, where I can see but the illusion of *trompe-l'œil*.

MORANDI: I find it above all in some works of Corot, Manet, Cézanne, Renoir and Bonnard.

E.R.: I suppose it is what some French critics mean when they refer to "pure painting", especially as it seems to have been one of the major preoccupations, after Chardin, of other French still-life painters, throughout the nineteenth century. One finds it in works of Courbet and Theodule Ribot, of Fantin-Latour and Manet, of Renoir and Odilon Redon, of Bonnard and Vuillard too. As I glanced through this old catalogue of an exhibition devoted to *La nature morte de l'antiquité à nos jours*, held in Paris in the Musée de l'Orangerie in 1952, I was surprised to see that it contains a reproduction of a work of the American painter John Frederick Peto, who was a contemporary and a competitor, if not a friend too, of William Harnett. So here you have an example of the "Magic Realism" of those nineteenth-century American painters whom I mentioned earlier and whose works you have never had occasion to see here in Italy.

MORANDI: Peto seems, from this photograph, to have been a painter of remarkable technical skill, though he has none of the spirit of Chardin, Cézanne and the other painters whom we were just discussing.

E.R.: It was probably economic necessity, in an age when American artists had little following in their own country, that forced Peto and Harnett and others to have recourse to the trickery of *trompe-l'œil* as a rhetorical appeal to a larger and less sophisticated public. In the case of certain later "Magic Realists" who are also represented in this catalogue, I mean Pierre Roy and

René Magritte, I would hesitate to say that they were at all sincerely concerned with problems of composition or, as you, with the private enjoyment of their craft as painters. On the contrary, I find these post-Surrealists obviously anxious to give us, in their representations of an unreal world, a deceptive illusion of reality. But is there any connection between your own philosophy of art and your apparent reluctance to produce as many works as most other contemporary painters of your international standing?

MORANDI: I suppose my works are less numerous, but this is a fact which I have never pondered and which does not really interest me. All in all, I must have produced by now some six hundred paintings, and only four or five a year now that I am having so much trouble with my eyesight.

E.R.: This means an average of barely one painting a month, if you began your career at the age of twenty.

MORANDI: But there is another problem involved here. I have always concentrated on a far narrower field of subject-matter than most other painters, so that the danger of repeating myself has been far greater. I think I have avoided this danger by devoting more time and thought to planning each one of my paintings as a variation on one or the other of these few themes. Besides, I have always led a very quiet and retiring life and never felt much urge to compete with other contemporary painters, whether in terms of productivity or of exhibitions.

E.R.: Still, you have had to face, in recent years, the demands of an expanding international market for your works.

MORANDI: All these problems don't ever occur to me or preoccupy my mind. My only ambition is to enjoy the peace and quiet which I require in order to work. But I have been robbed of this peace of mind ever since I was awarded a prize, a couple of years ago, at the Sao Paolo Biennale in Brazil. I now receive more visitors from abroad in a single month than ever in ten years of my life before that. Besides, I now find it increasingly difficult and tiring to paint, and all my visitors, together with the correspondence which I have to answer, keep me very busy. I suddenly seem to have made a lot of new friends and to know far more people than ever before.

E.R.: I have been given to understand that you keep a long waiting-list with the names of all those who have come to buy one of your works and found nothing ready or available.

MORANDI: It isn't really true. Of course, I'm rather sorry not to be able to satisfy the constant demand for my paintings.

E.R.: Many critics seem to stress your reliance on old-masterly lighting effects to create an atmosphere in your pictures. Have you consciously imitated the devices of any of the old masters?

MORANDI: I wouldn't really agree with any of these critics, though I have often found it very useful to study the works of some great artists of the past. But I have never lost my interest in the experiments of my contemporaries either. I believe, however, that Giotto, Masaccio, Paolo Uccello, Piero della Francesca and Fouquet can still teach a lot to any modern painter.

E.R.: Might I add Giorgione and Leonardo da Vinci to this list? Their names might explain to some extent your reliance on *sfumato* effects as opposed to the more clear-cut outlines of *chiaroscuro*.

MORANDI: Most certainly, though I have never been as interested in their works as in those of the artists whom I have just mentioned.

E.R.: I have also wondered whether you might not have studied the still-life arrangements which one finds in some of Antonello da Messina's interiors with figures.

MORANDI: Of course, Antonello interests me very much, but it was only much later in my life that I became aware of his great qualities. You see, Antonello worked in a different tradition, that of the Van Eyck brothers and the Flemish masters whose art we have little opportunity to study here in Italy. Still, I must add that I also owe much of my understanding of the art of the masters of the Italian Renaissance to Cézanne and to Seurat.

E.R.: Would you agree that there is a greater affinity between Seurat and Sassetta, for instance, than between Seurat and Lautrec or Van Gogh?

MORANDI: No, but between Seurat and Piero della Francesca rather than Sassetta.

E.R.: Many of my readers will be surprised by the frequency and the variety of your references to the great masters of the past. When I was recently in America, I was struck by the sight of the crowds visiting New York's Museum of Modern Art, its Whitney Museum, and the modern collections of its Metropolitan Museum. The galleries of old masters, at the Metropolitan and in

the Fricke Collection, on the other hand, seemed to be far less popular. I thus had the impression that the art-loving public is now far more familiar with the works of relatively unimportant younger moderns than with some great masterpieces of the past, and that many New Yorkers go window-shopping in exhibitions of modern art much as they go to department-stores, to see the latest styles in merchandise. Perhaps they feel that the art of the past, however great, is only second-hand today, or even slightly shop-soiled. But this isn't a specifically American phenomenon. I had observed it a year earlier in London, at the Tate Gallery, during a big retrospective exhibition of Braque's works, and in several West German and Swiss Museums too. In fact, I have been given to understand that the first *Documenta* exhibition in Cassel attracted far larger crowds of tourists than the Council of Europe's *Triumph of Mannerism* exhibition in Amsterdam. The art of the past perhaps makes demands on us that are beyond the scope of many art-lovers of today. To understand fully a painting of the great age of Humanism, like Luca Signorelli's *Pan* which was destroyed by fire, as a result of Russian carelessness, in Berlin in 1945, one must be able to consider man and the gods of antiquity as the Humanists did, sharing their scholarly and enthusiastic knowledge of classical mythology, all of which is very rare today.

MORANDI: I have only been abroad twice in my life, on visits to Switzerland, so that it would be difficult for me to offer any explanation of this interest of the general public, especially abroad, in modern art rather than in the art of the past.

E.R.: Of course, much of the art of our age can strike one as being merely decorative, if not intentionally dehumanized. But it seems to have been possible to create great works of decorative art too in the past. After all, many of the great masters of the Italian Renaissance were commissioned, as Raphael was by the Pope, to decorate rooms with murals, and were nevertheless able to produce masterpieces which transcend their immediately decorative purposes. Somehow, when I visit the Matisse chapel on the French Riviera, I feel that its murals are truly and brilliantly decorative, but still lack the multiplicity of meanings, the many dimensions of thought and emotion, that I enjoy so much in the Raphael and the Michelangelo murals in the Vatican. But this may also be why abstract or non-objective art, in our age,

appeals to so many people who do not expect a painting to make any intellectual or emotional demands on them; nevertheless, the real masterpieces of modern art, I mean especially some of the works of Picasso, like his *Guernica*, and some of those of Klee, are still those where the artist has transcended his immediate decorative or experimental objectives and made some demands on our powers of understanding or of sympathy.

MORANDI: These are all problems, as I have suggested earlier, that I have never really considered, as far as my own painting is concerned.

E.R.: I agree that they scarcely arise within the scope of subject-matter that you have generally set yourself. Still, would you now advise a younger artist to follow in the footsteps of the masters of contemporary non-objective art, or to return, as some painters now propose, to a more figurative conception of art?

MORANDI: When I was young, I never felt the need to ask anyone for advice of that kind. My only source of instruction has always been the study of works, whether of the past or of contemporary artists, which can offer us an answer to our questions if we formulate these properly. But those younger painters of today who really deserve this appellation as well as our attention would refuse, quite properly, to accept any gratuitous advice of the kind that you seem to suggest. I respect the freedom of the individual and especially of the artist, so that I would not be of much use as a guide or instructor, nor have I ever wanted to be one, even when I have been asked to undertake the job. When most Italian artists of my own generation were afraid to be too "modern", too "international" in their style, not "national" or "imperial" enough, I was still left in peace, perhaps because I demanded so little recognition. My privacy was thus my protection and, in the eyes of the Grand Inquisitors of Italian art, I remained but a provincial professor of etching, at the Fine Arts Academy of Bologna.

E.R.: You said just now that you had never been very willing to accept the responsibilities of teaching and giving advice. Yet you taught etching for many years.

MORANDI: I accepted to teach etching because it implies exclusively the teaching of techniques.

E.R.: In our discussion, you have mentioned so far only great painters, never any of the recognized masters of etching. Would

this mean that you have always considered yourself a painter rather than an etcher?

MORANDI: For me, it's all the same thing, the only difference consisting in the actual techniques of expression.

E.R.: I suppose, however, that the teaching of etching does not generally imply the same kind of discussion of the nature and objectives of art as the teaching of painting. In most academies, etching is taught as a kind of side-line, I mean as a technique rather than as a style.

MORANDI: That is exactly why I preferred to teach etching.

E.R.: Still, I suppose that there are some masters of the craft of etching whose works you particularly admire.

MORANDI: Of course, and I prefer those who were also painters, *les peintres graveurs*, especially Rembrandt and Goya, whose etchings are as great works of art as their paintings. As for myself, I have etched mainly between 1912 and 1915, then again from 1921 until quite recently. My last etching is of 1956. I did it for the catalogue of my complete etchings which was published by Einaudi in Torino a couple of years ago.

E.R.: I agree that an etching, even a drawing or a sketch, can be as great a work of art as a painting. Francesco Guardi's sketches, for instance, appeal to me even more than his paintings.

MORANDI: Certainly.

E.R.: It seems odd now that poor Guardi was scarcely appreciated at all by his contemporaries. Yet he was the last of the great artists of the Golden Age of Italian art. After Guardi, with the collapse of Venice as a sovereign state, Italian art remained, for over a hundred years, almost exclusively provincial.

MORANDI: It was in my generation that the Futurists then roused Italy from this state of decay and that our art again began to enjoy some prestige in the eyes of the world. Now, as a few centuries ago, one can again work in a relatively provincial centre, such as Bologna, without necessarily being a provincial artist, I mean a painter of local genre-scenes like most of our nineteenth-century Neapolitan, Venetian, Roman, Milanese or Florentine artists.

E.R. But even in the doldrums of nineteenth-century provincialism or regionalism, Italy had a few good painters. There were, for instance, the Tuscan *Macchiaioli*, in whose style Modigliani still painted his earliest works. . . .

MORANDI: Yes, Fattori was a fine painter.

E.R.: One of my friends in Pistoia, Commendatore Premuda, is a great admirer and collector of the works of the *Macchiaioli*. He insists that they had invented an Impressionist technique of their own, long before the work of any of the great French Impressionists had become known in Italy. But I feel that the *Macchiaioli* generally lacked the broader vision of the French Impressionists and, with the exception of Fattori, should rather be compared to the *petits-maîtres* of the Barbizon school. Most of the *Macchiaioli* never allowed themselves the scope of Manet, Cézanne or Degas.

MORANDI: I doubt whether our *Macchiaioli* ever set themselves the same tasks as the French Impressionists. In my opinion, they were certainly very gifted, but were prevented from developing and maturing as artists because the society in which they lived was not prepared to encourage any truly great art. Be that as it may, these Italian *Macchiaioli* cannot now be compared or even confused with the great French painters of their generation, nor is this only a problem of their choice of subject-matter. There is something grandiose, for instance, in a Cézanne still-life or a Monet view of a river-bank. Even in as simple a subject, a great painter can achieve a majesty of vision and an intensity of feeling to which we immediately respond.

E.R.: And that is what you yourself have achieved in your still-life arrangements of ordinary household crockery. But you have defeated yourself, in a way, since you can no longer enjoy the privacy and the peace of mind which, as you say, you need in order to produce your works. You have become a public figure, like those hermits of antiquity who attracted crowds of pilgrims to their desert retreats. This particular pilgrim hadn't come here expecting any miracle, but is ready to leave you now in a rare mood of peace, with no unanswered questions left lurking at the back of his mind.

*Morandi now offered, as I was about to leave, to show me his studio, after taking the usual precautions so as not to disturb his sisters. But they were not in their room, when he knocked on the door, and I passed through it as I might have passed through a deserted harem, almost on tip-toe and without daring to look to right or left. In the studio, a few unfinished paintings were hanging on the walls. Some very dusty household utensils, the familiar*

bottles and glasses and boxes, were grouped here and there on tables, in still-life arrangements. One or two of the unfinished paintings were surprisingly bright-coloured: in a finished Morandi, there are layers of concealed colours, bright reds and blues that give a warm glow to the greys and whites of the surface, just as there may exist bright colours, beneath the thick fuzz of neutral dust that covers them, on the actual porcelain or glass objects that Morandi paints.

As we parted, a few moments later, I was again reminded of a line of Horace: Integer vitae scelerisque purus. Since I had last nibbled, somewhat tremulously, a digestive biscuit over a cup of tea with T. S. Eliot in his office on Russell Square two years earlier, I had not experienced again this feeling of being in the presence of a sage, if not of a saint. Later, when I wrote to Morandi to obtain his approval of the written version of our talk and spent many hours translating into English the scrupulously considered corrections, improvements or additions that he had written into an Italian translation of my original English draft, I was reminded again and again of the atmosphere of these rooms in Bologna where everything, however small or unimportant in the eyes of others, seemed to have meaning and value, if not dignity too.

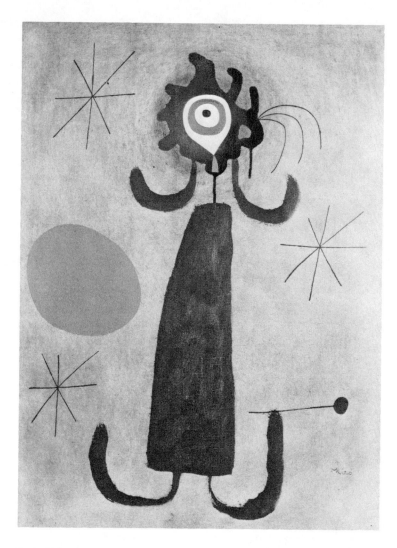

JOÁN MIRO
*Woman Standing before the Sun*

# Joán Miro

*Baudelaire once compared the artist's lack of grace, in his bearing as an ordinary citizen in daily life, to the awkward gait of the albatross, a bird that compels our admiration and wonder when we see it soaring gracefully in the air, but that appears ridiculous to us when we see it waddling on dry land. I was painfully re-minded of this simile throughout my very pedestrian conversa-tions with the great Surrealist painter Joán Miro.*

*When I first came to interview Miro in his Paris hotel, I found that I had to deal with a man who is articulate only in his art. If pressed to discuss his work, he remains notoriously vague and inexplicit, barely able to explain his activity as eloquently as a farmer might talk of his crops, a cobbler who is no Hans Sachs of the shoes that he mends. Miro's appearance is moreover that of a conformist Spanish businessman: short, stocky, grey-haired, he dresses very correctly and might more readily be identified as a prosperous orange-exporter than as one of the most revolutionary living painters.*

*Miro had come to the French capital from his home in the Balearic island of Majorca, to complete and supervise the work on the huge ceramic panels which he has been commissioned to execute for the garden of the new Unesco building in Paris. Like many other successful artists, writers, publishers, literary agents, dealers in books, antiques or paintings and interior decorators, he had chosen to stay at the Left Bank Hôtel du Pont Royal, in the Rue du Bac. It was there, in the somewhat conventional but luxurious lounge, just ritzy enough to satisfy the prestige-needs of its Madison Avenue clientèle without at the same time sacrificing all its Left Bank charm, that I found myself face to face for the first time with this extremist among the painters of the past thirty years.*

*How we had failed to meet before remains a mystery. In the heyday of Surrealism, thirty years ago, I had been one of those regular American contributors to the Paris expatriate periodical transition who had participated in a great number of Surrealist activities. But Miro, even in his less conformist youth, had never been very gregarious. As we now met for the first time, he proved at first to be, like many Surrealists, somewhat suspicious of me as a mere stranger, almost provincial or parochial in his aloofness. It took him quite a while to adjust himself to the idea that I was not a reporter from the daily press, trying to extract from him some sensational* obiter dicta.

*I came to see Miro three times, in the lounge of his hotel, in less than a week. In several hours of uneasy discussion, I was finally able to obtain from him about as much information as from Chagall in half an hour. Often, I had to force Miro to express an opinion: "Do you believe that. . .?" If I had formulated my question simply enough, his answer came as a monosyllable, without any qualification: "Yes", or "No". After that one syllable, I remained each time as if stunned, then had to dream up another leading question. Each time, as I pretended to take lengthy notes but was actually planning my strategy, there was an awkward silence: whole processions of angels seemed to pass through the lounge of the Hôtel du Pont Royal. Once, we were interrupted when Miro was called to the phone; a lengthy conversation in Catalan then ensued as Miro explained to his wife, in a veritable torrent of words, what an ordeal he was going through, and in what restaurant they would later meet to dine. I pretended not to have understood his Catalan.*

E.R.: Is it your first experience of designing this kind of ceramic panel?

Miro: Yes.

E.R.: Do you do all the work yourself?

Miro: No.

E.R.: So you have an assistant?

Miro: No. I paint the panels myself, but a qualified ceramist prepares the colours and later attends to the baking in the kiln.

E.R.: Charles Demuth at one time made a hobby of painting on porcelain. Technically, I suppose, your work is much the same.

Miro: Who is Demuth?

E.R.: A famous American painter, now dead.

Miro: Never heard of him.

E.R.: Well, he isn't very well known in Europe. But are your own panels only painted, or are the designs also in relief?

Miro: There are two large hollowed-out forms in the panels, and I did that work too.

E.R.: What are the dimensions of the panels?

Miro: The first is fifteen metres by three; the second, seven and a half metres by three.

E.R.: Are you working exclusively on these panels for Unesco while you are here in Paris?

Miro: No. I'm also supervising the printing of my illustrations for Paul Eluard's poems *A toute épreuve.*

E.R.: Is this an unpublished posthumous work of your great friend Eluard?

Miro: No. These poems had already been published, but without illustrations.

E.R.: Is this to be like other books that you have illustrated in the past?

Miro: No.

E.R.: What will be the difference?

Miro: These are my first wood-cuts.

E.R.: How many are there?

Miro: Eighty in all.

E.R.: Very few Paris artists of the past fifty years have tried their hand at wood-cuts. I remember that Dufy once did a few, but wood-cuts seem on the whole to have been more popular in Germany, among the Expressionists.

Miro: *Tiens!*

*Miro was plainly surprised, if not pained. He had apparently fancied himself almost as the discoverer of a lost art. At this point, in despair, I tried another approach.*

E.R.: A few months ago, a Dutch publisher asked me to translate into English a book that is entitled *Mondrian or Miro.*

Miro: *Tiens!*

E.R.: The author, a Dutch critic, argued that Mondrian's style is more universal in its appeal because it remains faithful to a few "pure" geometrical figures or forms which are archetypes of aesthetic experience. He seemed to be a believer in the psycho-

logy of Jung, and objected to your kind of abstraction because he found it too strictly personal or autobiographical, in fact too cryptic to enjoy any very broad validity.

*Miro's face expressed a puzzled surprise, if not actual distress. As if I were a Grand Inquisitor before whom he was afraid of committing a fatal blunder, he refrained from even saying: Tiens!*

*I resumed my monologue, though in a slightly less aggressive tone:*

E.R.: Of course, I feel that Mondrian's geometrical abstractions allow too little scope for the human element which we are accustomed to find in artistic expression. What do you think of Mondrian?

MIRO: I have the greatest respect for him as an experimental artist.

*Miro was obviously playing safe.*

E.R.: But do you believe that his art can lead anywhere beyond what he himself had achieved?

MIRO: Well, it is a kind of dead end.

E.R.: In America, Mondrian has had several disciples, many of whom only repeat what he has already achieved, with at most but slight variations or innovations. Do you think that his importance may have been overrated?

MIRO: No. His work remains unique in the art of his generation.

E.R.: But its very uniqueness makes me sometimes wonder whether it is still art in the same sense as the works of most of his contemporaries. Whereas the latter generally believed in self-expression, Mondrian followed an ascetic path of his own, always disdainful or suspicious of any individualistic element of self-expression. Would you consider yourself an abstract artist in the same sense as Mondrian?

MIRO: No.

E.R.: Would you say that your work is at all abstract?

MIRO: No.

E.R.: But many critics claim that your work of the past twenty years is abstract. When did you first begin experimenting in this style?

MIRO: Towards the end of the 'twenties. I have often been

called an abstract painter, but it has never been my intention to be abstract.

E.R.: I suppose your designs might be called ideograms, like those of Chinese writing, rather than abstractions.

MIRO: Yes, they *are* ideograms.

*Miro was visibly pleased with this definition. I felt that he was filing it away mentally for future use. At last, I seemed to have established what psychologists call "rapport" with this recalcitrant "patient".*

E.R.: I remember one of your paintings of the 'twenties that impressed me particularly when I first saw it, and that I still consider a very important work. I mean your *Dutch interior*. I immediately recognized it as a kind of derisive parody of a Vermeer or a Jan Steen. It would interest me to know if my guess was correct.

MIRO: Yes, I had been on a vacation in Holland and had brought back to Paris some postcard reproductions of pictures that are in Dutch museums.

E.R.: Do you remember which particular Dutch painting you had in mind when you painted your own *Dutch interior*?

MIRO: No. I just had a lot of postcards and I suppose I must have chosen one of them.

E.R.: But your *Dutch interior* interested me as one of the earliest, finest and most explicit examples of a kind of derisive attitude towards the art of the past which has become increasingly important in some schools of modern art. Of course, one finds many examples of this attitude in the work of Picasso, in his compositions, for instance, on themes borrowed from the Turkish interiors of the eighteenth-century Swiss painter Liotard, with their harem lovelies whom Picasso has transformed into dancing monsters. And Dubuffet has also, in recent years, developed a ribald style that is a derision of every style of art that has ever been claimed to be beautiful. But your own *Dutch interior* represents a more specifically Dada or Surrealist kind of derision. I remember also an early Max Ernst painting that has a similar quality, though with a more literary or anecdotic content. It represents a very classical Madonna, with the Child on her lap, but turned over for a spanking that she is administering diligently with her raised hand ready to strike.

MIRO: Yes. It was one of Ernst's Dada works.

E.R.: I suppose it was intended to shock in much the same way as the *Mona Lisa* to which Marcel Duchamp had added a moustache.

MIRO: Yes.

E.R.: But the derisive quality of your own work is no longer Dada, nor even strictly Surrealist. I feel that you are very Spanish as an artist, and that your humour is often of the same kind as that of Goya. Spanish painters sometimes have a peculiarly fatalistic sense of humour. They seem to believe that the mere fact of being human, I mean our "human plight", is in itself ridiculous and at the same time tragic.

MIRO. Yes, that is very Spanish.

E.R.: It is what disconcerted French classical critics in Spanish drama of the Golden Age. They objected to its mixture of tragic and of comic elements. *Don Quijote* is also both tragic and comic.

MIRO: Yes.

E.R.: In France, Don Quijote is rarely considered a tragic figure, and the book is generally published as a comic work, a classic for children rather than adults.

MIRO: But it is a tragic work too.

E.R.: I find a similar tragi-comic quality in your *Dog barking at the moon* that now hangs in the New York Museum of Living Art.

MIRO: Yes.

E.R.: Allowing for differences of style due to historical and personal reasons, it might well be considered a kind of *Capricho* like those of Goya.

MIRO: Yes.

E.R.: Of course, it is still one of your relatively early works and much more unequivocally figurative, in fact more anecdotic, than your later works which have been called abstract. One might conclude that, in becoming less anecdotic, you have also become less strictly Surrealist. In recent years, most other Surrealist artists have no longer relied on their individual subconscious but have drawn more and more heavily on Freudian literature or on anthropological sources. Only you and Arp have chosen this path of near-abstraction, whereas Dali now gives us allegories rather than dreams.

MIRO: Do you plan to interview Dali too?

E.R.: No.

MIRO: I would not like to be interviewed in a series that would also include Dali.

E.R.: I don't plan to interview Bernard Buffet either.

MIRO: That's good.

E.R.: But I do plan to interview Max Ernst.

MIRO: That's good.

E.R.: And Larionow.

MIRO: Never heard of him.

E.R.: Well, he's an elderly Russian painter who was one of the first to experiment in abstract art.

MIRO: I wouldn't know of his work if he doesn't live in Paris.

E.R.: But he has lived in Paris for over forty years. To return to Dali, you nevertheless approved of his work at one time.

MIRO: Yes, when he was still a member of our Surrealist group.

E.R.: That was the period of his soft watches, which were an authentic symbol, I suppose, of his own fears of impotence. Later, Dali seems to have over-compensated these fears by accumulating allegories and symbols which he borrows from all sorts of other sources rather than from his own dream-world. Now he has become a latter-day Symbolist, a painter in the same tradition as Arnold Boecklin, Max Klinger or Gustave Moreau, if not an outright Pre-Raphaelite who has had the misfortune to turn up a hundred years too late. But have you had occasion to see much of Dali in recent years?

MIRO: No.

E.R.: I suppose you lead a very quiet life in Spain, so that your paths never cross.

MIRO: Yes, I live on an island and see very few people.

E.R.: When did you last exhibit in Spain?

MIRO: In 1918.

E.R.: Why have you never exhibited there again, in the past thirty years?

MIRO: There is no point in exhibiting in Spain.

E.R.: Why?

MIRO: Nobody there would be really interested in my work and it would cause unnecessary scandal and idle discussion. There are practically no collectors of modern art in Spain, and very few critics who write intelligently about it.

E.R.: Vieira da Silva refrains for the same reasons from exhibit-

ing in her native Portugal. But is there no modern movement at all in Spain?

MIRO: A few experimental poets and one or two novelists of talent.

E.R.: So you find your island no less provincial than Madrid?

MIRO: It is easier to work in Majorca than in Madrid.

E.R.: Many outstanding artists seem to share your feeling and to want to avoid living in a great metropolis. Twenty-five years ago, most of these artists were quite content to crowd around the café-terraces of Montparnasse and to live in rickety studios on the outer fringe of the Left Bank, like Soutine and others in the colony known as La Ruche. But today Picasso, Chagall, Max Ernst and Manessier live dispersed in various retreats on the Riviera or in the country, where they are almost inaccessible to most of the younger artists of Paris who might profit so much from their guidance.

MIRO: But it has become increasingly difficult for us to work in Paris.

E.R.: Why?

MIRO: Paris is too crowded, too busy, too much of an art-market. One is disturbed here all day long, on the telephone and by visitors.

E.R.: I suppose you mean that there are too many dealers, collectors, critics and other unwelcome people like myself who constantly distract a successful artist from his work.

*Miro made a deprecating gesture, with a very Latin, almost Levantine hand, soft and somewhat pudgy. He thus implied that it was almost a pleasure to be disturbed by visitors like myself. Again, there was an awkward silence as more angels began to pass through the lounge, till I interrupted their procession:*

E.R.: So Paris is ceasing to be an artistic centre in order to be merely an art-market.

*Again, Miro made a deprecating gesture, more eloquent than his words. The procession of angels was about to resume its progress through the lounge, but I stopped it again:*

E.R.: It is not the first time in history that the intellectual and artistic élite has tended to withdraw from the capital cities. In the

Silver Age of the Roman Empire, especially during the reign of Hadrian and later, more and more Roman writers withdrew to country villas. Later, in the Byzantine Empire, many aristocrats and writers likewise retired from the capital to live in the monasteries of Mount Athos.

*Miro was visibly puzzled, if not bewildered or bored.*

But such a trend, *I continued unabashed,* might lead to a decentralization of art. We may have now entered an era in which each artist will develop a style of his own instead of being, as in the age of Impressionism or that of Cubism, an active member of a School or group. One of the consequences of such a trend might be a certain provincialism.

*Still no response from Miro, who had apparently never given much thought to these problems. I adopted a new line of approach:*

E.R.: What do you think of the situation of painting today in Paris?

MIRO: It is in an experimental phase.

E.R.: It has been in one experimental phase after another for at least fifty years.

MIRO: Yes.

E.R.: Have you visited many galleries?

MIRO: Yes, mainly Left Bank galleries, the Galerie Rive Gauche, Craven's, Stadler's. . . .

E.R.: What are your impressions of what you saw there?

MIRO: Well, it may all lead to something new.

E.R.: Perhaps, but it may also turn out to have been but a case of *grossesse nerveuse,* psychosomatic pregnancy.

MIRO: Perhaps.

*Miro smiled. My metaphor appealed to his Latin sense of humour.*

E.R.: The art of the School of Paris seems to me to have remained in this "interesting" condition for the past four or five years. Of course, we have no reliable information about the normal duration for the pregnancy of an art-movement. Do you think it might last as long as in the case of an elephant or a whale?

*This kind of spoofing amused Miro. He even joined in the fun:*

MIRO: Perhaps we should consult a veterinary obstetrician about this delayed delivery.

E.R.: If it ever takes place, it will come as a kind of eleventh-month wonder. But, seriously speaking, would you have any ideas of your own about the causes of this state of affairs?

MIRO: Well, art has closed and sealed too many doors in recent years. Now nobody has the courage to open any of them again. Most artists are afraid, if they should ever revert to figurative work, for instance, of being accused of having become reactionaries. Modern art progresses along an increasingly narrow path.

E.R.: It now progresses almost like a tight-rope walker.

MIRO: Yes, and it has become all the more easy to make a fatal mistake.

E.R.: Has this situation affected the evolution of your own work?

MIRO: I don't think so. On the whole, I seem to enjoy, in my work, more and more freedom.

E.R.: Space seems to play an increasingly important part in your work, some of which now has a rare quality of sheer lay-out. . . .

*Again, we were bogged down in silence. The procession of angels that I had managed to interrupt earlier now trailed slowly through the lounge. The tail end of it tripped rather hurriedly out of sight as I approached Miro with a new series of questions.*

E.R.: You were born in 1893. When did you first come to Paris?
MIRO: In 1918.
E.R.: Had you previously studied art in Spain?
MIRO: Yes, in Barcelona.
E.R.: In what schools?
MIRO: In the Fine Arts Academy and in several free academies.
E.R.: What kind of instruction did you receive?
MIRO: Academic, on the whole, but relatively free.
E.R.: I understand that there had long existed in Catalonia a real tradition of artistic non-conformity of which one sees the fruit in the work of the great *Art Nouveau* architect Antoni Gaudy. But had there been any important modern artists in Catalonia?

MIRO: No. Most of the art there was rather mediocre. Once in a while, an outstanding personality turned up, like Gaudy. But these were isolated cases, and there were no important schools or groups of artists in Barcelona.

E.R.: What was the style of your earlier work?

Miro: Well, I suppose I followed the Paris Cubists rather closely. Then I discovered Dada.

E.R.: Were you ever a Dadaist?

Miro: No, I was too young, and too isolated. But I was in sympathy with them.

E.R.: When did you become a member of the Surrealist group?

Miro: In 1925.

E.R.: Did you participate actively in any Surrealist demonstrations?

Miro: I attended a few of their gatherings, such as their banquet in honour of the old poet Saint-Pol Roux, who had come to Paris for the occasion from his retreat in Brittany. He seemed very bewildered among the Surrealists. But I used to spend only half the year in Paris, at that time, and always went back to Spain, to spend the other six months in the country.

E.R.: Where did you live, when you first came to Paris?

Miro: I stayed at first in an hotel, near the Bourse, to which I had been recommended by friends in Barcelona. The owner had relatives there, and most of the customers were Catalan businessmen. Later, I moved to the Rue Blomet, on the Left Bank, where I occupied the studio of the sculptor Gargallo, who also spent half the year in Spain. I used to share it with André Masson, when Gargallo was away.

E.R.: Did you associate with Gertrude Stein and other American expatriates, as Picasso did in those years?

Miro: No, but I met several of them casually.

E.R.: Why did you feel particularly drawn towards the Surrealists?

Miro: Painting had become a bit too restricted, in its style and subject-matter, after the so-called heroic era of early Cubism.

E.R.: I suppose you knew Juan Gris.

Miro: Yes, I was often in his studio in Boulogne, on the outskirts of Paris. I saw him the last time only a few days before his death.

E.R.: What do you think of his last works, those that were exhibited for the first time only recently.

Miro: I find them a bit frigid.

E.R.: Was Gris very enthusiastic about his work, when he died?

Miro: No, he was very perplexed and discouraged. But

most of the Cubists seemed to have lost their faith, in the early 'twenties.

E.R.: That was when former Cubists like Le Fauconnier, Metzinger and Hayden abandoned Cubism and tried their luck in less formalistic styles, reverting even, at times, to Fauvism and to a kind of Post-Impressionism. It was then too that Picasso went through his Classicist period. But you were never tempted to adopt any of these more traditional styles.

Miro: No. When I first came to Paris, I felt that Impressionism and Fauvism were both dead, and that Cubism was already moribund. Only Dada seemed to me to be really alive.

E.R.: Had there been any Dadaists in Spain?

Miro: Only a few poets, Alberti, Guillermo de Torre, and the Chilean poet Huidobro.

E.R.: Did you ever meet García Lorca?

Miro: No. We always missed each other, whether in Paris, Barcelona or Malaga.

E.R.: Who were your closest friends among the Surrealists?

Miro: The painter André Masson, with whom I shared Gargallo's studio, and the poets Robert Desnos and Paul Eluard.

E.R.: If I remember right, Desnos also lived in that studio, at number 45 of the Rue Blomet. I called for him there one evening, and we went to the Bal Nègre with a whole group of friends.

*Miro seemed quite surprised that we should ever have had any friends in common. It upset all his preconceived notions of me as an American journalist who had no roots in Paris and was more interested in news than in art.*

Miro: So you knew Desnos?

E.R.: I translated some of his poems for *transition.*

Miro: *Ah! transition. C'était la belle époque!*

E.R.: Desnos told me that he had discovered the Bal Nègre. You had all been living next door to this little West-Indian dancing-hall and had never even noticed that the band there played exotic *beguines.* It was in 1927 or 1928, long before that kind of music had become popular. Most of the women at the Bal Nègre were domestic servants and used to wear their native costume, with bandannas tied round their heads. It was all very colourful and unspoiled. Now that both Desnos and Eluard are dead, Masson remains, I suppose, your only close tie with the former Surrealist group.

Miro: Yes, but I have many other friends in Paris.

E.R.: Do many of your Paris friends visit you in Spain?

Miro: No. I spend most of my time in Majorca alone with my wife. I prefer to be alone, with nobody to disturb me when I work.

E.R.: You seem to be a veritable addict of work.

Miro: Well, I'm never satisfied with my achievements and am always interested only in the picture that I am actually painting. As soon as a picture is finished, it becomes something alien to me, no longer at all interesting.

E.R.: So your only interest, right now, is your assignment for Unesco.

Miro: Yes, for the time being, but it is already nearly completed, and soon I'll have something else to work on, some other interest. . . .

*As we reached the end of the third and last of our talks, I may have unwittingly expressed my sense of relief, perhaps in an indecently audible sigh. But Miro was visibly even more relieved than I. When we parted, he had the air of a visiting Spanish businessman who had just been quizzed by an over-inquisitive reporter from a trade-paper. He had done his duty, had avoided giving any unnecessary information, and would be able to report the whole incident satisfactorily, on his return home, to his Chamber of Commerce. Later, as I went through my notes of our talks and prepared the final draft, it occurred to me that he had perhaps been interviewing me. One thing was clear: to those who fail to find a satisfactory explanation of Miro's art in his actual works, no more explicit verbal explanation can ever be expected from the artist himself. Miro remains one of those rare artists to whom the magic of their own creative activity poses no problems. They accept it as something that requires no discussion, no explanation. It is their only way of being articulate, as natural to them as speech is to most of us.*

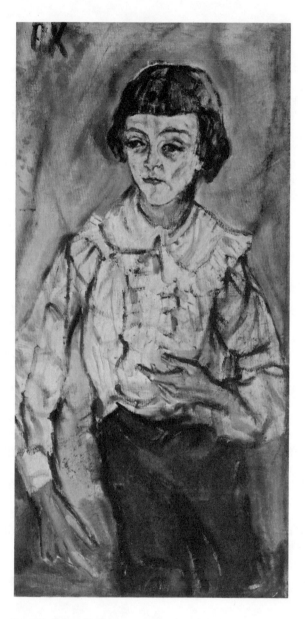

Oskar Kokoschka
*Portrait of the Composer Baron
Jacques de Menasce as a Boy*
76

# Oscar Kokoschka

*The Swiss Government's official Tourist Agency publishes, in three or four languages, a large number of illustrated leaflets to attract visitors to individual beauty-spots, historic towns or cities and other points of interest situated within the Helvetic Confederation. The leaflet devoted to Villeneuve concludes its description of this picturesque coast town at the far end of the Lake of Geneva as follows: "Many painters have appreciated the incomparable charm of this part of the country between lake and mountains, which is the present residence of the famous painter Kokoschka."*

*I had obtained Kokoschka's address from friends in London, and written to him to find out whether he would let me interview him in the course of a trip to Switzerland that I was planning for the near future. His reply had been encouraging and, a few weeks later, I then phoned him from Geneva, asking him if I might drop by the following Friday morning. My work as a conference interpreter had kept me in Geneva until late in the evening of the Thursday, and I thus arrived in Villeneuve by the last local train, well after midnight. The whole town seemed to be fast asleep, beneath a steady downpour of rain. Only the hotel where I had reserved a room, and which I had warned by phone of my late arrival, still had a couple of lighted windows, as if to guide me from the station, which was about to close down for the night. The station-master, on his way home, showed me a short cut, through the town, to my hotel, which was situated on the lakefront. We were the only living souls in the deserted streets of Villeneuve. No stray cats would have deigned to go marauding under such torrential rain.*

*On reaching my hotel, I enquired, before retiring for the night,*

*how far I would have to walk, the next morning, to reach Kok-*
*oschka's house. The proprietress had never heard of him, so I*
*produced my printed leaflet about Villeneuve and explained that*
*I had come all the way from London to visit the town's most*
*famous resident. She read about him with sceptical interest: "If*
*you're interested in interviewing artists, you should write about*
*me. I paint flowers on porcelain and sell a lot of my work to*
*tourists. I'll show you a few things tomorrow morning."*

*The next day, I was up early. It was still raining steadily. As I*
*breakfasted, I asked several members of the hotel staff how I*
*could get to Kokoschka's house. None of them had ever heard of*
*him. Finally, a young Italian maid had a bright idea: famous men*
*are generally old and frail and are known to the local pharmacy*
*as good customers. So she phoned a friend, who worked for the*
*pharmacist, and obtained the necessary information. Kokoschka's*
*house, I was told, would be easy to find. I need but follow*
*the lake-shore road towards the Castle of Chillon and, before*
*reaching this romantic landmark, in fact just before the Grand*
*Hotel Byron, I would find a narrow road branching up the hill*
*behind the hotel. There, a bit beyond the hotel, I would see a*
*pink house, the only one there, and that was where Kokoschka*
*lived.*

*On reaching my destination, I found two large pink houses*
*instead of one. The first was closed, all its windows shuttered,*
*and obviously uninhabited. So I rang the bell of the second pink*
*house, but was told by the owner that Monsieur Kokoschka lived*
*opposite, in the white house. When I found myself at long last in*
*Kokoschka's entrance-hall, I was dripping wet, and my plastic*
*rain-coat threatened to flood the place. But Kokoschka and his*
*wife greeted me without dismay, as if river-gods were indeed the*
*kind of visitor with whom they most often had to deal: "Whether*
*here or in Salzburg, all our friends from abroad seem to call on us*
*in pouring rain. As refugees from the much-maligned London*
*weather, we have chosen to live in the two rainiest spots in all of*
*Europe!"*

*Throughout our conversation of the next few hours, it continued*
*to rain so relentlessly, with such spectacular persistence, that it*
*was difficult to avoid referring, every once in a while, to the*
*weather which, like a badly disciplined child, took great pains to*
*attract our attention. Kokoschka was worried, with good reason,*

*about his garden, where the spring flowers were taking a cruel beating:*

KOKOSCHKA: You cannot imagine today how lovely the view and the flowers can be, when the weather chooses to be fine. But I seem to have bad luck. As soon as the weather begins to improve here, I have to go away, each year, to Salzburg, where I teach art-classes in the Summer School. Here it rains all winter and all through the spring; in Salzburg, it then rains all through the summer.

*He began to speak with enthusiasm about his teaching:* I try to teach my students how to see. Artists no longer take the trouble to use their eyes in looking at the outside world. Most of them have become Puritans, Iconoclasts, as if it were a sin to reproduce any aspect of reality, of the objective world. In Salzburg, we now have one of the few art-schools where students are taught to observe, to see, and to paint what they see. Not that we try to inculcate an academic style of art, or any theories of Realism or Mannerism. On the contrary, academic art is also a rejection of reality, an escape from the world of objects. Instead of painting what he sees, an academic painter generally imitates existing works of art and offers us only trite memories of the world as other generations of painters have experienced it. But painting remains a visual art, and a painter who refuses to see and to observe is voluntarily impoverishing his art. Goethe once wrote: "We know of no world except in relation to man, and we do not want a kind of art that is not a reflection of this relationship." I interpret these words of the poet as meaning that art must express the artist's relationship to a visible world.

E.R.: Would you then exclude, from the domain of art, all imaginary worlds, all that is unreal in visions or dreams?

KOKOSCHKA: Not at all. True dreams and visions should be as visible to the artist as the phenomena of the objective world. The test of the truth of such a vision or dream is its compelling visual reality, and that is why many merely academic allegories remain, in art, so deplorably unreal, simply because the artist has never been able to visualize them properly, to see and observe them as a prophet observes his dreams and his visions, with accuracy, with all the spontaneous emotional impact of a real experience.

E.R.: Would you therefore reject, as subjects for the artist, all

more intellectual abstractions, such as those of Mondrian, which no longer concern themselves with man's relationship to the outside world?

KOKOSCHKA: To me, Mondrian remains a kind of architect of a world lost to man rather than a great painter. He is too exclusively concerned with only one aspect of art, with the problem of proportions. He is a Puritan, a Calvinist, an Iconoclast. The subjective world that he communicates to us appears, in my eyes, tragically dull and uninteresting. I am still far too much interested in the visible world to want ever to escape from it. As an artist, I seek no evasion from the present, from the world of here and now. I am passionately devoted to life as man experiences it, with his eyes and other senses, with his emotions as he apprehends the visible world. But mankind seems to be losing its interest in this here and now. When I read the papers, I see that the most important news is about rockets aimed at the moon, and I am told that people are already trying to book seats on the first space-travel ships. I am still interested in travel only on this planet, and God forbid that I should witness its destruction! All this talk of a scorched earth or a scorched moon horrifies me.

E.R.: So you are proclaiming, in your work, your allegiance to a more traditional conception of art and of its relationship to reality than most of the great painters, since Picasso and Klee, have chosen to expound. Does this mean that you disapprove of the work of Klee, for instance?

KOKOSCHKA: No, I am not prepared to condemn Klee, whom I consider a true visionary, except that I am not always satisfied with the material quality of his works. I often feel that these are a bit sketchy, sometimes even amateurish, as if he had limited himself to a kind of hasty or almost absent-minded doodling.

E.R.: I have also felt that Klee refrains at times from allowing himself to develop his ideas or his visions fully as finished works of art. Still, Klee's attitude to his art has preserved, in much of his work, a kind of private and spontaneous quality that is generally lacking in the work of masters like Poussin or Manet, except of course in their sketches.

KOKOSCHKA: When we look at many of Klee's works, we experience the delightful feeling of eavesdropping, as when we read the private diary of a gifted writer, his notes and impressions that were never intended for public consumption. It is a very subjec-

tive and private art and teaches us more about the working of the artist's mind than about the nature of Art or the nature of nature.

E.R.: Your own art has also been called, by some critics, a very subjective art. Would you care to distinguish your own subjectivism from that of Klee or of some of the younger action-painters?

KOKOSCHKA: I suppose my own subjectivism limits itself to expressing my emotional reactions to what I see, whether my subject-matter is chosen from the objective world or from a world of dreams or of visions. Klee, on the other hand, is more solipsistic. He plays around with his dreams and visions and seems to invent them to fit his moods and emotions. He functions, so to speak, in reverse, projecting these moods and emotions as visions, not deriving them from what he sees or visualizes.

E.R.: But some action-painters go even further than Klee. They seem to be satisfied with the reality of their own moods and emotions, without ever concerning themselves at all with the visible world, without trying to project these moods and emotions in terms of forms borrowed, even as remotely as some of those of Klee, from the visible world.

KOKOSCHKA: Yes, Klee still meets his audience, in much of his work, on a common ground of recognizable forms; to this extent, his art is still a language of communication, whereas that of some of the younger action-painters no longer communicates anything but the intensity of their own emotion. Their work tends to become pure self-expression of the moment and tells us no more about the artist, about the world in which he lives, or the world of his visions and dreams, than a fever-chart tells us about a patient in a hospital bed.

E.R.: Some of my readers will find us both very harsh in our condemnation of action-painting. One has become accustomed, in recent years, to hearing it praised by all but a few die-hard Royal Academicians or less reputable Philistines of the daily press.

KOKOSCHKA: The action-painters and their friends have established a kind of Reign of Terror in the world of art-criticism, and many of the great critics of the past few decades no longer dare condemn something that is so new or obviously iconoclastic that they fail to understand it. These critics are so afraid of losing their following among the younger artists, in fact of compromising themselves by appearing at all conservative, that they now

behave like certain hysterical old women who are terrified of losing their charm and accept the advances of any man, as if each man in turn might be their last chance. In German, we have a word for this kind of hysteria. We call it *Torschlusspanik:* the panic that breaks out before the final closing of the door. But I feel that the art-critic should not be irrevocably committed to novelty or to what is generally believed to be progress in the arts. On the contrary, he should be committed only to *quality*, and we all know, from our studies of art-history, that a great period may be immediately followed by one of shocking mediocrity. It is foolish to assume that everything new must inevitably be better. This may be true of gadgets, of machinery, but not necessarily of art. In the last few decades, some of the most influential art-critics seem to have had no other purpose than to encourage a constant lowering of the standards of art. By praising indiscriminately every kind of primitive art, they have created a market for the pseudo-primitive and corrupted the truly primitive artists of our age. We thus have phoney *peintres du dimanche* and African artists who pretend to be less sophisticated or more primitive than they really are. In the same way, art-critics have corrupted the art of children, so that we now have art-teachers in our schools who often rebuke the children in their classes for producing works that are not childish enough. With action-painting, this process has gone one step further, and the art-critics are busy corrupting the natural devices of self-expression of chimpanzees, and already condemn the works of a more sophisticated or skilled animal as not sufficiently bestial. But they forget that a real chimpanzee, in wild life, would never dream of painting. Only in a cage or in a zoo have these chimpanzee-artists been forced to paint. As for any action-painters who might deliberately set out to emulate these chimpanzee-artists or be willing to allow comparisons between their own works and those of animals, well, I need only refer you to the parable of the Gadarene Swine, in the Bible, to let you know what I think of them.

E.R.: Do you have any theory of your own to explain this trend in modern art which you condemn as decadent?

KOKOSCHKA: Art has always been a craft rather than an industry, producing hand-made objects which bore the mark of the personality of the artist even more recognizably and distinctively than those produced by mere craftsmen who were not artists. Now

that the crafts have almost disappeared because everything is machine-made, the arts find themselves divorced from this infrastructure of handicrafts and the artist is losing his awareness of a real relationship between his own activity and the many other productive activities of our economy. Instead of emulating the craftsman and surpassing him, he is tempted to emulate and surpass the machine, or anything else that can produce forms or patterns, such as our chimpanzee-artists. Gradually contemporary art is thus abandoning its human standards and ceasing to be humanistic. For a long while, European civilization, in the Western world, resisted this trend and remained a repository of terms designating mental facts which can be expressed by images. Modern art can be likened to modern language, losing the means of expressing the more subtle relations and connections between thoughts that can strike a responsive spark in the human mind. But our European civilization is now doomed. It can no longer compete with the technical civilizations of America and Russia, except by borrowing their techniques of production. What we are witnessing, in the new styles of art of the last few years, whether in Europe or in America, is the final stage of this decay, in which action-painting and other extremist innovations are but the death-throes of the art of the Western world, I mean the humanistic art that we have inherited from ancient Greece. Exhibitions like the Venice Biennale are so to speak the Armageddon of Western Art.

E.R.: But would you condemn all art that is abstract or non-objective?

KOKOSCHKA: No, because everything we see can be reduced to some kind of abstraction. Like Rembrandt, Titian, another great genius, had been neglected for centuries. Now we realize that it is not the subject-matter, but the abstract painting *per se* which matters in Titian's work and makes it divine. There is abstract painting, as I fully acknowledge, in every square inch of the pattern of Titian's great art. But the abstract or non-objective art of today is often the art of an ostrich that refuses to see the world as it is. At the same time, it presupposes the existence of an extraordinarily rich, varied and worth-while subjective world, that of the artist. Wouldn't you agree that most of these abstract or non-objective artists of today are very ordinary men who reveal to us, in their works, only the extreme poverty of their own ideas, sentiments and emotions? I am shocked, when I visit some exhibitions

of this sort, by the platitudinous nature of the statements made by many abstract or non-objective artists, and by the terrible over-simplifications and conformist ideas that they seem to communicate. I often feel that an eighteenth-century craftsman like Roentgen, who made exquisite rococo furniture, had more imagination and a richer temperament, as a sheer artist, than some of the latter-day disciples of Mondrian or of the Bauhaus. As craftsmen, too many of these abstract artists have regraded themselves, like Circe's lovers in the *Odyssey*, by emulating the non-human. They have stooped to emulate animals or machines, and now their minds and souls function as if they were computers already without a soul or a mind. Man should always emulate only man or some higher order of beings, never machines that he himself has created. Now that man has even invented electronic brains which, we are told, are capable of composing original music, of writing poetry or of creating works of art, we must be careful to avoid emulating these robots. Though my faith in humanity is sorely bruised, I still hope that, after the present period of nebulous dreams, the spirit of Europe may become manifest in works of art which are more poignantly human than anything that an electronic brain can imagine or create. If art has any future at all, it must seek inspiration from the great art of the past, in the works of all those artists who remained faithful to the humanistic Greek tradition, rather than in the work of cave-dwellers, primitive and exotic art, or in the art of children or in psychopathic doodles. I mean, for instance, that an artist must now seek to achieve, in each of his works, something unique from a human point of view, like Piero di Cosimo's *Death of Procris*, which represented a peak of Renaissance neo-paganism after the mystic or cabbalistic gnosticism of the disputing theologians of the Dark Ages, or like Seurat's *La grande jatte*, which transforms a Sunday view of Paris suburbia into a vision of the divine light as seen by the artist in spite of the optical theories and the scientific materialism of his contemporaries. An artist should even refrain from settling down to the repetitive routines of his own particular manner or style, which may blind him to the freshness and novelty of a world which never repeats itself. . . .

E.R.: I suppose you mean the kind of repetition that one finds, for instance, in so many of the works of Fernand Léger, as if a whole series of them had been fed into an electronic brain

instructed to produce more of the same kind, but each one only slightly different from the original information supplied and from the other products of the series now produced artificially.

KOKOSCHKA: Perhaps you are now being a bit harsh on Léger, as I too was harsh on the action-painters. But that is exactly what I mean. Rather than compete with the machine, the artist must try to transcend it. Only thus can the artist preserve his freedom, a freedom of the individual. . . .

E.R.: Do you feel that our age offers sufficient guarantees for this individual freedom of the artist?

KOKOSCHKA: No, we are living in what I would call *die grosse Zeit der Gleichschaltung*, the great age of levelling down to the lowest common denominator. Never have the masses felt such an urge to follow a leader like sheep. Most men now seek security rather than freedom and prefer not to think or feel with their own minds and emotions. Instead, they accept vicarious experiences and prefabricated thoughts and withdraw into their homes to indulge in orgies of television rather than go out and face reality.

E.R.: I recently came across an eloquent illustration of this reliance on machinery as a substitute for thought and emotion. I was on a holiday and, though I'm not much good as an artist, I decided one afternoon to do some sketching. Suddenly, a young man who was watching me as I painfully tried to formulate my impressions of the landscape asked me why I took so much trouble. Condescendingly, he produced his camera and photographed the view. He then asked me to give him my name and address and promised to send me a print as a souvenir. It was quite difficult for me to explain to him that the mental process of sketching allows me to integrate what I see far more thoroughly, as an experience or a memory, than merely photographing it and later referring back to a mechanically produced memory, filed away in an album, whenever I might want to relive that particular moment of my past.

KOKOSCHKA: Now that is exactly what I am trying to teach my students in the Salzburg summer school. When I was a young man, fewer people could afford to travel, but the proportion of those who took sketch-books with them on their holidays was as high as that of those others who now carry cameras. Nor did all those who sketched have ambitions as artists or illusions about

their talents. On the contrary, sketching was considered to be part of the fun of travel, a device for enhancing and integrating one's visual experiences. I feel that many of the tourists of today who carry cameras with them, wherever they go, are mentally, if not physically, quite blind, or rather that their eyes no longer function as human organs, only as a kind of accessory to their cameras.

E.R.: To me the effort of sketching can be an essential element in the experience of enjoying a view, just as the effort of climbing a mountain on foot, instead of sleeping in a cable-car that carries you up, can be an essential element in the experience of travel. That is why the sketches of quite anonymous and unskilled nineteenth-century travellers often tell me more about Italy and what it could mean to them than most of the photographs that so many tourists now bring back from the same places. I own, for instance, a view of Taormina, painted by a minor German Romantic, and have often wondered how the artist could possibly have climbed to the spot from which he has depicted the ruins of the Greek theatre; at the same time, I feel that the picture also expresses some of the triumphant sense of achievement of a man whose experience of this beautiful view included a certain athletic prowess.

KOKOSCHKA: Still, I think it would be wrong to insist that art should always be a trial of strength, as if it were a kind of weight-lifting. The element of effort, in art, is often concealed, and the artist's virtuosity consists in giving us the impression that he achieves his feats of skill and strength with ease. The world of experience, as it is revealed to our sense and our understanding, is always chaotic. Each one of us must seek to organize so many conflicting facts, impressions or sensations in some kind of understandable synthesis, I mean in a *Weltanschauung* which will allow one to face the world as an individual, without being overwhelmed by the kaleidoscopic flow and swirl of phenomena. *Die Welt muss stündlich neu geschaffen werden*, the world must be created again in every hour, by each one of us, if not in every minute and second. It is the task of the artist to illustrate this process, to organize the chaos of the visible world in patterns from which some meaning can emerge. Each artist, of course, specializes in certain patterns, and thus suggests particular meanings and emotions rather than others. . . .

E.R.: Your own panoramic views of cities, especially of cities

situated on rivers that are spanned by bridges, somehow convey to me the individual character which you seem to detect in the tangle of architectural details and of geographical features. Like Greco's *View of Toledo*, your views of Prague, Florence, Dresden, London, Hamburg or Paris are each time the fruit of a successful search for the character of a community, and you interpret it to us as a sum total of the city's past, revealed to us in its present appearance. In some of your portraits too, I can detect a similar ability to see, in the facial expression of a man or a woman, the culmination of a whole life of joys and sorrows, of hopes and fears. Rembrandt had the same kind of psychological insight, whereas most portrait-painters, even such great artists as Frans Hals or Reynolds, tend to depict their models exclusively in the present, without interpreting their immediate appearance as a visible fragment of a kind of huge submerged iceberg.

KOKOSCHKA: It is most important that an artist should always face what he depicts, at least in the beginning, with a sense of sheer wonder. However ugly a face may be, we can discover some beauty in it if we first experience wonder before it and then begin to understand it too.

E.R.: Géricault's series of portraits of inmates of an insane asylum are particularly brilliant examples of this kind of understanding, which can transform something horrible or frightening into something beautiful.

KOKOSCHKA: Yes, but such a task requires an effort of charity or pity, of humility and of wisdom or prudence. *Caritas, humilitas et prudentia*, these must be the virtues of an artist who seeks to discover the hidden beauties of a chaotic world. Without these virtues, he might easily produce works that are merely macabre.

*It was no longer raining as obstreperously, and I felt that I might soon risk returning to my hotel without too much discomfort. Before we parted, Kokoschka took me over to the window, again apologizing for the weather, and began pointing out to me the beauties of his garden and of the view of the lake and the mountains.*

KOKOSCHKA: If the weather permits, I enjoy working in the garden. Nature is like a tremendous kaleidoscope, and there is no end to its appeal, to the variety of its forms, its colours and its patterns. . . .

*I was about to leave, when Kokoschka produced a folder of water-colours which he began to show me. They were exquisite studies of details of his garden, of the effects of light and shadow on flowers and shrubs. One could feel that they had all been painted in a completely relaxed mood, with the mastery achieved at the climax of a life devoted to drawing and painting, but also with the wonder and delight of a child or a mystic. As I turned towards Kokoschka and observed the expression on his face, the eager and youthful eyes, the smile transfiguring the ravaged features, I was reminded of the Latin term used by certain medieval mystics to describe their ideal. Kokoschka is indeed a* puer senex, *a white-haired boy, and the water-colours that he was showing me had the same quality of wisdom and of wonder as those of a whole school of mystical painters of the Far East, the Taoist and Zen artists of China and Japan who were able to discover, as he, order and beauty in the confusion of natural appearances.*

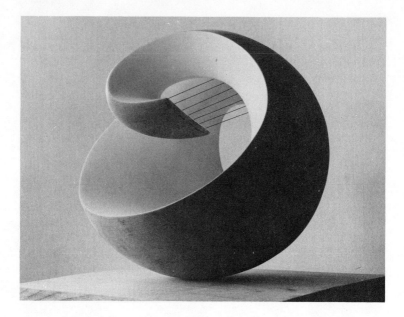

BARBARA HEPWORTH
*Pelagos*

# Barbara Hepworth

*The steep and narrow streets that lead up from the small Cornish harbour of St Ives can appear, on a sunny day, disconcertingly Mediterranean. Is their Kasbah-like intricacy a relic of the town-planning of the Phoenician merchants and mariners who once established trading-posts along this coast in order to export its tin-ore? Are the white walls and bright blue shutters of some of these houses intended, as in Sidi-Bou-Said, near the ruins of ancient Carthage, to ward off the Evil Eye? The gardens behind some of the high stone walls of St Ives, its houses built almost like for-tresses, the intimate narrowness of its streets where the interplay of light and shadow can be so dramatic, all these remind one, at first, of St-Tropez, of Ischia, of Hydra or of some eagle's nest of the Saracen pirates of the Barbary Coast rather than of the British seaside resorts, with their promenades, their bandstands and their piers, on which Osbert Sitwell has lavished his satire.*

*Long the home-port of a small fishing-fleet, then also an artist's retreat, St Ives has only recently begun to be threatened with the vulgar prosperity of a trippers' paradise. Barbara Hepworth's house stands but a few yards from the water-front where, during the season, the holidaying crowds ceaselessly flow past the espresso-bars, hamburger eateries, fish-and-chip shops, "Studio" souvenir emporia stacked with the mass-produced wares of Bir-mingham and Clerkenwell workshops, and the bed-and-breakfast lodging-houses that seem to be dedicated to the cult of perpetuat-ing the aspidistra displayed prominently in the parlour window. Just beyond the outer frontier of this absurd Cornish Disneyland, Barbara Hepworth's home faces the outside world, as many an artist's retreat in St-Tropez and Ischia, with the austere exterior of a kind of fortress. Its pale blue doors and few narrow windows*

91

*seem secretive; as one enters it, one is struck at first by the
ordered economy of the rooms, which have a monastic and cell-
like quality, until one reaches those that face the garden. Here
one discovers a less reticent private world, which one can contem-
plate from large windows and doors that open onto it as onto a
patio. On the lawns, among the flowers and shrubs, a number of
Barbara Hepworth's works of recent years are scattered, some of
them in close groups like the tombs in a strangely modern Moslem
cemetery. An open-air studio reveals that the artist prefers to
work, whenever the weather permits, in the light of nature. She
derives from it a sense of freedom, no longer feeling constrained
by artificial limitations of space.*

*Before calling on the artist for this interview, I had approached
her over the phone, though I happened to be staying with her
neighbour, the young sculptor John Milne. The informality of my
now dropping in from next door helped us to get down to the job
of discussion without any awkwardness, avoiding all time-consum-
ing preliminaries. We sat in one of her studios or work-rooms, in
the one that overlooks her garden, facing the wall that separates it
from John Milne's property. Over this wall, I had taken the liberty
of peeking, a day earlier, at Barbara Hepworth's Moslem necropo-
lis, which I now viewed from the opposite side. The artist's ap-
pearance, her gestures, her manner of speech, even her style of
dress, suggested unusual poise and efficiency. Without being
merely pretty, her features are beautifully modelled, as if her
mind had sculpted her body from within. One cannot help feeling
that she is exactly as she would like to be. Yet there is nothing
odd about her, no histrionic Bohemianism, no flim-flam-flummery
of facile protest. One would not be surprised to discover that such
a handsome, pleasant and obviously intelligent woman is a bril-
liant physician or a succesful politician rather than an artist. Yet
she speaks of her art with a rare awareness of dedication, in a tone
of authority and also of humility.*

E.R.: What are the advantages, in your opinion, of working in
the open air?

HEPWORTH: Light and space are the sculptor's materials as
much as wood or stone. In a closed studio, you cannot have the
variety of light and shadow that you find in the open air, where
even the colours of the shadows change. I feel that I can relate

my work more easily, in the open air, to the climate and the landscape, whereas the light and the space of a closed studio are always more or less the same, and more or less artificial.

E.R.: In almost every explanation of your work that I have read, I find that the word *landscape* occurs, obviously used with a very special meaning. Certainly, when you refer to the relationship of one of your works to a landscape, you are not thinking of a view such as one finds in a painting by Constable or by Turner.

HEPWORTH: Certainly not. I think of landscape in a far broader sense. I extend its meaning to include an idea of the whole universe.

E.R.: The landscape of one of your works might thus be interpreted as its ecology, I mean its relationship to nature.

HEPWORTH: Yes, I suppose that would be a correct interpretation of what I mean by landscape.

E.R.: But the relationship of a sculpture, as a man-made object, to its natural surroundings might be based either on harmony or contrast.

HEPWORTH: That would depend on the artist's response to a specific landscape. A sculpture, as I conceive it, is for a specific landscape. My own awareness of the structure of the landscape, I mean the individual forms too that contribute towards its general quality, provides me with a kind of stimulus. Suddenly, an image emerges clearly in my mind, the idea of an object that illustrates the nature or quality of my response. This object, once I have created it as a sculpture, may harmonize with the landscape that inspired it, in that its form suggests those that I observed in nature. On the other hand, the form of the sculpture may also contrast with the forms of the landscape. But, whatever the formal quality of this relationship, the sculpture remains, in my mind, so closely associated with the landscape to which I originally responded that I often try to perpetuate this relationship in the title that I choose for the work.

E.R.: Do you mean that you give your works specific titles like those that landscape-painters choose? I mean like the titles of paintings of Constable or Whistler?

HEPWORTH: Not exactly, since I'm always thinking of landscape in a broader and less specific sense. For instance, one of my sculptures is entitled *Pelagos*, meaning "the sea". Well, from my studio, I could see the whole bay of St Ives, and my response

to this view was that of a primitive who observes the curves of coast and horizon and experiences, as he faces the ocean, a sense of containment and security rather than of the dangers of an endless expanse of waters. So *Pelagos* represents not so much what I saw as what I felt.

E.R.: Do you believe that it is possible to explain or justify in words such an individual response to a landscape?

HEPWORTH: No such explanation would be entirely satisfactory. It would always fail to convince some individual spectator. But the individual also remains free to repudiate my particular response and to affirm his own different response to the same landscape. Still, the violence of such an individual's repudiation of my response may also serve its purpose in clarifying his own response. The important thing is that there should be a genuine response, whether to my own work or to the landscape that originally suggested it to me. . . .

E.R.: So you admit that different artists may conceive different forms as responses to one and the same landscape?

HEPWORTH: Certainly, and each different form, each different response, is valid as a kind of testimony. My own testimony represents the sum total of my own life and experience, in that particular moment, as a response to that particular experience.

E.R.: In terms of Platonic philosophy, your works should thus be defined as imitations of something that occurs in your own mind rather than of nature as it is or as it might ideally be.

HEPWORTH: Yes—an imitation of my own past and present and of my own creative vitality as I experience them in one particular instant of my emotional and imaginative life.

E.R.: Would you say that you set out to impose upon your material a very clearly conceived form, or that you allow your material, as you work on it, to suggest to you the final form of the sculpture?

HEPWORTH: I must always have a clear image of the form of a work before I begin. Otherwise there is no impulse to create. The kind of sculpture that I indulge in is hard work, and I would always hesitate to start doodling with a mass of wood or stone as if I were waiting for the form to develop out of the work. Still, the preconceived form is always connected with a material. I think of it as stone, or as bronze, or as wood, and I then carry out the project accordingly, imposing my own will on the material.

The size of the sculpture is also important, in my first clear image of what I want to do. I can see the material that I want to work on, and also the exact relationship of the object to its surroundings, I mean its scale. I hate to think of any of my works being reproduced in a smaller format.

E.R.: You mean as a kind of pocket edition reproduced in ceramic and tucked away on the shelf of a book-case, in front of a row of cookery-books?

HEPWORTH: Yes—that might well be one of my nightmares.

E.R.: But doesn't the material, as you work on it, ever suggest to you any modification of your original image?

HEPWORTH: Of course it does, and that is the great temptation. Half-way through any work, one is often tempted to go off on a tangent. But then one knows that there can be no end to such temptations, such abandonments of one's plan. Once you have yielded, you will be tempted to yield again and again as you progress on a single job. Finally, you would only produce something hybrid, so I always resist these temptations and try to impose my will on the material, allowing myself only, as I work, to clarify the original image. At the same time, one must be entirely sensitive to the structure of the material that one is handling. One must yield to it in tiny details of execution, perhaps the handling of the surface or grain, and one must master it as a whole.

E.R.: It sounds rather like the art of mastering a thoroughbred horse.

HEPWORTH: I've never ridden a horse, but I can well imagine that this is a good simile.

E.R.: As I look around your studio and see all these samples of your work, I feel that you have an awareness of what I would call the different epidermis of bronze, stone or wood. Your bronzes, for instance, have a rougher surface that is peculiar to them, whereas your stone and wood sculptures achieve as smooth a "skin" as the grain of the material can allow.

HEPWORTH: It requires an extra effort, some additional strength, to discover the wonderfully individual quality of each material. In the case of bronze, this problem of the finish is particularly subtle as the model which I send to the foundry is of an entirely different material. I have to visualize it, as I work on it, as if it were bronze, and this means disregarding completely its own material qualities. That is why I find it necessary to work with a

foundry that has an artistic understanding of the quality of finish and of colour that I want to obtain in the bronze. I enjoy working for instance with Susse Frères, the great Paris foundry. They are artists and masters and I can always trust them to interpret my ideas. Look at the colour, for instance, of that bronze, which came back from Paris only recently. The blue-grey quality of the shadows, on the interior surfaces, is exactly what I wanted, though I had never seen it before in any bronze. It turned out exactly as I had visualized it when I was still working on the plaster model.

E.R.: This awareness of the specific qualities of various materials is what strikes me as lacking in most nineteenth-century sculpture.

HEPWORTH: Many sculptors then tended to misuse clay, wax or plaster. In handling something that is soft and yields, they would forget too easily that their model was to be reproduced in stone. Generally, it was another man, a craftsman rather than an artist, who carried out in marble the model that the sculptor had entrusted to him.

E.R.: The French poet Léon-Paul Fargue once referred to this kind of art as "noodles camouflaged to look like steel". I suppose that is why so many marble figures of that period look as if they had been squirted out of a toothpaste tube, then hastily and quite easily licked into shape and allowed to cool off and harden.

HEPWORTH: That sounds rather revolting to me. But so many of these human figures of the nineteenth century are like petrified humanity, as if they had been injected with a chemical that immediately transformed living flesh into bronze or stone.

E.R.: The Greeks were already aware of the dangers of this kind of naturalism. Medusa, the gorgon, could turn human beings to stone by merely looking at them, and the legend horrified the ancient Greeks.

HEPWORTH: Well, I share their horror of a living being that has been overcome by a kind of *rigor mortis*. I feel that a work of art should always reflect to some extent the peculiar kind of effort that its material imposed on the artist.

E.R.: May I interrupt you here to say how much I am enjoying the aptness and articulate quality of everything that you have said to me about your art? I've had the occasion of interviewing, in recent months, quite a number of artists, whether in English, French, Italian or German. Some of them, I found, were quite

inarticulate, except in their own medium. Others, when they spoke, were almost too articulate, so that I felt that they often failed to express, in their particular medium, all that they claimed, as they spoke, to have set out to achieve. In your case, I find that your verbal explanations apply very aptly to your actual sculpture.

HEPWORTH: It is important for an artist never to talk out his ideas until he has made them concrete as works of art. In explaining what one intends to do, one always wastes or loses some of the energy or force that is required to achieve the work of art. I suppose I am able to explain only those works which I have already completed. I don't think I would ever want to talk about an image or an idea that is still in my mind, or that I haven't yet made fully concrete.

E.R.: Brancusi was never very eloquent about his own sculpture.

HEPWORTH: No. I visited him twice in Paris, in his studio, before the war. It was wonderful. He simply pulled the dust-sheet off each sculpture in turn, and there it was, something that needed no explanation because it was already as much a part of the visible world as a rock or a tree.

E.R.: For Brancusi, the act of creation was something as simple and as self-explanatory as the act of procreation among animals. But he could also be articulate whenever he discussed the work of another artist. I happened to meet him shortly before he died, when I called one afternoon on a young American painter who lives in Paris and occupies a studio next door to Brancusi's. That day, I didn't recognize Brancusi at once as I hadn't seen him for over twenty years. My American friend, Reginald Pollack, is a figurative painter who has settled in France in order to study the techniques of the great French post-impressionists and Fauvists, from Bonnard to Dufy—which is scarcely the kind of art that one generally associates with the name of Brancusi. Well, here was Brancusi, carefully analysing his young neighbour's recent works and giving him very specific advice on how to solve certain problems of colour and texture that Pollack was still trying to solve.

HEPWORTH: That doesn't surprise me at all. There was an essential humility in Brancusi. He knew very well what he wanted to achieve, but this did not exclude the other aims which other artists might set themselves. Within the scope of his own field of creation, he could achieve the perfection of form that he sought.

At the same time, he was aware of other types of expression which other artists might achieve.

E.R.: I seem to detect a great affinity between your own work and that of a few Continental sculptors, I mean Brancusi and Arp. But I also feel that your work, like that of Henry Moore, has contributed very decisively towards establishing the notion of a specifically English school of contemporary sculpture. I would even say that England and Italy are now the only two European countries that have a national style of contemporary sculpture.

HEPWORTH: It is safe for you, an American to make this kind of remark. On my lips, it might sound almost too chauvinistic, though there may be some truth in it.

E.R.: Until 1939, English artists tended, I feel, to follow almost too closely the directives of the School of Paris. When they were cut off from Paris by the war, they became aware of their own power and of their own potential style.

HEPWORTH: It is an awareness that we developed as a group rather than as individuals. After the First World War, we became conscious of all the values of our civilization that we were called upon to defend. We then realized that sculpture, as a stone-cutter's art, had been widely and successfully practised five centuries ago in England.

E.R.: I suppose you are referring to the masters who carved such figures as those that one sees on the façade of Exeter cathedral.

HEPWORTH: Yes. But this stone-cutter's art had been abandoned and forgotten. In the 'twenties, we began to seek a return to the fundamentals of our art. We recoiled at last from the kind of reproduction of a reproduction which had satisfied the sculptors of the Victorian era. Epstein, Eric Gill and Gaudier-Brzeska had cleared the decks for the sculptors of our generation, I mean Henry Moore, myself and others. We then rediscovered the principles of Anglo-Norman sculpture too. I remember how, during the war, a bombing once led to the accidental unearthing of a carved Anglo-Norman capital in which the artificial colouring of the stone had somehow been preserved. I was able to see how the cavities of the reliefs had once been coloured with a bright terra-cotta red, and this was exactly the kind of effect that I too had been seeking from 1938 onwards, in some of my own works. What

I had considered an innovation thus turned out to be a lost tradition in English sculpture.

E.R.: Of course, there had also been at one time a specifically French school of modern sculpture, from Carpeaux, Degas and Renoir in the generation of the Impressionists, to Rodin, then Bourdelle, Maillol and Despiau in our own age. But the great sculptors of the School of Paris, in recent years, have generally been foreigners, I mean Brancusi and Modigliani, Lipschitz, Zadkine and Arp, who had been active in German artistic movements before his native Alsace, in 1919, became again a French province.

HEPWORTH: The English sculptors of my generation still owe a great debt to these artists of the School of Paris. They have taught us the basic principles of form in its relationship to the surrounding space. But we also had to solve a problem of our own. I mean that we had to deal, in our relations with the English public, with that very English characteristic of always seeking a literary explanation for every work of art. In France, the Impressionists had solved that problem decades earlier. But we had to remind England that a sculpture need not be a monument to the dead, or a reminder of a great work of Michelangelo. On the contrary, a sculpture should be enjoyed for its own intrinsic qualities.

E.R.: That had already been the basic doctrine of Oscar Wilde's campaign against the "anecdotage" of Victorian art. But Oscar Wilde had been so eloquent in his praise of French art that most English artists, from 1890 until 1940, looked to France for their directives.

HEPWORTH: In 1940, we were then cut off from France and suddenly realized that everything that we really needed, for the time being, was available here. In sculpture, painting, architecture and music, everything that we stood for, that we had to defend in the war, was here. We realized that contemporary English art and music could indeed be as rich and varied as contemporary English literature. It was up to us to forge ahead and prove it.

E.R.: I think you, in particular, have proved it very eloquently.

HEPWORTH: I sometimes feel now that we are beginning to be threatened by a certain chauvinism. People would love to return to the comfortably insular or English ways of thinking. Now we have to combat this danger. We must avoid contributing towards the establishment of a new kind of specifically English academism.

E.R.: So you feel that you are now committed to defending the kind of non-figurative art which is considered most controversial.

HEPWORTH: No, not necessarily. I have not always been a non-figurative artist, and I may very well, one day, feel the urge to return to a more recognizably figurative style of art. Besides, we are already having to cope—I mean those British artists who have long been pioneers of abstract art—with a kind of placid academic recognition that is at times quite disconcerting.

E.R.: When did you first begin creating abstract forms?

HEPWORTH: Around 1931, I began to experiment in a kind of organic abstraction, reducing the forms of the natural world to abstractions. Then, in 1934, I created my first entirely non-figurative works. But it was in 1931 that I began to burrow into the mass of sculptured form, to pierce it and make it hollow so as to let light and air into forms and figures.

E.R.: Is there any connection between this idea of an inner surface, I mean of a hollow mass that is penetrated by light, and the concave-convex ambiguity of certain Cubist paintings—it's actually a kind of optical punning—where objects that are convex in real life are depicted as concave, or vice versa?

HEPWORTH: No, I don't think there is any such play, in my work, with the ambiguities of optical impressions. I think this development, in my sculpture, was a response to an organic sensual impulse. I believe that the dynamic quality of the surfaces of a sculpture can be increased by devices which give one the impression that a form has been created by forces operating from within its own mass as well as from outside. I have never seen things, even inadvertently, in reverse, though I have often observed that some other artists tend to suggest that they have seen in relief what is actually hollowed out, or vice versa. In my own work, the piercing of mass is a response to my desire to liberate mass without departing from it.

E.R.: This is indeed a curiosity of the senses rather than of the intellect. It suggests a desire, on your part, to explore the inside of a mass with your finger-tips rather than with your mind. But the Cubists were more intellectual, as artists, than sensual; besides, they invented and tested most of their devices, even those that suggest sculptural effects, in paintings rather than in sculptures.

HEPWORTH: Still, there is an element of intellectualism in my

sculpture too. I feel that sculpture is always, to some extent, an intellectual game, though the sculptor generally obeys sensuous impulses. The sculptor sets out to appeal to all the senses of the spectator, in fact to his whole body, not merely to his sight and his sense of touch.

E.R.: In most Cubist sculpture, I seem to miss, above all, this appeal to the spectator's sense of touch, except when the Cubist sculptor sets out to fool the spectator by offering him a convex form where one expects a concave one.

HEPWORTH: But there is a certain amount of fooling of this kind in all art. You are perhaps right when you suggest that the Cubists refrained from appealing to our sense of touch, except perhaps when they set out to deceive us. But my own sculpture also sets out, at times, to deceive the spectator. I thus try to suggest, in my forms, a kind of stereoscopic quality, but without necessarily allowing the spectator to touch these forms. The piercing of masses, by allowing light to enter the form, gives the spectator a stereoscopic impression of the interior surfaces of this mass too. I set out to convey a sense of being contained by a form as well as of containing it, I mean of being held within it as well as of holding it, in fact of being a part of this form as well as of contemplating it as an object. It is as if I were both the creator of the form conceived and at the same time the form itself, and I deliberately set out to convey this ambiguity to the spectator, who must feel, as I did, that he is part of this sculpture, in its relationship to space or landscape.

E.R.: This would indeed be the ideal of communication between artist and spectator. But it requires a kind of contemplative approach to the work of art, on the part of the spectator, that has become almost impossible in our overcrowded world where one often feels that there is already standing room only. In the Museum of Modern Art in New York, for instance, the modern sculptures are so crowded that one can sometimes see a detail of a César through a hollow in a Henry Moore. I found that very disturbing, like a vision of skulls and bones piled up promiscuously in a charnel house.

HEPWORTH: To me it sounds quite macabre. Besides, it is contrary to the basic idea that underlies most sculpture ever since that of ancient Greece. A human figure, set in the daylight and in a landscape, should give us there the scale of everything. If you wish to

suggest a deity that dominates nature, a colossal figure will do the trick. But if you crowd together, in a single space, a lot of figures conceived on different scales, you deprive them all of their aesthetic purpose and reduce them to the status of "ancient remains", I mean of objects of interest to an antiquarian. In the case of modern sculpture too, this overcrowding in galleries and museums deprives each work of its intended relationship to space, I mean of its ideal landscape. Once, when I was in Greece, I became intensely aware of the relationship that a single human figure might bear to a whole vast landscape. It was on Patmos, and I was coming down a mountain-side when I saw a single black-robed Greek Orthodox priest standing beneath me in a snow-white courtyard, with the blue sea beyond and, on the curved horizon, the shores of other islands. This single human figure then seemed to me to give the scale of the whole universe, and this is exactly what a sculpture should suggest in its relationship to its surroundings: it should seem to be the centre of a globe, compelling the whole world around it to rotate, as it were, like a system of planets around a central sun. That is why each sculpture should be contemplated by itself.

E.R.: But the public generally gets to know sculptures only in a crowd, in exhibitions or museums, or else in photographs. Even the best photograph, I feel, betrays a sculpture, depriving it of its proper format and of its own quality of surface. A photograph reduces polished brass or polished marble to mere outlines, robbing them of their content, their mass, their density or weight. Museums might thus be said to have become concentration-camps for works of art, and art-books be compared to rogues' galleries in which each individual work is stripped, in a reproduction, of most of the qualities that should compel our admiration. But here we are beginning to discuss problems of economics or sociology— I mean the problems that arise in our age if one wants to bring art to the attention of the public, especially when the public approaches art as a Sunday crowd in an already crowded museum.

HEPWORTH: Yes, that would take us too far, though I am sure we could still talk about enough problems to fill a whole book.

*I slipped my ball-point pen and my note-book into my pocket and we then strayed into the garden together. Later, Barbara*

*Hepworth also showed me, in another house in the same street, another studio, a huge room that is more convenient for larger works. Here too, individual works seemed to conflict, each one interfering with another's aura or landscape. To create, for each work, its own ideal space, a sculptor must indeed be purposeful enough, or obsessed enough, to block out of his own field of vision all the other works that surround him in his studio.*

PAVEL TCHELITCHEW
*Toby*

# Pavel Tchelitchew

*When I first met Pavel Tchelitchew, I was still a naïve and easily perturbed eighteen-year-old near-surrealist poet. But I already shared, with Charles Henri Ford and Paul Frederick Bowles, the honour of being numbered among the very youngest contributors to* transition, *a now legendary Paris-American publication in each issue of which James Joyce was publishing a new instalment of his* Work in Progress, *later known as* Finnegans Wake. *Sylvia Beach had been kind enough to think of inviting me to Edith Sitwell's reading of her own poems in the "Shakespeare et Compagnie" bookshop in the Rue de l'Odéon, where the "expatriate" avant-garde of England and America used to foregather. I came there, that evening, compulsively early, and drifted, as the crowd increased around the door behind me, towards the reserved chairs in the front row. This may have been, on my part, a serious breach of etiquette, as I was certainly one of those younger men who, in a crowd, are expected to stand at the back of the room, leaving the chairs to older and more famous guests. But sins and errors, it seems, are sometimes rewarded richly, and I soon found myself close to Gertrude Stein, who was holding court in the front row; she struck me, that evening, as looking like one of my father's American-Jewish business associates who might suddenly have gone mad and appeared in public wearing his mother-in-law's clothes, his own wife being too chic, too much of an Edith Wharton character of that "Age of Innocence", to wear the kind of timeless "practical" garb that the author of* The Making of Americans *affected.*

*Gertrude Stein was accompanied by a lively and less strikingly masculine younger man who spoke English and French with equal fluency, though always with a slight Russian accent. They*

*switched constantly from one language to another, often in the middle of a sentence, with grammatical and syntactical pirouettes that betrayed a rare linguistic virtuosity. When Edith Sitwell, another formidable figure, at last appeared, it was all like a late-gothic painter's representation of "A visitation of Saints". They were soon joined by others and those of the group who spoke French generally addressed each other as "tu", indicating a degree of intimacy which set them in a veritable empyrean of celebrity, far above the outer circles of the avant-garde heaven where such obscure neophytes as I still grovelled.*

*Edith Sitwell's appearance was even more striking than that of Gertrude Stein. As an English eccentric, she managed to synthesize, much as Nancy Cunard did some years later, four or five foreign, obsolete or exotic styles of dress and ornament in as unmistakably insular a "native costume" as that of a London Pearly. Edith Sitwell's head-dress, that evening, was a bottle-green skull-cap turban, a personal improvement on those that the Paris modiste Agnès had recently launched; but this particular turban also suggested both the blue head-dress of the Vermeer portrait of a girl that hangs in the Mauritshuis in The Hague and the more formal sugar-loaf hair-do of a Benin bronze. Her necklaces of heavy and dark amber beads might have been an heirloom from a Mandarin uncle, but were supplemented with odd pieces of antique Russian or Italian filigree and enamel-work that transformed her ample, ageless and somewhat monastic dark grey robe into a garment of almost sacramental splendour. All this, combined with her stature, her commanding bearing and her junoesque proportions, made her look like the twin-sister of a Guards officer disguised as a Madonna for a religious pageant held in eighteenth-century Portuguese Goa.*

*After the reading of her poems, I found myself too estranged from this world to think of forcing my way through the crowd to the door and thus escaping from the crush of celebrities as modestly as my self-consciousness might have required. Marooned close to Edith Sitwell, Gertrude Stein and their birdlike companion, I was graciously introduced to them by Sylvia Beach, but remained speechless with terror and respect. Their companion turned out to be Pavel Tchelitchew, and it never occurred to me then that I would one day be so close a friend of his that our meetings, our polyglot exclamations, our use of the second person*

*singular in French, German or Italian, and our peculiarly European exchanges of kisses on the cheek would, some thirty years later, perplex younger American poets as much as Tchelitchew's and Gertrude Stein's meeting with Edith Sitwell had dumbfounded me, that evening, in 1929.*

*I met Tchelitchew again, by chance, a couple of days later in Montparnasse, where he was seated at a café-terrace with the poet and novelist René Crevel, whom I knew quite well. Far from being inaccessible, Tchelitchew turned out to be a close friend of Maurice Sachs, Christian Dior, Christian Bérard and other unknown young men who are now celebrities and who were then my day-to-day companions. After that, Tchelitchew and I met frequently through the years, in Paris, London or New York, though our paths often failed to cross for several years at a time. The last time I saw him, in Paris, in November 1956, I had just returned from Berlin, where I had undergone a serious operation. It was the last evening of his one-man show at the Galerie Rive Gauche. He had entertained great misgivings about the fate of this exhibition, but was satisfied with its success: he had indeed achieved a rather remarkable but well-deserved come-back, after neglecting, since 1939, to indulge in the kind of intrigues that ensure an artist a great reputation on the Paris market. As he was leaving the next day for Rome, where he subsequently fell ill and died, I had made a special point of meeting him at the Galerie Rive Gauche after dinner, though I was still hobbling around with two canes. There was something poignant in our meeting, as if we both felt how very nearly we might never have set eyes on each other again, and it was then that we decided that I must interview him and write what might turn out to be his artistic credo and testament. During the ensuing months, I wrote many letters to Tchelitchew, and he answered them whenever his failing health allowed him the effort. Shortly before his death, he sent me a mass of notes, drafted in English, French, Italian or German, which he asked me to study so as to be ready to interview him as soon as his health would allow him to come to Paris. But he never returned to Paris and, when I learned of his death a couple of weeks later, I understood that his notes gave me the answers to all the questions which I had raised in my letters and to most of those that might still have occurred to me had we met again. As I now write my interview of Pavel Tchelitchew,*

*based on his polyglot answers to my questions which I must draft
in a single language and complete with memories of earlier con-
versations, it is as if some Spiritualist miracle were allowing me
to communicate with him beyond death.*

E.R.: Many of your old Paris friends and admirers seem to have
been a bit disconcerted by the astronomical or mathematical
nature of the works that you have just exhibited here. But I re-
member, Pavlik, that you have often been tempted to interpret
the real world in terms of a very personal and mystical geometry,
as if all living things and all phenomena were constellations re-
volving in infinite space.

TCHELITCHEW: Mathematics fascinate me. As a young man, my
father had obtained his doctorate in mathematics and later de-
voted much of his time to studies of the philosophy of numbers.
This may explain why I have always been aware of geometry, of
numbers, and of the value of forms and figures as signs that con-
vey hidden meanings. I have the feeling that the whole visible
world can be reduced to mathematical formulae or geometrical
figures, which develop before our eyes like those coloured Japan-
ese pills that one drops into a glass of water to make them slowly
unfold as artificial flowers. The Jewish Cabbalists believed that
the world had been created out of the letters of the Hebrew
alphabet, which are also used as numbers. In thus reducing the
world of appearances to its basic numbers or geometrical forms,
we probe the very mysteries of Creation. But I have never been
at all brilliant in arithmetic or geometry. On the contrary, I always
remained content with being puzzled by the mysteries of mathe-
matics and never wanted to solve them or to put them to any
practical use. Mathematics remain, for me, a kind of contempla-
tive exercise.

E.R.: Can you remember your first conscious display of interest
in mathematics or geometry?

TCHELITCHEW: I was born in Russia on September 21st, 1898,
which was also September 8th according to the Old Calendar of
the Orthodox Church. These two dates still seem to me to bear
special meanings, which I'll explain to you later. Anyhow, I must
have been nine months old when I was given one of those boxes of
wooden cubes with which a child can compose six different pic-
tures by selecting the elements of each picture from the various

sides of each cube. I could play for hours with these cubes, and each time I had completed one picture I remained mentally so very much aware of the five other possible pictures concealed within the one which I had composed that I could visualize them as if I were actually seeing them all at the same time, through the one picture which was there before my eyes. I thus learned that a cube has three dimensions, but also six sides, and that each one of these six surfaces can appear to lead a life of its own, offering us a different image of the world and suggesting to us a different meaning. But all these six different pictures are somehow related, though there may seem to be no logical connection at all between them. Imagine, for instance, a set of cubes with which you can compose the portrait of the Gioconda, a Watteau love-scene in a park, a patriotic battle-scene painted by a Russian nineteenth-century academic painter, a Dutch still-life with fruit, fish and vegetables, the Sistine Madonna, and the famous Millais picture of Bubbles. And then imagine a child who knows perfectly well that this Dutch still-life can be transformed at will into a patriotic battle-scene or the picture of Bubbles, to say nothing of the three other possibilities offered. There you will find the key, I suppose, to my whole conception of art as a kind of science of metamorphosis, I mean as a magic which can transform any visible object into a whole series of other objects.

E.R.: The kind of geometry that you have just explained to me is a far cry from that of Cézanne and the Cubists.

TCHELITCHEW: Certainly. I might add that I see geometry as something basically dynamic, never static as it is in so many Cubist compositions. And I can explain this in terms of another childhood memory. Of course, you know those cardboard marionettes whose arms and legs are activated by an ingenious arrangement of strings that one can pull. I remember being taught to walk by being shown the movements of such a cardboard harlequin, and I then believed that I was also being manipulated, or could even manipulate myself, by means of similar strings, though they might be invisible. I still feel, in fact, that we are all guided, in our movements, by invisible strings. Later, when I designed the sets and costumes of Nicolas Nabokow's ballet *Ode* for Serge de Diaghilew, I developed this idea in terms of choreography, and I am sure you have detected memories of it in many of my paintings of the late 'twenties and early 'thirties.

E.R.: I happened to be present at the first night of *Ode*. It was in Paris in 1928, shortly before our first meeting. Your designs seemed to me to interpret the world as a kind of cat's cradle in which we live as if our movements were all governed or predetermined by shifts of tension within this web of strings. But was *Ode* your first experience of designing for the stage?

TCHELITCHEW: No. I had always been devoted to the theatre, especially to the ballet. As a child, I had been brought up in the country, on my father's estate near Kaluga, till I was sent at an early age to a boarding school in Moscow. Puppet-shows on market-days in the near-by town, mountebanks at animal fairs, all the traditional entertainments of the Russian peasantry had fired my imagination. Once in a while, I would be allowed, as a great treat, to go to a Moscow theatre. When I came to the University of Moscow in 1917, I spent most of my spare time either attending classes in art-schools or going to see plays, operas and ballets. In the early years of the Revolution, I found myself, in 1918, in Kiev, with a group of other art-students. Kiev was at that time the capital of an independent non-Communist Ukrainian government, and we managed to earn our living designing and painting scenery for theatres. In 1919, I then managed to escape to Constantinople with some French friends and got a job there as stage-designer for a Russian ballet company with which I travelled to Bulgaria, Vienna and Berlin.

E.R.: Immediately after the First World War, Berlin seems to have been the inflationary Mecca of the refugee Russian *avant-garde*. Chagall was also there, for a while.

TCHELITCHEW: Yes, but I had little contact with Chagall and his circle. My own associates were mainly in the theatrical world, and none of us had ever had much to do with the Communist régime in Russia, where Chagall had been Commissar for Fine Arts in his native Vitebsk and had worked for the Moscow theatres. In Berlin, from 1921 to 1923, there were two main groups among the Russian emigrés: those who, like myself, had never expected any mercy or favours from the Communist régime and had been dispossessed by it, and those others who, at first, had hoped somehow to fit into the new order. Among the latter, many had even managed like Chagall to be successful for a while as artists in Soviet Russia, or, like the writers Ilya Ehrenburg and Karl Radek,

were still sitting on the fence and constantly travelled back and forth between Moscow and Berlin.

E.R.: Did you work in Berlin exclusively for Russian theatrical ventures?

TCHELITCHEW: Not at all. It was in Berlin that I experienced my first European successes, when I designed sets and costumes for German theatres, even for the famous Berlin Staatsoper's production of *Le Coq d'Or*. And it was in Berlin that I held my first one-man show, in Alfred Flechtheim's gallery on the embankment of the Landwehrkanal.

E.R.: Flechtheim was one of those dealers to whose faith and efforts modern art owes many of its earliest commercial successes. But he exhibited, with a few German exceptions, almost exclusively artists of the School of Paris. In selecting you, he seems to have made a kind of prophetic exception to his general policy.

TCHELITCHEW: Flechtheim always spoke French to me, as if I were a Paris artist, though I had never yet been to Paris, and it was he who first advised me to abandon my theatrical work and concentrate on sheer painting. So I moved to Paris in July 1923, when Serge de Diaghilew suggested that I join him there. At first Diaghilew may have been a bit disappointed by the somewhat limited interest that I displayed in working for his ballet company. But he was a man of unusual insight and soon realized that I was not wasting my time, so that he too began to encourage me to concentrate on easel-painting. In fact, I owed Diaghilew many of the contacts that assured me my first Paris successes, including those that facilitated my first Paris exhibition, after only a year of work in the French capital.

E.R.: Was it already a one-man show?

TCHELITCHEW: No, it was a rather modest group-show, and you will probably be surprised to hear that the two other young Russian artists who made their first bow to the Paris public in the same show in the Galerie Henri, on the Rue de Seine, in 1924, were Terechkovitch and Lanskoy. Today, Terechkovitch is popular as a kind of decorative or illustrative and very Russian Post-Impressionism, and Lanskoy is reckoned among the more esoteric Paris Abstract Expressionists, whereas I remain a lone wolf, always exploring new visionary but figurative worlds of my own. It must be difficult to imagine that the three of us could ever have had enough in common to be classed as a group. But we did, and

it would be folly for any one of us to try to deny it or be ashamed of it. We were all three very young and still very Russsian in a kind of folksy way, relying to a great extent on traditional Russian themes, perhaps as an expression of our natural homesickness as exiles. Each one of us, however, was destined to achieve a different kind of adjustment and to steer a different course in art.

E.R.: When did you first begin, in your opinion, to steer this course and to paint in a distinctive style of your own?

TCHELITCHEW: An artist who is destined to develop a distinctive style has the elements of it at his disposal from the very start. I remember, for instance, one of my earliest water-colours, a *Head of Medusa* that I painted, as a boy of ten, in 1908, when I was still at school. In 1946, I was surprised to find myself painting it again, of course with far more skill and in a more complex form, when I was working on *The Lady of Shalott* that now hangs in the Edward James collection. One is haunted by certain ideas, images or patterns which one manages to bring to the surface, at first only by accident, in occasional moments of vision or of luck. Gradually, one learns to exorcize those spells—whether images, ideas or patterns—that seem most meaningful, and gradually too one learns to express or communicate them more immediately or with more skill.

E.R.: I understand what you mean. Take an artist like Rouault, for instance. His early works, when he painted them, looked like somewhat immature or clumsy imitations of the mythological compositions of his master, Gustave Moreau; but today it is easy for us, in the light of Rouault's mature art, to recognize even in these early works the unmistakable characteristics of his personal style and genius.

TCHELITCHEW: Yes, it is almost like the development of a child's handwriting. At first the child may hesitate between various styles of writing and try each in turn with more or less skill; only later can we detect, in these early samples, the personality that finally emerged in the adult's writing.

E.R.: Still, you must feel that your own personality as an artist began to mature more specifically at some given moment in your career.

TCHELITCHEW: That moment probably came towards the end of my first year in Paris, in fact immediately after the exhibition that I shared with Terechkovitch and Lanskoy. It was then that I

met Gertrude Stein and exhibited, in the 1925 Paris Salon d'Automne, my *Basket of Strawberries* which is now in the John Hay Whitney collection in New York. I had begun to emerge from my almost exclusively Russian emigré group of artists and intellectuals. The French Surrealist poet and novelist René Crevel—I had first met him in Berlin through Flechtheim—was soon one of my closest friends. You remember how selflessly generous he could be. He introduced me to all his Paris friends and, by 1926, I was already exhibiting with a more specifically Parisian group of artists, though there were still several Russians among us. This group came later to be known as the Neo-humanists or Neo-romantics and included Christian Bérard, Eugène Berman and his brother Léonid, Paul Strecker, Léon Zack, Hosiasson and a few others whose critical spokesman was our dear friend Waldemar Georges. A few months later, I met Edith Sitwell too, and our friendship has prevented me, through the years, from ever becoming rooted in a kind of Parisian provincialism, like that of many Russian artists who have divested themselves on the Left Bank of their Russian provincialism only to become *paysans de Paris*, real moujiks of the Quinzième arrondissement. Gertrude Stein and Edith Sitwell have taught me to feel at home in England and America too. But my first Paris success was my 1926 Exhibition, before I had become so intimate with either of them.

E.R.: And it was a couple of years after your 1926 show that our paths began to cross. By that time, you were already a celebrity, one of Diaghilew's protégés, whereas Bébé Bérard and the other painters of the Neo-humanist group were still but brilliant beginners. Christian Dior, among our friends, was still far from dreaming of revolutionizing the *haute couture*. He was then but an enthusiastic young salesman in Pierre Colle's Gallery, where you all exhibited. Maurice Sachs, in his diaries, noted one day in 1928 that he had met, at the Galerie des Quatre Chemins, a whole new crowd of bright young men among whom he listed Bérard and Dior. . . .

TCHELITCHEW: If I remember right, he mentioned you too in that list. You make me feel as if I had already been, in 1928, some kind of hoary elder statesman of the art-world, which is all the more depressing now that so many of our friends of those happy years—the writer Maurice Sachs, the painter Paul Strecker and Bérard too—are no longer among us. But this whole busines of

so-called artistic generations is such nonsense. In 1928, when I was already thirty and you and Paul Bowles and Charles Henri Ford and others who came to see me as if I were an established institution were still 'teen-agers, ten or twelve years of difference could mean a lot to us. As the years go by, however, we select our friends on the basis of spiritual affinities and common tastes and experiences rather than of mere age, and now you and I are both equally ancient in the eyes of a new generation of 'teen-agers, and at the same time I can feel much closer to some younger painters, I mean Cremonini or Matta, than to some of those with whom I was exhibiting thirty years ago, such as Lanskoy or Hosiasson.

E.R.: Would this imply that you condemn the whole school of Paris non-formal, Abstract Expressionist or Tachist art in which Lanskoy and Hosiasson have achieved such prominence?

TCHELITCHEW: If I believed in it, I would be producing that kind of art too. But I condemn it as a trend, without wanting to condemn the work of individual non-formal painters. If I now felt that a style like that which Lanskoy has adopted really suited my own purposes too, well, I suppose that Lanskoy and I would still be exhibiting together as we once did in 1924, though each of us would have achieved, within this general language of abstraction, his own particular idiom of speech. The same applies to my relationship to Léon Zack and Hosiasson, who were both members of the same Neo-humanist group as I, around 1928, and have now both become leaders in the Paris non-formal abstract movement. I have never quarrelled with either of them, and I am not prepared to condemn their choice of an abstract style. Still, I view this whole movement as a kind of aberration, a real denial of art or rather of certain human and artistic values that still mean so very much to me. But this is no war of Religions and I myself am by nature no zealot. Though I reject the theology of the new Iconoclastic Movement and refuse ever to identify myself with it, I can still admit that some of its Neo-puritans are honest men and artists of real talent.

E.R.: What do you mean when you refer to human and artistic values?

TCHELITCHEW: I mean that much of the abstract art of recent years seems to me to be too subjective, too solipsistic. I was educated in a liberal milieu of the Russian aristocracy, but was still taught to believe, though without any predjudice, in some tradi-

tional cultural and religious institutions. We had Jewish friends, for instance, but it never occurred to us that they should abandon their Jewish traditions any more than we might suddenly scrap our own Orthodox heritage. We have all inherited from the past much that is still meaningful, whether as members of a nation, a cultural minority, a religious group or even a family. In my case, this heritage included pagan Slavic myths, more or less apocryphal legends of the lives of Russian saints, fairy tales that had reached us from all parts of the world. Later, the heritage of other religions enriched this lore, and a miraculous Hassidic Rabbi now means as much to me as a crucifix does to Chagall. To this vast, complex and often confused or contradictory heritage I owe the strength, the faith and the courage which have allowed me, throughout the ghastly revolutions, massacres and wars that I have survived, to go ahead in my work as a painter, concentrating all the while on a few artistic and emotional problems which I have felt that it was my destiny to formulate or to solve.

E.R.: This very singleness of purpose means, in the long run, that you must exclude from your preoccupations as an artist many subjects and styles for which you were gifted but which seemed to you less urgent or less meaningful.

TCHELITCHEW: Life is too short for most artists to try their hand at everything. We cannot all hope to achieve the universality of Leonardo da Vinci, Dürer or Michelangelo. Many a great artist must remain content with the destiny of a Caravaggio, a Corot or a Manet.

E.R.: Would you be able to define what you believe to be your own destiny or vocation as an artist?

TCHELITCHEW: Yes, though it has been in a way a twofold pursuit. On the one hand, I have always been interested in problems of light and darkness, in the sheer lighting that gives a picture its life and its truly magical quality. As a child, I was spell-bound when I chanced to see a rainbow, or frost on a lighted window in winter, or a sunset or a sunrise, or to peer into a kaleidoscope. Sheer light transforms the atmosphere, the crystals of frost, the clouds in the sky, the pieces of glass in a kaleidoscope, into seemingly quite different materials, lending them a different kind of solidity or mass, often suggesting a kind of volume or perspective that is perhaps illusion but remains nevertheless a real optical phenomenon. I have tried, in my own paintings, to achieve this

kind of mirage by experimenting with light and shadows and, in my latest work, with perspective too. The ambiguity of concave and convex, when one cannot really make up one's mind whether an object is hollow or rounded, seems to me to give a far more convincing impression, both of the concave and of the convex, than an unequivocal style of presentation in which a convex object is obviously and only convex, a concave one obviously and only concave. This has been one of the more important problems that I have tried to solve in my work.

E.R.: But your work has always suggested other preoccupations too, with subject-matter and meaning rather than with the technical devices of draughtsmanship and of lighting, of perspective and *chiaroscuro*. I suppose that this has been the other aspect of your twofold pursuit.

TCHELITCHEW: Such problems of subject-matter have been like obsessions—images that have haunted me sometimes for years before I was at last able to understand what they really mean to me or could be made to mean to others.

E.R.: Like Millet's famous theme of the farm-labourer pushing a wheel-barrow through a half-open door into a shed. All through his life, Millet felt compelled to add this element to other pictures or to draw it again and again, as if it were a childhood memory that haunted him without his ever being able to unravel its true meaning in a single picture which would develop it fully and independently and thus solve it as an emotional problem.

TCHELITCHEW: Yes, that is exactly how an image haunts an artist. It is some emotionally charged element of a dream or a remembered experience, a detail of the world of illusion of the goddess Maya, I mean the realm of natural phenomena which we must accept as real. After years of concentration on such a detail, one may suddenly understand what it means in terms of spiritual or emotional values. Only then can one integrate it properly in the world of one's own art and beliefs which remain, after all, one's only reliable record of the reality of all that one sees and dreams.

E.R.: How does your preoccupation with mathematics fit into this somewhat more psychological philosophy of life and of art?

TCHELITCHEW: When I was nineteen—that was during the Russian Revolution—I suddenly found myself intrigued, perhaps as a consequence of my exposure to certain Cubist, Suprematist

or Constructivist theories of art, by the relationships which exist between geometry and painting. But my father had been a mathematician, and I knew from him that geometry had originally been conceived as a practical science, as a device for measuring fields, determining their boundaries and equitably distributing among the heirs their various shares of an estate. Obviously, art cannot pretend, however geometrical it may be, to serve such practical purposes. It can be, at best, a kind of geometry by analogy, no longer serving practical purposes but offering us the same aesthetic or philosophical satisfactions as geometry. Then I also understood that the famous shortest way from one point to another, I mean the basic straight line of geometry, is after all but an illusion, a very useful convention in a practical science. On the surface of our planet, every line between two points is inevitably curved to some infinitesimal extent, being always but a section of the circumference of a vast circle. I then decided that it was absurd to try to emulate in art the mere conventions of an applied science. I therefore began to try to develop, in my own work, a kind of artistic geometry analogous to the real geometry of the universe, so much more mysterious than that of Euclid. I also began to understand that all the things that we see can, in the last analysis, be reduced to figures or to mathematical formulae, but this does not simplify matters or condemn the universe to a greater monotony. On the contrary, there is as much variety in these mathematical formulae, with their laws and exceptions, as in the immediate appearances of the world which we call real. But an understanding or a mere inkling of this mathematical or geometrical nature of appearances is essential to the artist: it helps him to achieve those proportions, in his work, which give it the appearance of reality. Nor do I mean the kind of tricky but relatively cheap appearance of reality that is known as *trompe-l'œil*. I mean the more intense reality which makes it possible for a still-life painting to appear more real, more charged with meaning and emotion, than a clutter of real fruit and vegetables on a real kitchen table.

E.R.: How did you set about achieving, as an artist, this kind of mathematical imitation?

Tchelitchew: By a system, I suppose, of philosophical trial and error in which there may have been, for all I know, far more foolish error than justifiable and valid experiment. But the proof

of the pudding is in the eating, and my mathematics must be tested by their results in my paintings rather than as pure science or philosophy. Anyhow, I seemed to understand that I must seek, in everything that I wished to paint, some intrinsic number that might at first be but a symbol. A swan floating on a lake, for instance, was like a figure 2, with its curved neck. But the same figure 2 could also mean water, whereas a 3 could look like a little seated man. All this may sound very childish, but I was progressing, like a real primitive, from a mere awareness of the existence and meaning of numbers to something more complex. It was only much later that I began to understand the philosophy of numbers of the Pythagoreans, with their theories of proportions, of the Golden Mean and of the mystical meanings of the basic numbers. Slowly, however, numbers were allowing me to discover a world of sheer harmony and of metamorphosis that reflects the world of appearances or exists parallel to it. I even reduced the date of my own birth to figures which must have some mystical meaning. As I told you earlier, I was born on September 21st according to the new calendar and September 8th according to the older orthodox calendar. Twenty-one is three times three-plus-four, and eight is two multiplied by two multiplied by two. Could this mean that I had been born under two different and conflicting spells? Instead of allowing this problem to worry me, I rejoiced in its very ambiguity. The whole universe began to reveal itself to me as a kind of vast secret ballet, with hidden stage machinery that achieves before our eyes all sorts of metamorphoses and miracles. It is the wonder of it all that matters, at least in art, far more than the prosaic understanding of facts.

E.R.: If I understand you correctly, the artist's quest is destined to remain, in the long run, almost fruitless. Unlike the scientist, he should never come up with some formula, joyously crying: "Eureka! I've found the answer to my question!" Instead, he seeks a reason for his wonder rather than an explanation for natural phenomena.

TCHELITCHEW: If I were a philosopher or a scientist rather than an artist, I might be able to satisfy your curiosity more readily on this subject of ultimate knowledge and ultimate wonder. As it is, my enquiries into the real nature of the outside world, in all these early years of my quest, always brought me abruptly to the same ultimate question: what is there, what exists, at the bottom of

this or that, of this object in itself, this subject in itself? And this question always brought me back, from the object or subject of enquiry, to the ultimate subject of all questioning, to myself and to the world that exists within me, to the structure and mechanism of my own body and mind, of all that seemed to add up to my own individual existence. I was thus led to check on myself all the knowledge that I brought back from my investigations of the outside world, and all these investigations finally seemed to centre on the problem of form in art.

E.R.: Perhaps you could explain more fully what you mean by form. It surely cannot mean to you the same thing as to a painter like Léger, who reduced everything to a sort of massive architecture, or who, like Mondrian, has developed a kind of basic geometry of aesthetics.

TCHELITCHEW: To me, there exists a great difference between a form or a shape as we see it and one that we remember or create in thought. At the same time, I have never believed, as an artist, in the need to break up the forms of the natural world, as certain Cubists have done. This would have been no solution to my problem: a form that one has broken up into its various component parts, if one puts these together again differently, remains only a kind of humpty-dumpty. It is no new form, no more ideal a form than the original three-dimensional one that existed originally in the outside world. To be reborn of its own ashes, a phoenix must first burn of its own fire.

E.R.: But what is this fire? You are speaking, like a prophet, or a sphinx, my dear Pavlik, in riddles. . . .

TCHELITCHEW: And like a prophet, I'm puzzled by my own words, now that you press me for an explanation. It is as if I were painting, not speaking. You somehow manage to bring me to the point where I create without knowing, until the work is actually created, what I'm really trying to create.

E.R.: Shall we leave that aside, for the moment. Or shall we agree that this mysterious fire is the intensity of the artist's emotion and vision, the moment in which, whether as image, idea or memory, the observed object or detail of the outside world transcends itself and becomes part of the artist's own inner world?

TCHELITCHEW: I think you are right—and that moment is a kind of *verklärte Nacht*, a transfigured night, a blinding darkness, a white night that we cannot explain or explore. After that, the

form, in memory or thought, no longer corresponds to the original form that had been seen. My job, in my quest, was to define this imagined or remembered form and to discover how I could transform it again into an object, a work of art that had a life of its own in the outside world, in time and in space. To be able to define such a form, I had to explore it from within and from without, so as to know all its surfaces and properties and understand how they are interrelated. It is like wanting to paint an imaginary moon in an imaginary sky. Well, if that painted moon, which is an object in the real world, must look at all real, then the artist must at least know that his imagined moon is a sphere. Unless he can suggest, in his picture, that it also has another side, however mysterious, his painted moon will look as flat as a silver sixpence. Nor will it help the artist much to break up his moon into component parts and then put it together again as best he can. He might then create, in his painted sky, some strangely bumpy kind of cubist lantern that has nothing at all lunar about it.

E.R.: Would you then agree that the forms which the artist creates as objects must have an integral or organic quality? In fact, that they must come into being as complete as a child at the moment of its birth, though still capable of a growth which will make them more viable as objects, less dependent on whatever interpretations or explanations the artist might still need to provide in order to make them fully self-contained?

TCHELITCHEW: Yes, I think you have formulated my beliefs correctly. There is a moment of birth, and the artist is then like a mother nursing a child till the work of art no longer needs this help and care. . . .

E.R.: Like the mother bear in the old bestiaries, the artist has licked his little bundle of living fur into shape.

TCHELITCHEW: Really, Edouard, we're just a couple of midwives. Here am I recounting my own experiences of child-birth, with you assisting me in my spiritual labours whenever my experience in artistic creation fails me in philosophical or literary self-expression. But you should also allow me to reciprocate by helping you in child-birth as a painter.

E.R.: I may take you up on that, Pavlik. But let's get back to the job of explaining your wonderfully lucid philosophy of art. Now what would be, in your opinion, the basic difference between a real object, as the artist or anyone sees it, and a form created

by the artist, I mean the same kind of object as appearing again in a work of art as another kind of object?

TCHELITCHEW: You mean the difference between the pears that you eat and the pears that Cézanne painted?

E.R.: Yes.

TCHELITCHEW: Well, the pears that you eat are there to be eaten and should have the taste of a good pear. But you would be a fool to peck, like the birds in the story about the Greek painter Apelles, at the pear that Cézanne painted. Cézanne's pear should only suggest to you the texture or the flavour of a real pear; but it should also communicate to you, as directly as a real pear, its natural taste, the flavour of Cézanne's mind, the reality of his life and of the world as he experienced it. If art consisted merely in reproducing the real world as it is, I would long ago have abandoned such a dreary pursuit. It is industry's task to duplicate useful objects and to supply whatever a demand requires. Van Gogh's chair was not painted because there was a shortage of chairs in the house, nor to match an existing chair. To me, as an artist, the world of objects has always been rather disappointing, if considered only from the point of view of supply and demand. Everything in such a world is more or less useful or useless, but I have always been concerned with other values, I mean other criteria. Of course, these values and criteria remain, even today, something mysterious, almost unknown or ineffable.

E.R.: Perhaps because science, for many centuries, has taught us more about the outside world than about man. We know today far more about the atom or the basic living cell than about the soul, and there's more agreement about what constitutes a good internal combustion engine or good plumbing than about what constitutes a great work of art or about the treatment that should be prescribed for a sick soul.

TCHELITCHEW: Yes, man remains the great question mark, often a *terra incognita* even in his own eyes. A man may speak about himself and honestly affirm—as an ancient map says *hic sunt leones*—that such an area of his personality is inhabited by wild beasts or monstrous fish-eating savages; then you go and explore that area, and find no lions and no savages there at all. Man knows very little about his own soul, and even our body often plays mysterious tricks on us, proving to us how little we can know and

control it. Sometimes our body forces us to do things that we do not want to do or that we even condemn; sometimes a man's body seems to be intent on deliberately destroying him, or at least harming him, for instance when a man is responsible, whether consciously or unconsciously, for his own sickness. Man's real nature, his ego, is like a prisoner within an unknown world, a mysterious universe which, in my own case, I call my own body. The soul is a bird that sings in this cage. Long before this image of the caged song-bird had acquired its present meaning in my eyes, I was already using, in my still-life compositions, bird-cages and cage-like structures such as dressmakers' dummies and those wire baskets that French housewives have in their kitchens to shake the water out of a lettuce after washing it. . . .

E.R.: I'm afraid we are now wandering off the main track of our discusion of your art. Let's return to a definition of the work of art as an object.

TCHELITCHEW: Well, a painting is an object, like any other object in the real world, I mean a chair, a table or an apple. But a painting is more like a chair or a table, in that it is man-made, than like an apple, which grows by itself on a tree. At the same time, a painting is a dream or an illusion, in fact a deliberate piece of trickery. It is as if the artist were a magic lantern, capable of projecting onto a wall, as deceptive shadows, the images that haunt his mind. Still, a painting has more objective reality than a magic lantern's projected images. You can remove a painting from the wall and hang it elsewhere, you can even weigh it or buy it or sell it or damage it or alter it or restore it. Besides, it offers you a glimpse of another world and seems to live a life of its own, the inner life of the artist who created it. How can an artist give to his inner life this tangible form in a three-dimensional world where the work of art must be as real as any other object? A three-dimensional object must have an independent entity of its own in time and in space, and thus becomes subject to the same laws as other objects which have not come into being out of the artist's own ideal world. The work of art, as an object, can even age, and one of the artist's most serious technical problems is that of choosing his materials and using them in such a manner as to avoid, as far as possible, the kind of ageing whereby the images that he creates gradually lose their original colours and forms and grow darker or become almost unrecognizable. The

work of art, in becoming a part of the changing world of physical appearances that is governed by time and space, has also accepted, so to speak, the fate of all things that exist in this changing world; it has acquired a kind of mortality of its own.

E.R.: Such considerations must lead you, I suppose, to formulate a philosophy of time and space too.

TCHELITCHEW: A painter is less concerned with time than a poet, a novelist or a musician, and more concerned with space. Within the limited and framed space of a picture, the artist creates a kind of window onto another world, and must be able to suggest in his picture the quality of space and of light and of textural reality of this imagined world. I have already explained to you how I learned, as a child, that my game of wooden blocks could compose six different pictures, each one of them endowed with a different quality of reality. Here I had a series of three-dimensional objects with which I could create six different kinds of reality. Time and space offered me the key to this mystery: by turning the blocks around in space, an operation which required some time too, I could change the reality with which I was playing. Now I sometimes compose paintings which seem to represent different objects or scenes as one contemplates them from different points of view or at different moments. I am primarily concerned, as an artist, with this magic of illusion, because I consider a work of art to be, first and foremost, a masterpiece of magic and illusion, at least in its more technical aspects.

E.R.: Hasn't this made your work of recent years acquire a puzzling ambiguity that certain critics have defined, in the case of the works of Arcimboldo, as anamorphosis, and that Salvador Dali has called paranoid art?

TCHELITCHEW: Technically, I suppose my work uses the same rhetorical devices of ambiguity as Arcimboldo or as Dali. But I prefer to believe that my own ambiguities are less arbitrary or fortuitous than those of Dali. I try on the contrary to stress some mysterious but intrinsic relationship between the various objects that my forms can suggest.

E.R.: A relationship, I suppose, like that between the fruit of which Arcimboldo's portrait of the Emperor Rudolf is composed and the idea of the Emperor as Vertumnus, the Roman god of orchards which ripen when the planet Saturn, under which the Emperor had been born, dominates the astrological horizon.

TCHELITCHEW: Yes, that is the kind of more permanent or sub-
stantial relationship that I try to suggest, rather than the generally
accidental and impermanent relationships suggested by paranoid
hallucinations or optical illusions.

E.R.: This makes your art a white magic that is never con-
cerned, as is black magic, with achieving immediately useful ends.
The world that you create by the magic of art can serve only one
purpose, to educate or initiate by means of a kind of contem-
plation. It is what Dante, in his poetics, has called an anagogical
art.

TCHELITCHEW: Really, all this talk of anamorphosis and of
anagogical art is going to make people believe that I'm a kind of
a Cagliostro and, at the same time, a mystical visionary.

E.R.: And do you think that they would be wrong? After all,
you have defined the task of the artist as that of a demiurge whose
technical magic translates into the terms of reality his own visions
as a more purely contemplative mystic or dreamer.

TCHELITCHEW: But let's return to my various attempts to solve
for myself the problems of art. We can certainly agree that the
artist is not a creator of really living forms: he does not create his
works as an animal does by procreation, nor as a God might create
a living world; nor again as *natura naturans* creates herself out of
herself. When I realized this, I abandoned for a while my investi-
gations of the formal nature of the objects which I depicted in
order to investigate more thoroughly their potential metamor-
phoses or changes in time. And that is why, around 1928 and
1929, I began to depict things as transparent cages, like those
French wire salad-baskets that I mentioned before. I no longer
tried to communicate the real form of the objects which I had in
mind; instead, I began to study objects from the points of view
of their various identities, in the light of the metamorphoses to
which my "magic" or my imagination subjected them. For the
time being, I still limited myself, however, to a three-dimensional
world. It was as if I were trying to invent, in my art, a game
similar to those wooden cubes with which I had played as a child.
But now I wanted the six possible pictures to be somehow con-
nected, not chosen at random like the patriotic battle-scene and
the Gioconda, the Sistine Madonna, the Dutch still-life, the por-
trait of Bubbles and the Watteau love-scene. The coexistence of
these six realities within a single object had once confused and

puzzled me. Now I wanted to suggest, in my pictures, the same kind of coexistence of various surfaces, but with some justifiable relationship between the different realities depicted on these surfaces.

E.R.: But might not this preoccupation also lead you to abandon painting in favour of sculpture? As a sculptor, you would literally be achieving this kind of relationship, creating three-dimensional forms in the round, with their surfaces achieving the synthesis that you require.

TCHELITCHEW: I suppose you are right. But I'm a painter, concerned above all with the magic and the illusions of a two-dimensional art which can only suggest other dimensions. By remaining content with the limitations of painting, I also enjoy a greater freedom in my choice of subject-matter.

E.R.: Yes: it would be difficult to imagine Tintoretto's *Last Judgement*, or Boecklin's *The Isle of the Dead*, or Watteau's *L'Embarquement pour Cythère*, or Rembrandt's *Night Watch* as sculptures. Thirty maids with thirty feather dusters, dusting for half a year, would never keep the cobwebs out of them. One might even say that the sculptors of those weird monuments of the Campo Santo in Genoa were really Pre-Raphaelite painters whose art has succumbed to some mad three-dimensional and colour-destroying cancer.

TCHELITCHEW: That is the painter's problem: to achieve within the two dimensions which assure him of so much freedom, a kind of stereoscopic realism too. But time can also be a valuable tool in achieving this realism. To begin with, the artist can recount, in a single picture, as some Italian primitives have done, several incidents of the same story, with the same characters appearing again and again within the same limited space, as if three or four acts of the same play were being performed simultaneously on one stage by different but identical sets of actors. Or else, the artist can present the same object or person or scene simultaneously from several different points of view, for instance, in three different perspectives, as if seen from above, from below and from a third point facing the picture. A judicious use of these three different perspectives can endow a painted image with a stereoscopic quality of mass, as if one were seeing three different surfaces of it, not so much simultaneously as in the quick succession of one's awareness of each surface in turn. It is then as if the

object were actually moving, revolving on its own horizontal axis, or as if the still spectator were moving around the motionless object.

E.R.: And thus you have reached, in art, what T. S. Eliot has called "the still point of the turning world", in the centre of the wheel where the motion which can be measured so easily on the outer circumference can no longer be measured at all, in fact where motion ceases to be motion and stillness ceases to be stillness.

TCHELITCHEW: It is also the moment of pause between two states of being, the interval in a metamorphosis when the prince who is turned into a toad is no longer a prince and not yet a toad. In my composition *Hide and Seek*, now in the New York Museum of Modern Art, I have tried to determine the rhythm of recurrence of such intervals in the act of a reality which is a kind of quick-change artist. I believe I have achieved in *Hide and Seek* a continuity in the discontinuity of metamorphosis and change. Such a continuity is to be sought, above all, in the spectator's interest, in a human element of curiosity roused by the mystery of the composition which derives much of its life from this human effort to understand and solve it as a riddle; and the human element, the curiosity, the effort and pleasure of understanding, add the life-breath of time to a composition that is basically organized only in two dimensions of space.

E.R.: Pavlik, I think you have just given me the most ingenious interpretation of the magic of a work of art that I've ever heard from the lips of an artist.

TCHELITCHEW: Perhaps it is too ingenious. Perhaps I was trying, in *Hide and Seek*, to achieve a kind of magic that relies on too much abracadabra, too much trickery. After painting it, I felt compelled to concentrate on much simpler themes, in fact on the human figure and the human head as standards or central elements of all art. I was no longer interested in story-telling, as in *Hide and Seek*, but in investigating and explaining the nature of the hero of the story. This was the most difficult phase of my evolution as an artist, a phase that I have just completed after many years of study and of meditation.

E.R.: It has also been a period in which you have isolated yourself more and more as an artist from all the schools of contemporary art in which so many of your friends are active as

leaders. No longer at all neo-humanist or neo-romantic, you have transcended the dream-anecdotes of Surrealism and all the learned or esoteric paraphernalia of post-surrealist mannerism as we discover it in the work of Dali or of Leonor Fini. On the other hand, you have also transcended every kind of expressionism, whether figurative or abstract, and all the merely graphic or geometric preoccupations of pure abstraction. Some of your recent works even suggest to me that you may have reached a point where art ceases to serve primarily its own traditional purposes, I mean the pursuit of the Beautiful, and concerns itself almost as much with the purposes of Science and Religion, I mean the pursuit of the True and the Good. You appear to be carrying out some vast project of anatomical, biological or astronomical research, investigating the nature and properties of beings that are human only by analogy. These human beings may be gods, angels, demons or constellations endowed with a human form, but at the same time with an organized collective life similar to that of certain colonies of unicellular beings such as we find in the lower orders of biology.

TCHELITCHEW: You have defined these beings correctly. They are allegories of human nature, which I see as something situated half-way between the infinitely small of these lower forms of biological life and the infinitely great of the constellations. At either extreme, the individual star and the individual unicellular being also leads an autonomous life of its own, being self-sufficient or complete in itself. But man remains, as a being, a single unit that cannot be broken up into component parts which might survive independently. At the same time, man remains the point where all knowledge converges, the measure of the universe as he conceives and understands it. That is why I now seek to represent man in his relationship to the whole of the created world, which forms part of his own inner landscape in so far as he is aware of its existence. I therefore began by trying to paint allegories of this inner landscape, depicting man's body as if it were a microcosm, reflecting in its nature and properties the macrocosm of the universe and, at the same time, as if it were a macrocosm reflecting in its nature and properties the microcosm of the infinitely small world of biology. In some of my pictures, the five senses are symbolically identified with the five basic elements. The nerves of the body, painted in a vivid yellow that exhales a halo of magenta red, represent fire or the ambiguity of all that burns,

whether hot or cold. The veins and arteries are blue and represent the air and sky, through which flows the life-blood of light; for the lymph, I chose a green that also suggests water; for the bones, an ochre yellow that suggests rocks and earth; for the soft tissues of the body, for the flesh that is like the empty spaces beneath the stars, I chose white to symbolize the ether.

E.R.: Actually, this is a kind of cabbalistic physiology, and some of your ideas were not alien to such medical philosophers as Paracelsus, in the Middle Ages.

TCHELITCHEW: But I was not seeking a scientific explanation, nor trying to discover any principles of therapy. As an artist, I am concerned only with meanings and values, with elucidating and illustrating beliefs that haunt my own mind and the minds of others, whether factually true or false. Their existence as latent beliefs or superstitions makes it necessary for us to try to know and understand them. As I progressed in my investigations of these beliefs, I seemed to find the universe less and less mysterious and opaque, increasingly luminous and translucid. I hoped, in this manner, to discover the answer to the ultimate question, the *summa sapientiae*, the sum of all wisdom rather than of all knowledge. But the confused tangle of beliefs within me, this jungle of contradictions and doubts, seemed on the other hand to become increasingly opaque. It became clear to me that my ideas were leading me into complete chaos. I had to find another method of approach. So I abandoned my considerations of matter, I mean this transcendental biology, and returned to a study of forms, I mean to a kind of dynamic geometry.

E.R.: This is represented in the very latest phase of your art, in those wonderful linear bodies that you have designed in the last couple of years in Rome, as opposed to the anatomical studies which you painted during your last years in America.

TCHELITCHEW: Yes. In these last works, I am no longer concerned with the material nature of man or of my universe, with the chemical or biological composition of all that I imagine or depict, but with the laws that govern these beings as sheer structures. It is as if I were observing a crystallized world, investigating how it comes into being, how and why and where it refracts and reflects light, how it can magnify or reduce things in its transparency. A single spiral line proved to be the most adequate tool in this research: such a line, seeming to have no beginning and no

end, is already a symbol of eternity and infinity, undying and always live. I then remembered the bird-cages and salad-baskets of my earlier still-life compositions and began to design human heads that were constructed like cages or like transparent vases, but felt by the artist and the onlooker rather than viewed, though both from within and from without, so as to convey to the onlooker an impression of being contained within these forms as well as of being kept out by them. A face thus became a surface that is concave as well as convex as if we could also see ourselves from within, not only from without as when we contemplate our reflection in a mirror. Finally, I achieved a true ambiguity in the trompe-l'œil of my human forms, a kind of reversible quality in the masses that I created. As one contemplates them, one follows a movement of doubt, seeing them convex, then concave, and this very movement of the mind endows the forms with a semblance of life. Such forms are generally suggested against a dark background, in linear arrangements of colours that suggest light. The space of the picture is stated in terms of a perspective which creates a cube, and the picture itself has the quality of a mirror reflecting a real world while endowing it at the same time with an unreality, with something dreamlike or visionary, as in those fairy-tales where a magic mirror reveals an incident of the past or of the future, or something that is happening elsewhere or that might conceivably happen but is still only hoped or feared. I believe that these recent works of mine are founded on two different principles of movement. Firstly, the whole space of the picture suggests the infinite revolving movement of the universe, that of the wheel within a wheel which the prophet Ezekiel saw in his vision. Secondly, the movement of the object depicted is that of something that moves forward and recedes too within the picture, as one hesitates to decide whether it is concave or convex. But the centre of the revolving universe and the vanishing-point of this ambiguous perspective are one and the same point, which seems to generate both movements, palpitating with the life of the whole design. I have attained, at long last, what I wanted, and in a basic form, I mean in the human figure. Now I should set about constructing according to the same principles a whole world, until my art becomes a true speculum naturale, reflecting in its forms the infinite variety of nature's forms.

E.R.: But would a man's life-span suffice for such a task?

TCHELITCHEW: Is that sufficient reason for an artist to lose his faith and his courage? Does Arachne, the nature-goddess in whose infinite spider-web all creation is contained, abandon her ceaseless weaving now that man has invented the atom-bomb? The task of creation is always subject to interruption. . . .

*Pavel Tchelitchew was not destined to progress beyond the threshold of this infinite world which he still proposed to create. Perhaps such a task is in any case better suited to an artist who has been freed from the shackles of time and who can dispose of all eternity in order to create and recreate a world of his own. I can imagine him now, in Elysian fields rather than in a Christian paradise, studiously following his plan, blessed at last with the ataraxia, the liberation from all haste, disturbance and anguish, which was the ideal of all the sages of antiquity.*

*Many months after Tchelitchew's death, as I drafted the present record of his notes, and of our conversations and correspondence about the problems that he raised, I began to understand the philosophical or mystical meaning of the works which he had produced during the last period of his creative life. By concentrating on a very limited number of themes, almost exclusively on the human head and the human figure, he had achieved great variety within a very narrow scope. A few months before our last meeting, I had visited, in the monasteries of Mount Athos, the Greek Orthodox monks who are the last heirs to the tradition of the Mystics who once painted Byzantine ikons which were often believed to have dropped from Heaven, not seeming to have been created by human hands. The monks of Byzantium had endowed their work with an intensely visionary or hieratic quality by painting again and again the same ikon, each time with a slight but significant difference which seems to regenerate the whole picture, saving it from the automatism of a merely repetitive art. This art, peculiar in the Western world to the Greek Orthodox Church in its heyday, had much in common, in its disciplines and intensity, if not in its techniques, with that of the Zen mystics of Japan. In all of contemporary Western art, I can think of only two painters who have followed this almost forgotten Byzantine tradition, whether intentionally or by accident. Both of them had been brought up as believers in the Russian Orthodox Church: Alexis de Jawlensky, who spent the last years of his life*

*painting an apparently never-ending series of nearly abstract Veronica-images or heads of Christ, and Pavel Tchelitchew, whose faith was more humanistic than religious and who concentrated all his thought and emotion on the one theme of the appearance of man.*

*In repeating again and again the same picture, an artist can produce variations on one theme as significant as those of a Chinese calligrapher whose various renderings of the same ideogram express each time a different mood, a different degree of emotional, intellectual or spiritual intensity. But Tchelitchew's last interpretations of the human figure as a kind of constellation revolving in an infinite space were also transfigured versions of the lightning sketches which I had once seen him paint quite naturalistically in water-colour, nearly thirty years earlier, while we had spent an afternoon together in the Paris Cirque Medrano and watched the great tight-rope dancer Con Colleano rehearsing his amazing act. For all its diversity, Tchelitchew's art, if only as a constant pursuit of an impossible ideal, displays a basic unity, though this unity cannot always be detected at once and remains, without his explanations, almost beyond the scope of the understanding of most art-lovers.*

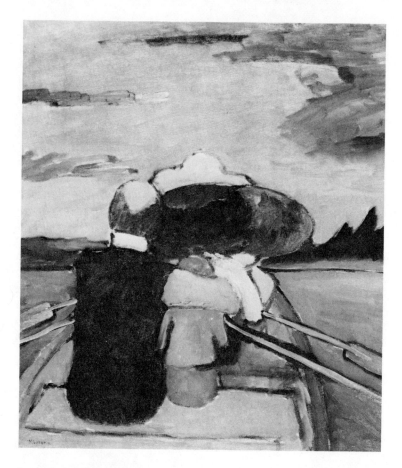

GABRIÈLE MÜNTER
*Kahnfahrt*

# Gabrièle Münter

*Munich celebrated on a grand scale, in 1958, the presumed eight-hundredth anniversary of its somewhat legendary foundation. Among other attractions planned to draw every kind of tourist to the capital of the former Kingdom of Bavaria, an exhibition of modern art, in the* Hause der Kunst, *set out to stress the city's contributions, as an international centre, to the great movement which began about a hundred years ago with the Realism of Gustave Courbet and the French painters of Barbizon, and has now reached, in an unprecedented swing of the pendulum of taste, the opposite extreme of abstract, non-objective or non-formal art.*

*Accustomed to the values and tastes that are currently respected by most museum-directors, critics, historians, dealers and collectors throughout the Western world, many a visitor from abroad may have made, in this Munich exhibition entitled* Aufbruch zur Modern Kunst, *some unexpected discoveries. For instance, that Gustave Courbet, when he came to Munich in 1869 as one of the foreign guests of honour of the city's First International Art Exhibition, had immediately found, in the German painter Wilhelm Leibl's circle of associates and pupils, a school of kindred spirits who set themselves the same ideals and aims as he and his French followers. Courbet's own exhibits,* Les casseurs de pierres *and* L'halali du cerf par temps de neige, *indeed roused less antagonism in Munich than his Realist works currently did in Paris, where such academic latter-day Romantics as Winterhalter and Jean-Léon Gérome were the only artists to receive official recognition. After being awarded, together with Camille Corot, a decoration offered by the Bavarian State, Courbet wrote a number of surprisingly ungrammatical if not altogether illiterate letters to his Paris friend Castagnary, to whom he pointed out that the Bavarian*

*monarchy apparently granted to a jury of artists more freedom than "governmental action" could tolerate in Napoleon the Third's police-state.*

*Nor had Courbet's friend Wilhelm Leibl, with Wilhelm Trübner, Hans Thomas, Karl Schuch and the other disciples whom he had attracted, established in Munich but a group of isolated or freakish local geniuses. These artists had found their way to the Bavarian capital from almost every region of Germany and included in their ranks even a couple of gifted young natives of distant America, the painters Frank Duveneck, from Kentucky, and William Merrit Chase, from Indiana. For all their devotion to the beauties of the South Bavarian Alpine landscape and their interest in depicting local peasant types, the Munich Realists remained indeed an international rather than a regional school of art, and their contacts with other schools of the same general persuasion ranged from Leibl's personal friendship with Courbet to an awareness and an understanding, among his followers, of the aims of the French Barbizon painters, of the Tuscan Macchiaioli such as Fattori, Lega, D'Ancona and da Tivoli, of the Milanese group gathered round Mosé Bianchi, and of the Dutch painters of The Hague, such as Jan Hendrik Weissenbruch, who were later destined to number Vincent Van Gogh among their disciples. In Munich, in Barbizon, in Holland and in Northern Italy, four different schools of Realist painters were then practising the same kind of "plein-air" painting as the French Impressionists are often believed to have initiated. In the works of all these Realists, one can detect the same interest in sheer painting as opposed to academic smoothness, and in everyday life as opposed to the "tableau-vivant" historical reconstructions of the later Romantics, in fact in those qualities of painting that French critics now call "matière" and "intimisme". Whatever their national origin, the Realists were guided by a passionate reverence for the truthfulness and sobriety of such old masters as Rembrandt and Franz Hals in Holland and Velasquez and Zurbaran in Spain. Many a portrait painted in Munich by Leibl is thus of the same rare quality as those that Monet was then beginning to paint in Paris, and many a landscape by Hans Thomas or a still-life by Karl Schuch has the same luscious sensuality of colour and of texture as some of the less rhetorical masterpieces of Courbet.*

*Munich continued moreover to be one of Western Europe's*

*most creative art-centres for a good half-century. After being the home of the German Realists, it saw the emergence of the so-called "New Dachau School" of contemporaries of the later Paris Impressionists. The importance of their leading spirit, the painter Adolf Hoelzel, as one of the first practitioners of abstract art, if not the actual source of some of Kandinsky's theories, has begun to be appreciated, even in Germany, only in recent years. The 1958 Munich exhibition very judiciously stressed Hoelzel's significance as a link between the earlier Realists and some later Schools that became increasingly idealist or abstract in their styles. In addition, it devoted due attention to two other remarkable movements which had flourished in and around Munich between the turn of the century and the collapse of the Weimar Republic: the Munich School of Jugendstil, which overshadowed for a while the Viennese Sezession as well as the Art Nouveau of Paris, and the Blue Rider School which, in the works of Klee, Kandinsky, Jawlensky and a few of their friends, has now influenced the art of a whole generation of younger painters in France, in England, in the United States and even in distant Japan.*

*The Munich retrospective exhibition of works of the Blue Rider School may have been disappointing in that it included few of the more famous masterpieces of Klee, Kandinsky, Jawlensky, August Macke or Franz Marc, so many of these being scattered among museums and private collections which could not easily be persuaded to part with them for a period of several months. But it made up for this deficiency by including, in addition to important works by these artists, loaned mainly by local collections, an unusually representative and almost unprecedented choice of works of the many other painters who constituted the rank and file of the Blue Rider group. The biographical notes, in the catalogue, were particularly instructive; they revealed, for instance, that the Blue Rider School shares, with that of the Paris Cubists, the honour of having been the first truly international school of modern art, drawing almost as many of its members from Russia as from Germany and including several artists who had been born in America or had at least spent some of the formative years of their youth in the United States. Besides, the Blue Rider painters maintained close contact with the more experimental Paris Cubists, especially with Robert Delaunay, who for a while had*

*tried to establish a separate school, that of the short-lived Orphists.*

The Russians among the Blue Rider artists included Kandinsky, Jawlensky, the latter's unduly neglected friend Marianne de Werefkin, the ill-starred Russian-Jewish sculptor Moishe Kogan, destined later to be deported by the Nazis from Paris and to die in an Eastern European extermination camp, the painter David Burliuk and his brother Wladimir, the latter remembered mainly as a Russian Dadaist poet, and the painter Wladimir de Bechtejew. Both David Burliuk and Bechtejew subsequently emigrated to the United States, where their former association with so epoch-making a German group of artists failed, for a long time, to earn them the kind of recognition that they deserved. Though the American painter Lyonel Feininger became an associate of Kandinsky only later, when he joined him on the faculty of the Weimar Bauhaus and, together with Klee and Jawlensky too, exhibited with him in a group called The Blue Four, there had already been some American elements, before 1914, in the Blue Rider group: the German painter Adolf Erbslöh, one of the more strictly Fauvist artists of the group, was born in New York, the American painter Albert Bloch was a close friend of Kandinsky, and Gabrièle Münter, Kandinsky's companion, though born in Germany, was the daughter of German-American parents and had spent part of her adolescence in the United States. Gabrièle Münter shared moreover the honour, with Marianne de Werefkin, Erma Barrera-Bossi and Elisabeth Eppstein, of being a rare pioneer, in Germany, as a woman among the modernists. Berthe Morisot and Mary Cassatt had already attracted attention among the Paris Impressionists, and Nathalie Gontcharowa was well known in the avant-garde of St Petersburg as one of the founders of the Rayonnist movement, but women were rarely encouraged in the German art-world, where the Dresden Fauvist group known as Die Brücke, for instance, included no women at all, and Paula Becker-Moderssohn, the mainstay of the Worpswede artist-colony, was long looked upon as a kind of freak. Even in Paris, Marie Laurencin and Maria Blanchard, in the Cubist Bohemia of Montmartre, were often hailed, by the poet Apollinaire and his friends, as Muses rather than as colleagues and equals of Picasso, Braque and other males in their group.

In 1958, when the city of Munich decided to organize so

*important a restrospective of the art of the Blue Rider, Gabrièle
Münter, already over eighty years of age, was the only surviving
member who still resided in Germany. In America, David Burliuk,
Wladimir de Betchtejew and Albert Bloch were still alive; in
Austria, just across the border from the Bavarian frontier-city of
Passau, Alfred Kubin was also living, but in a state of health that
would not permit him to face the strain and excitement of the
interview which I had requested. To my telegrams pressing for
an appointment, his companion had replied laconically: "Arterio-
sclerosis of brain makes Kubin interview pointless." With the as-
sistance of Dr Hans-Konrad Röthel, curator of Munich's Lenbach-
Haus Museum which houses the long-forgotten collection of early
Kandinsky paintings that Gabrièle Münter had so dramatically
salvaged from oblivion and given to the city of Munich two years
earlier, I was then able to visit her in her home in Murnau, a
delightfully situated small town in the lake district of Southern
Bavaria.*

*I arrived at Murnau in the late afternoon, and was immediately
struck by the colours of the landscape: the unmodified bright
green of the pastures, the equally flat blue tones of the distant
mountains, all justified the technique of those early landscapes of
Kandinsky, Jawlensky and Franz Marc in which areas of con-
trasting colours, without any glazes or effects of brush-work, sug-
gest receding planes rather than perspectives. At the inn where I
chose to stay, I enquired that evening where Gabrièle Münter's
house might be; I was surprised to discover that it is still known
locally as the House of the Russians, because she had lived there,
before 1914, with Kandinsky, Jawlensky and Marianne de Weref-
kin.*

*In spite of her great age and her physical disabilities, Gabrièle
Münter had almost a youthful manner, that of a woman accus-
tomed to great independence, when she received me in her study
the next morning. In some ways, she reminded me of those spry
pioneer grandmothers whom I had often met in the Western states
of America twenty years earlier, rare survivors, even then, of the
era of the covered wagon. This impression was confirmed when
Gabrièle Münter began to question me about the United States,
to tell me of her own memories of life in Arkansas and in the
Texas Panhandle between 1898 and 1900, and to show me some
of the pencil-sketches which she had brought back from this girl-*

*hood visit to her American cousins. Though she no longer speaks much English, she still understands the language and occasionally uses, when speaking to an American, American words, which she pronounces without a foreign acent*

"I still have many cousins over there," *she explained to me, using the American word "cousins", as she spoke German, rather than the German word "Vettern".* "In those days," *she went on,* "St Louis was to a great extent a German city, and we spoke German there most of the time. I also visited New York briefly, and met many Germans and German-Americans there. In Moorefield, Arkansas, and in Plainview, Texas, of course, it was different: we associated with American-born families and always spoke English, except at home."

E.R.: If I understand correctly, both your parents were German-Americans.

MÜNTER: Not exactly. They had both been born in Germany, but had emigrated very young to the United States, where they subsequently met and married. My father came from Westphalia, where most of his relatives were in the civil service or the Protestant clergy. He must have been a very fiery and idealistic young man, an enthusiastic believer in the liberal ideas of 1848. Shortly before the March Revolution of that year, he got into trouble for his political ideas and activities and, to avoid the scandal of his arrest and imprisonment, was packed off to America by my grandfather. He arrived there with very little money and started off as a huckster, but soon made good and met my mother and married. During the Civil War, the young couple then found business increasingly difficult in the Southern States, where they had settled. As traders, the German immigrants were not committed to the plantation-economy. Most of them, besides, had come to the States as political refugees and believers in the Rights of Man; they were often suspected by their neighbours of sympathizing with the Northern Abolitionists. So my father decided, in 1864, to bring his family back to Europe, where he settled in Berlin. I was born there in 1877, as the youngest of his children.

E.R.: How did you come to make your trip to America in 1898? Surely such an expedition, for so young a girl, was very unusual in those days.

MÜNTER: Well, my father had died in 1886, then my mother too

in 1898, and our relatives thought it might be good for my older sister and me to spend a couple of years with our American cousins.

E.R.: Had you studied art at all before going to America?

MÜNTER: I had taken some drawing-lessons, as many girls did in those days, but I had also attended an art-class for a couple of months in Düsseldorf, which still had a great reputation as an art-centre. I found the teaching of its Academy, however, very un-inspiring, still dominated by the ideas and tastes of the later Romantics; besides, nobody there seemed to take seriously the artistic ambitions of a mere girl.

E.R.: Did your family encourage you much as an artist?

MÜNTER: No. The cultural interests of my relatives were rather in the fields of theology, philosophy, literature and music than in that of art. When I came to the United States, I filled my sketch-books with drawings, very much as any educated girl of my generation might have kept a diary. But nobody attached any more importance to my drawings than they might have done to a diary.

E.R.: Still, many a future writer's career has begun with the keeping of such a diary.

MÜNTER: In those days educated men and women nearly all kept diaries or sketched what they saw when they travelled. It was not like today, when every traveller has a camera, even if he has no ambition of ever achieving the skill and the status of a professional photographer. My American sketches were private notations of visual experiences which I wanted to fix on paper as a personal memento.

E.R.: But this little sketch of Plainview, Texas, with its farm-houses and artesian wells outlined against the sky, is now an interesting document, if only from the point of view of cultural history. I'm sure that an American museum in the South-West would be proud to own it.

*Among the other sketches of America that Gabrièle Münter was showing me as we chatted, I noted a coloured-crayon draw-ing of a woodland scene, a souvenir of Moorefield, Arkansas, and a charming sketch of an intense and very young girl, seated awk-wardly and revealing a surprising expanse of lanky legs, like those of a filly. This last drawing was entitled* Listen to the grapho-

phone, *reminding me of the days when Americans were still unsure of the names under which some strange modern inventions would finally become popularly known to us.*

E.R.: Would you be offended if I say that these drawings seem to me to be very much in the tradition of those of the German Romantics? They express the same respect for nature, the same concern with sheer draughtsmanship, with line and outline, and the same *Innigkeit*, I mean a kind of spiritual or psychological intensity or empathy.

MÜNTER: I'm not at all offended. As a child, I devoted much of my leisure to drawing sketches of relatives and friends, familiar sights and scenes, a view that suddenly moved me or appealed to me. I always concentrated on depicting nature as I saw it or felt it, in terms of line, and on obtaining a kind of psychological likeness which would convey the personality of my model or the mood of the moment. In this girl, for instance, I tried to convey the unconscious boyishness of one of my young cousins, who spent so much of her time with her brothers and with other boys that she was almost unaware of being a girl. You can see that in her pose and her expression, I hope. There is nothing defiant or hoydenish in her boyishness, and her attitude and pose are not at all immodest, just naturally boyish.

*We were interrupted, at this point, by Gabrièle Münter's houseguest, a somewhat younger but already elderly Danish woman who entered the room bearing a tray with a bottle of wine, three glasses and some biscuits. As we partook of this refreshment, the artist asked her friend to show me, on an easel that was produced from a corner of the room, some of her paintings. These included a number of earlier works, strikingly Fauvist in feeling but composed in a recognizably German rather than French idiom. There were also many more recent flower-studies, painted in oil on paper, all surprisingly youthful in their freshness of vision, their brilliance of colour, their sureness of design. I was reminded, as I saw them exhibited here in quick succession, of a similar experience that I had known a year earlier in Paris, when I had visited Nathalie Gontcharowa in the apartment that she shares, in the Rue Jacques Callot, with Michel Larionow. But Gontcharowa and Larionow had lived for forty years in the increasingly catastrophic disorder of their cavelike dwelling; they seem*

*never to have intended, as Russian exiles, to establish themselves
there on a permanent basis and to have only allowed themselves
to be slowly submerged under an accumulation of old news-
papers, art-magazines and exhibition-catalogues proliferating
around them as the years went by. Finally, when I visited them
in Paris, they were like nomads who had been forced to become
sedentary because they had accumulated in their camp too many
possessions to be able to move any longer. They wandered around
laboriously among stacks of paper and of paintings that littered
the whole floor, leaving them almost no available space for living
and for working.*

*Not that any such chaos was apparent in this house in Murnau
where Gabrièle Münter had lived intermittently since 1909. On
the contrary, everything here was neat and tidy and could easily
be found, if needed. But this elderly German artist seemed to me
to share with Gontcharowa a curiously eternal youth, revealed all
the more touchingly when Gontcharowa had actually blushed as
I remarked that the colour-harmonies of her most recent abstract
compositions, painted to a great extent in a Rayonnist idiom in
various shades of pink and of pale silvery grey, were those of a
"toute jeune fille".*

*Again and again, in the course of the two clear autumn morn-
ings that I spent in Murnau with Gabrièle Münter, I was similarly
surprised by some impetuously youthful expression or intonation
in her speech, though she received me each time upstairs, in a
room where she now spent most of her time resting rather than
working. In the last couple of years, she had experienced, as she
admitted to me, great difficulty in moving around. An infirmity
of the semicircular canals made her lose her sense of equilibrium
very easily, but her eyesight was still excellent and her hand firm
enough to allow her to draw and to paint. Among her recent
works, there were again a few abstractions in which she reverted
to her experimental style of 1912, much as Gontcharowa too had
done in the last few years. Yet Gabrièle Münter admitted to me
that she had always expressed herself more spontaneously in
figurative compositions. Only between 1912 and 1914, when she
had been working in close association with Kandinsky, and again
in the last few years, had she felt the urge to paint abstract "im-
provisations". As I spoke to her, I could contemplate, through the
window that I faced beyond her, the Murnau landscape that she*

*and Kandinsky and Jawlensky had so often painted. Again and again, I was able to observe that the bright flat tones of her landscapes were truly those of the countryside that she had faced.*

E.R.: When did you first come to Murnau with Kandinsky?

MÜNTER: We came here together, on a brief visit, for the first time, in 1908, in June, and we were both delighted with the town and its surroundings. In August, we then returned to Murnau for two months, with Jawlensky and Marianne de Werefkin. The following year, we heard that this house was for sale. Kandinsky fell in love with it and said: "You must buy it for our old age". So I bought it and we then made it our home until he returned to Russia in 1914. Jawlensky and Marianne used to stay with us here, and the people of Murnau called it "The House of the Russians", though I actually owned it. I'm glad I bought the house, even if it is a bit big for me now that I am alone. But I only occupy these rooms upstairs. During the great housing shortage of the years of the war and its immediate aftermath, the lower part of the house was requisitioned and I had to make room there for tenants. That was when I had to store away all my early works and those of Kandinsky that I am reported to have "rediscovered" a couple of years ago. Of course, I knew that I had them, but I always seemed to postpone taking them out of storage. Now I would prefer to live downstairs, but it is difficult for me to evict my tenants. If I wanted to work more, I would have very little space up here.

E.R.: When did you begin to work with Kandinsky?

MÜNTER: I met him shortly after my return to Germany from the United States. At first, I lived for a while in Bonn, where my sister married a professor. A year later, in 1901, I decided to move to Munich, but still found very little encouragement as an artist. German painters refused to believe that a woman could have real talent, and I was even denied access, as a student, to the Munich Academy. In those days, women could study art, in Munich, only privately or in the studios of the *Künstlerinnenverein*, the association of professional women artists. It is significant that the first Munich artist who took the trouble to encourage me was Kandinsky, himself no German but a recent arrival from Russia.

E.R.: Was Kandinsky still considered an outsider by most of the Munich artists?

MÜNTER: Not exactly. He had come from Russia in 1896 and had studied at first, with Paul Klee and with the young German painter Purrmann, under Franz von Stuck, who was then at the height of his fame. Kandinsky and Klee both had a high opinion of Stuck as a teacher and already had many friends among German artists of the Schwabing *avant-garde*.

E.R.: Purrmann mentions their admiration for Stuck in some memoirs that he published a couple of years ago in a German magazine. It is now difficult for foreigners, who lack a knowledge of the Munich art-world of 1900, to realize that Klee and Kandinsky should both have been pupils of Stuck. But it is no more surprising than that Matisse and Rouault should have been pupils of Gustave Moreau. Both as a painter and as a teacher, Stuck had much in common with Moreau. In the *Aufbruch zur modernen Kunst* exhibition that I visited yesterday in Munich, there were several examples of Kandinsky's early *Jugendstil* style. But they suggest an affinity with Léon Bakst rather than with Stuck. Did Kandinsky ever mention Bakst to you as having been, in Russia, one of his masters?

MÜNTER: He rarely spoke of his earlier Russian associations. It was as if he wanted to forget Russia and to make a fresh start in Munich, perhaps too because he had been unhappily married in Russia and had left his wife there. Still, he did mention Bakst from time to time, especially in his arguments with Jawlensky and Marianne de Werefkin. But Kandinsky never, as far as I can remember, said he had been a pupil of Bakst.

E.R.: I feel that he must have known much of Bakst's work. In Kandinsky's earlier compositions on traditional Russian fairy-tale themes, there is a quality of folkloristic decorative art that reminds me often of certain works of Bakst. Even in such large compositions as *Die Bunte Welt*, which Kandinsky painted as late as 1907, I can still detect a specifically Russian style of *Jugendstil* that he shares only with Bakst and Roehrich, far more theatrical than that of Munich. To me, *Die Bunte Welt* is typical of the Russian *Art Nouveau* of the St Petersburg *Mir Iskustvo* or "World of Art" group: the canvas is transformed into a kind of stage-setting, with the figures disposed according to the choreographic principles of a ballet, whereas the Munich *Jugendstil* artists tended more generally to create a two-dimensional world, treating even their canvases as if they were designs for posters or book-illustrations.

MÜNTER: You seem to attach considerable importance to this *Jugendstil* element in Kandinsky's early work.

E.R.: I feel that it is the element in his work that has been least studied in recent years, and I believe that we may yet discover the sources of his early abstract style in some of the theories of the *Jugendstil* artists whom he had known in St Petersburg before 1896 or in Munich between 1896 and 1910. After all, he had painted quite naturalistically at first.

MÜNTER: As a student of Stuck, he still continued for a while to paint quite naturalistically. He admitted to me that he had always loved colour, even as a child, far more than subject-matter. Form and colour were his main interests. To me, he often remarked that "objects disturb me". But he could paint portraits too.

E.R.: I have seen several of his portraits. In the Munich Lenbach-Haus, I saw for instance his little 1903 portrait of you, the *Gabrièle Münter painting* that is executed in a very post-impressionistic style of *plein-air* painting. But I have also seen in New York a portrait of a woman that he painted, in 1902, if I remember right, in an entirely different style of studio-painting, with an elegant bravura similar to that of fashionable artists such as Hugo von Habermann or Boldini.

MÜNTER: Kandinsky pretended that he had painted only two portraits, one of his father, in Russia, and the one of me that you saw in Munich. But I have seen other portraits that he had painted before 1905.

E.R.: When did he paint his first abstract or non-objective compositions?

MÜNTER: Between 1908 and 1910. He had already expressed a great interest in abstraction when we had visited Tunisia together in 1904. The Moslem interdiction of representational painting seemed to stir his imagination and that was when I first heard him say that objects disturbed him.

E.R.: Had Kandinsky associated in Munich with the abstract *Jugendstil* artists Hans Schmithals, Hermann Obrist and August and Fritz Endell? They had begun to create, as early as 1898, abstract designs that were inspired mainly by natural forms, those of plant-life, for instance.

MÜNTER: Kandinsky knew Obrist well and appreciated his ideas. At one time, we were often invited by Obrist and his family and we thus had occasion to see several of his abstract designs and

sculptures. But they were always more decorative, in their inten-
tion, than Kandinsky's abstractions. Besides, Kandinsky never
allowed himself, after 1902, to be influenced to any appreciable
extent by the styles of other artists. Between 1900 and 1910, he
began to rely increasingly on his own theories of art, which many
of his friends could understand only with great difficulty.

E.R.: Did Jawlensky and Klee share his ideas?

MÜNTER: They were constantly arguing about art and each of
them, at first, had his own ideas and his own style. Jawlensky was
far less intellectual or intelligent than Kandinsky or Klee and was
often frankly puzzled by their theories. My 1908 portrait entitled
Zuhören (Listening) actually represents Jawlensky, with an ex-
pression of puzzled astonishment on his chubby face, listening to
Kandinsky's new theories of art. Jawlensky had many friends in
Paris and had spent, with Marianne de Werefkin, almost more
time in France than in Munich. He was a great admirer of
Matisse, of Van Gogh and especially of Gauguin. For a while,
Jawlensky always kept his studio very dark when he painted; this
was a habit that he had acquired in France. Like many great
painters of the School of Paris, he was a consummate craftsman
and artist rather than a theorist.

E.R.: One of the characteristics of your own painting as well as
of the art of Kandinsky and Jawlensky, in their Murnau period
of 1909, is the use of flat areas of bright colour, sometimes placed
in contrasting juxtaposition, sometimes set like pieces of coloured
glass in a stained-glass window, in heavy darker outlines. Would
this technique have been derived from Gauguin and some of his
pupils in Pont-Aven?

MÜNTER: Not consciously. As far as I am concerned, I learned
this technique from Kandinsky and, at the same time, from the
glass-paintings of the Bavarian peasants of the Murnau area, who
had painted for centuries in this style.

E.R.: As a matter of fact, other German painters were also using
this technique around 1900, I mean Adolf Hoelzel in Dachau and
Paula Becker-Moderssohn in Worpswede.

MÜNTER: But we had no contact with the painters of the Neu-
Dachau and the Worpswede Schools. It was only much later, for
instance, that we discovered that Hoelzel had already been ex-
perimenting with non-objective compositions as early as 1908. We
were only a group of friends who shared a common passion for

painting as a form of self-expression. Each of us was interested in the work of the other members of our group, much as each of us was also interested in the health and happiness of the others. But we were still far from considering ourselves as a group or a school of art, and that is perhaps why we still displayed so little interest in the styles of other groups or movements. I don't think we were ever as programmatic in our theories, as competitive or as self-assertive, as some of the modern schools of Paris.

E.R.: Yet you did finally decide to establish yourselves as a group or school, I mean when Kandinsky published in 1912 the first issue of *The Blue Rider*. Had this originally been Kandinsky's idea, or had it been a collective project?

MÜNTER: Of course, there had been a lot of discussion in our group before the book was actually ready for publication. I have now forgotten who was responsible for the original idea, perhaps because I have never been particularly interested in theory.

E.R.: If I understand correctly, the idea of exhibiting as a separate group was more or less forced on you.

MÜNTER: Yes, the *Neue Künstlervereinigung* didn't approve of Kandinsky's ideas in 1911 and rejected his *Composition No. 5* as too big for their show. So Kandinsky withdrew from the association, and Franz Marc, Kubin, Le Fauconnier and I followed his lead. It was then that Kandinsky began to write the book that became *The Blue Rider*. Franz Marc, who was one of his pupils, managed to interest a German publisher in the project, and everything suddenly began to crystallize. But the title of the book was still undecided, till Franz Marc insisted that a name for the book and for an exhibition of works of our group be found at once. That evening, Kandinsky said to me suddenly: "We'll call it *The Blue Rider*." You know, of course, that this had already been the title of one of his canvases in 1903.

E.R.: Yes. Blue seems to have always suggested some secret meaning to Kandinsky. In 1908, he had also painted a *Blue Mountain*, and both his *Blue Rider* and his *Blue Mountain* belong to the same kind of legendary world as Maurice Maeterlinck's *Blue Bird* and as, perhaps, the *Blue Rose* after which a group of Russian modernists in St Petersburg, around 1905, had named their exhibition.

MÜNTER: I remember that Kandinsky sometimes mentioned the Blue Rose group, but I myself never knew much about it.

E.R.: Was Kandinsky in touch with Gontcharowa and Larionow or any other artists of the St Petersburg *avant-garde*?

MÜNTER: Not exactly, though many of them turned up every once in a while in Munich and dropped in to see him. Jawlensky was much more sociable, more in touch with other Russian artists. But Kandinsky was very much interested, at one time, in the work of Larionow and Gontcharowa.

E.R.: What was the basic factor, in your opinion, in the ideas or the style of the Blue Rider group?

MÜNTER: I think we were all more interested in being honest than in being modern. That is why there could be such great differences between the styles of the various members of our group.

E.R.: It has always surprised me that two such different artists as Kandinsky and Kubin should have been close friends, in fact members of the same school or group.

MÜNTER: They had great faith in each other. I think that each of them knew that the other, as an artist, was absolutely honest. Whenever Kubin came to Munich from his near-by country retreat, they spent many hours together, and I wish I had been able to take down in shorthand some of their conversations. Their ideas about art and about life were so different. I was never interested in being just modern, I mean in creating a new style. I simply painted in whatever style seemed to suit me best. But Kandinsky was a thinker and had to express his ideas in words too, so he constantly formulated new theories of art which he liked to discuss with Kubin, who was also a thinker, though in an entirely different vein. Kandinsky was an optimist; he had been interested, at first, in fairy-tales and legends and chivalrous themes of the past, but he then became increasingly interested, after 1908, in formulating what he called the art of the future rather than in indulging in romantic visions of the past. Kubin, on the other hand, was a pessimist, always haunted by the past and suspicious of the future. This basic difference in their temperaments made their discussions all the more fruitful, and their friendship was all the more intense.

E.R.: Would you say that Jawlensky was one of the optimists or one of the pessimists in your group? Was he interested in the art of the future, like Kandinsky, or in that of the past, like Kubin?

MÜNTER: I suppose he was a middle-of-the-road man. In some

respects he was very conservative, not at all interested in ideas or theories. He often disagreed with Kandinsky. On several occasions they even became estranged. Jawlensky and Marianne de Werefkin, for instance, remained at first with the *Neue Künstlervereinigung* and refused to secede with us when we formed our new Blue Rider group in 1911. Later, they patched up their differences.

E.R.: I understand that Jawlensky also disapproved later of Kandinsky's activity as an artist in Soviet Russia. Jawlensky was always deeply religious and believed that the Bolshevists were truly the Anti-Christ. I have been told that he was quite shocked when he first heard that Kandinsky, after his return to Russia in 1916, had become, for a while, a believer in the Revolution.

MÜNTER: I don't think that Kandinsky was ever really a Communist. He just happened to be in Russia and to become involved in some revolutionary artistic activities because of his reputation as a revolutionary in the arts. In any case, he left Russia as soon as an opportunity arose. But we had parted, by that time, and I prefer not to express any opinion on Kandinsky's later ideas and beliefs, with which I was never familiar.

E.R.: Did Kandinsky ever share Jawlensky's religious interests?

MÜNTER: He was never at all religious-minded, but he shared Jawlensky's admiration for Rouault as a religious painter. They both believed that Rouault was one of the most important Paris painters of their generation, though they also admired Matisse very much.

E.R.: It is interesting to learn that Kandinsky, a revolutionary former pupil of Franz von Stuck, who had so much in common with Gustave Moreau, should instinctively have preferred, among the more revolutionary Paris painters, those who had been pupils of Moreau. But I somehow feel that Jawlensky was much more interested in Rouault and Matisse than Kandinsky ever was.

MÜNTER: Jawlensky and Marianne de Werefkin were much more involved in the politics of modern art, in those years, than Kandinsky and I; they had both lived in France and had many friends among the Fauvists as well as in other groups of advanced painters abroad.

E.R.: I have never had occasion to see much of Marianne de Werefkin's work.

MÜNTER: Most of it seems to have vanished since her death. I

often wonder what her heirs did with it. Of course, her nephew may have stored it all away in an attic somewhere in Italy.

E.R.: I saw a couple of her works in Munich, in the Blue Rider retrospective exhibition and in the Municipal Museum. She seems to have been both a Fauvist in the French sense and a painter of landscapes and of still-life compositions of the same kind as your own Murnau works of about 1912.

MÜNTER: Yes, we shared very much the same tastes and ideas, when we lived together in this house. She was extremely perceptive and intelligent, but Jawlensky didn't always approve of her work. He often teased her about being too academic in her techniques, and too intellectual and revolutionary in her ideas. He used to pretend that she had never managed to liberate herself entirely from the academic teachings of the Russian master under whom they had once studied together, the old painter Ilya Riepin. Suddenly Jawlensky would pick on some tiny detail of one of Marianne's best and most original pictures and exclaim: "That patch of colour, there, is laid on much too flat and smoothly. It's just like old Riepin." Of course, it was nonsense and he was only saying it to annoy her. But Jawlensky really was a devotee of the *touche de peinture* of the French Fauvists, rather than an innovator, a believer in a new kind of art of the future.

E.R.: If I understand correctly, Jawlensky and Marianne de Werefkin were, until the First World War, the painters who associated most closely with you and Kandinsky.

MÜNTER: I suppose so. They often lived here in our Murnau house. But Paul Klee and Franz Marc were also close friends, and August Macke too, whenever he was in Munich.

E.R.: What part did Klee play in formulating the theories of the Blue Rider group?

MÜNTER: Klee was never as active a theorist, in those years, as Kandinsky or Marianne de Werefkin. Besides, it took Klee much longer to become a truly and consciously modern artist. When he first came to Munich as a student, from Switzerland, he was still a very timid Romantic. You can see that in his earliest paintings, many of which were small portraits that strove to achieve the quality of intense perception or of intimacy that we Germans call *Innigkeit*.

E.R.: Yes, but I was surprised to see that he also seemed to be an imitator of Arnold Boecklin, in a way.

MÜNTER: Well, Klee was then one of Stuck's pupils, together

with Kandinsky, and that is where they both learned to paint. Then Klee abandoned painting, for a while, and concentrated on drawing.

E.R.: That was the period, I suppose, of his *Jugendstil* drawings which are often in much the same style as those of Kubin or even of his near-namesake Kley.

MÜNTER: It has never occurred to me that there was any similarity between Klee and Kley. After all, Kley was practically a commercial artist, I mean a newspaper cartoonist.

E.R.: Yes, but he also drew grotesques, and I once saw one of his signed grotesques exhibited abroad, out of sheer ignorance, as an early work of Paul Klee.

MÜNTER: How absurd! Anyhow, Klee achieved freedom, as an artist, only very slowly. He developed his interest in the drawings of children, for instance, only after many years of study and of experiment here in Munich. As you can see in my portrait of Klee, which I painted in 1913, I mean the one where he is seen seated in one of the rooms here downstairs and wearing white summer slacks, he was not very communicative. That is why I depicted him all hunched up and tense, as if he were constraining some mainspring within himself. In my eyes, it was almost a portrait of silence rather than of Klee, and for many years it no longer occurred to me that he had been my model. But Klee was always a close friend of ours, and Kandinsky and I both had great confidence in his talent and his future, though he was not yet very active as a leader or a theorist in our group.

E.R.: Was Feininger also one of your group?

MÜNTER: No, I don't remember ever meeting him. I believe he came much later. His association with Kandinsky began at the Bauhaus, after the First World War.

E.R.: Was the American painter Albert Bloch a member of the Blue Rider group?

MÜNTER: Yes, Bloch was at one time one of our closest friends. But I never hear from him now. Has he been very successful in America?

E.R.: I'm afraid his work has been rather shockingly neglected by most American critics and collectors. He has never been active in any American group of artists, and has always lived very much alone. What were your group's contacts with the Paris painters, I mean the Cubists and the Fauvists, before 1914?

MÜNTER: Kandinsky and I had made several trips to France, though we never associated there with many artists. Most of the time, we were content to visit galleries or, as soon as the weather was fine, to go out on sketching and painting expeditions. But some Paris painters, especially Delaunay and Le Fauconnier, exhibited in our group's shows in Munich. I don't remember meeting most of them personally here. Macke and Marc, of course, were great friends of Delaunay, whom they had met in Paris. They were both enthusiastic about Delaunay's Orphist theories of form and colour. Delaunay was jealous, however, of their devotion to Kandinsky. Marc once told me that he had insisted that Kandinsky was an inspired painter, and that Delaunay had then been rather offended and had replied: *"Vous dites qu'il a de l'inspiration. Mais, moi aussi, j'en ai. . . ."*

E.R.: You have said that Kandinsky was the first artist to take your work seriously and to give you any real guidance. Would you care to explain this in greater detail?

MÜNTER: Well, when we first met, Munich was still very much a centre of *plein-air* painting, and Kandinsky himself was a *plein-air* painter too, to some extent. We used to go out sketching and painting together in the countryside, and he painted a picture of me sketching, and I also did one of him. That was a long time ago, in 1903. It was only some ten years later, when he painted his first *improvisations*, that he began to work exclusively in his studio. You have probably understood that I had always been mainly a *plein-air* painter, though I also painted portraits and still-life compositions. At first, I had experienced great difficulty with my brush-work, I mean with what the French call "la touche de pinceau". So Kandinsky taught me how to achieve the effects that I wanted with a palette-knife. In the view from my window in Sèvres that I painted in 1906, when we were together in France, you can see how well he taught me. Later, of course, here in Murnau, I learned to handle brushes too, but I managed this by following Kandinsky's example, first with a palette-knife, then with brushes. My main difficulty was that I could not paint fast enough. My pictures are all moments of my life, I mean instantaneous visual experiences, generally noted very rapidly and spontaneously. When I begin to paint, it's like leaping suddenly into deep waters, and I never know beforehand whether I will be able to swim. Well, it was Kandinsky who taught me the tech-

nique of swimming. I mean that he taught me to work fast enough, and with enough self-assurance, to be able to achieve this kind of rapid and spontaneous recording of moments of life. In 1908, for instance, when I painted my *Blue Mountain*, I had learned the trick. It came to me as easily and as naturally as song to a bird. After that, I worked more and more on my own. When Kandinsky became increasingly interested in abstract art, I also tried my hand, of course, at a few improvisations of the same general nature of his. But I believe I had developed a figurative style of my own, or at least one that suited my temperament, and I have remained faithful to it ever since, with occasional short holidays in the realm of abstraction.

E.R.: Did your association with Kandinsky continue during the years of his teaching at the Bauhaus?

MÜNTER: No, we parted in 1914, when Kandinsky, being an enemy alien, had to flee from Germany, as did Jawlensky and Marianne de Werefkin too. I then went to Denmark and Sweden, which were neutral countries, hoping that he might join me there, and it was in Stockholm that he visited me briefly, in March 1916, on his way back to Russia. There, during the Revolution, he was at last able to obtain a divorce from his first wife, but he also met in Moscow a woman who was able to hold him in a firmer grip than I and whom he married. I never saw him again, and I met her for the first time in Munich, long after his death, in 1949. Ever since we parted in 1914, I have worked mainly by myself. After the First World War, here in Munich, we found that our old Blue Rider group had broken up. Marc and Macke had both been killed, Kandinsky, Jawlensky and Marianne were no longer here, Bloch and Burliuk were in America. Those of us who were still in Munich remained friends, of course, but each one of us had learned to work by himself rather than in a group. Besides, as I told you before, we had always been individualists and our Blue Rider group had never had a style of its own as uniform as that of the Paris Cubists.

*I spent two more days in Murnau, after my conversation with Gabrièle Münter, and went on several excursions around the lake or into the blue mountains beyond it. Everywhere, I discovered views of the Bavarian countryside that had exactly the bright colours and the curious lack of perspective as the paintings of*

*the more Fauvist artists of the Blue Rider group. These land-*
*scapes indeed had no vanishing-point, but seemed to be disposed*
*in receding planes. I thus understood how important the Munich*
*tradition of* plein-air *painting had been in the development of*
*Kandinsky's later style. It had liberated him from all that had*
*been too purely decorative or calligraphic in his earlier* Jugend-
stil *art, when he had first adopted the fashionable modernism of*
*the more urban Munich aesthetes because of its obvious affinities*
*with his own Russian aestheticism, which he had inherited from*
*Bakst and the* Mir Iskustvo *painters of St Petersburg.* Plein-air
*painting, with Gabrièle Münter in Murnau and elsewhere, had*
*then weaned him away from all that was too literary or con-*
*strained in this art, still of much the same nature as that of*
*Aubrey Beardsley; and this had made it possible for Kandinsky*
*to develop his own style in abstract improvisations, especially*
*after 1912, when he returned to indoor studio-work after a fresh-*
*air cure as a landscape painter.*

*Two different artistic traditions of the Munich* avant-garde *had*
*thus contributed towards Kandinsky's later abstract styles. On the*
*one hand, he developed in these the theories of a non-objective*
*art that had first been formulated in Munich, as early as 1898, in*
*the writings of the* Jugendstil *sculptor Obrist, and that had later*
*been applied to painting, in Dachau, by Adolf Hoelzel. On the*
*other hand, by then achieving a synthesis of the indoor modern-*
*ism of the* Jugendstil *draughtsmen and colourists and of the older*
plein-air *painting of Leibl and the Munich contemporaries of the*
*French painters of Barbizon, Kandinsky had vastly expanded the*
*scope of abstract art so that it ceased to be merely decorative or*
*playful and was at last able to cope with major tasks of artistic*
*self-expression. His first improvisations, often composed in the*
*same Fauvist colours and with the same kind of brush-stroke as*
*his Murnau landscapes painted a couple of years earlier, are really*
*landscapes of the mind or of the emotions. They remain, I feel,*
*his greatest works. To what extent should we attribute this dae-*
*monic exuberance, in Kandinsky's abstract improvisations of be-*
*fore 1914, to the encouragement and friendship of Gabrièle Münter*
*or to the constant prodding of Marianne de Werefkin, whose*
*recently discovered diaries prove that her ideas were often more*
*original and more advanced than her actual painting? After*
*they parted, Kandinsky's art seems to have hovered again and*

*again on the brink of the merely decorative or of the excessively schematic. He remained a magnificent theorist, a wonderful teacher. But his most creative period, that in which he covered the most ground and matured the most rapidly, was between 1900 and 1914, in the years that he spent with Gabrièle Münter and Marianne de Werefkin, whether in Munich and its surroundings or on their numerous trips to foreign countries.*

*A few weeks after my conversations with Gabrièle Münter, I chanced to call on Dr Clemens Weiler, the scholarly curator of the Art Museum in Wiesbaden. I had reviewed, a few years earlier, his first book on Jawlensky, in the American Journal of Aesthetics. He now began to discuss with me some of the fruits of his recent research in the history of the Blue Rider movement. Among other things, he had discovered, among Jawlensky's papers, a collection of photographic reproductions of works by Russian painters of the turn of the century. Jawlensky had kept them preciously for close on half a century: they proved his respect for the art of Riepin, Serov, Vrubel, Levitan and others whose influence on modern painting is no longer suspected. Dr Weiler also showed me extracts from the remarkable diaries that Marianne de Werefkin had kept in French, from 1898 until her death during the Second World War. Here she had noted, before 1900, that she felt herself "devoured" by abstraction. As a convinced anthroposophist and believer in the colour-theories of Rudolf Steiner, she had constantly urged Kandinsky to desert, in his art, the objective world.*

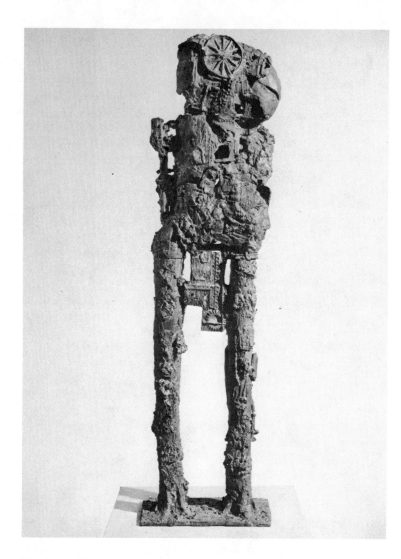

Eduardo Paolozzi
*Cyclops*

# Eduardo Paolozzi

*A visitor to an exhibition of the sculptures of Eduardo Paolozzi
enters an enchanted forest of ambiguities. Are these bronzes, with
their curiously bark-like surfaces, intended to represent giant
mandrakes, creatures of a plant-world that apes the forms of the
animal world too? Or were these menacing totem-poles once men
and animals that have been transformed into trees, as punishment
for their sins, then charred and blackened by a forest-fire before
being turned to bronze by the gaze of some new kind of Gorgon?
On closer inspection, the barks of Paolozzi's trees that are nearly
human or animal appear moreover to be an intricately rugged
tangle of tiny forms borrowed from among man's discarded arti-
facts, fragmentary and not always immediately identifiable parts
of machinery, scrap-metal salvaged from broken clocks and locks.
Like barnacles on an old wreck, all these details emerge from the
bronze in which they appear to be embedded, encrusted or
welded together, as if they had been caught in a quicksand of
molten metal from which they seek to escape, if only to preserve
their vestigial identity as objects that once were functional and
useful.*

*In fifty years, modern art may well be said to have progressed
from a realistic depiction of all that the contemporary world dis-
cards as valueless, as in the legendary or apocryphal still-life com-
position to which the "Ash-can" School of New York owed its
derisive name around 1900, to a new magic whereby the artist,
seeking his materials as well as his inspiration in the trash-heap
and the junk-yard, salvages all sorts of otherwise valueless and
disintegrating objets trouvés and ready-mades which he sets out
to transmute into valuable and lasting works of art. Were our
Marxist art-critics not moralists rather than materialists, believers*

157

*in the pious homiletics of Socialist Realism rather than in the critical principles implied in* Das Kapital, *they would all acclaim Paolozzi's work as an eloquent illustration of man's ability, through his thought and his labour, to transmute valueless and meaningless matter into something costly and cryptic. But these sculptures fail to conform to the preconceived and platitudinously optimistic standards of Socialist Realism, as it has been expounded to us by politicians and bureaucrats. Marxist art-critics therefore condemn them unanimously as symbols of the corruption and degeneracy of our age. Spokesmen of the new Victorianism, these prophets of the culture of a future classless society, where only the tastes and the beliefs attributed to the "lower orders" of yester-year will be tolerated, have thus decided, much as some eminent Victorians eschewed all but the pathos or Kitsch of their own élite, to vilify as decadently esoteric one of the few styles of modern art that might well appeal to the fantasy and the sense of invention of the gadget-minded skilled workers of our metal-industries.*

*A somewhat heavily built and very Italian-looking Englishman with a slight but nevertheless surprising north-country burr to his speech, Eduardo Paolozzi greeted me, when I first met him in the sacred grove of his sculptures in London's Hanover Gallery, with the cordiality of one of those kindred spirits, rare enough in my life, who have known of me, or of my writings, for many years before at last meeting me. The son of poor Italian immigrants from Frosinone who had established themselves in the ice-cream trade in Scotland, he had nourished his inherited nostalgia for a warmer or more colourful life, in the bleak surroundings of his youth, on a steady diet of advanced-guard publications from Paris and New York. He had thus become aware, many years ago, of my long-standing but intermittent connection with the Dada and Surrealist movements:*

PAOLOZZI: I had read your English translation of a few episodes selected from Raymond Roussel's *Impressions d'Afrique* in the war-time New York periodical *View*. Then I looked all over Paris, shortly after the War, for a copy of the French original, which I subsequently read in full, together with several other works of the same wonderful writer. I was particularly interested by Roussel's *Comment j'ai écrit certains de mes livres*, where he

explains how he has expanded ready-made phrases that he has chanced to find, almost like *objets trouvés*, in such a manner as to imagine a whole story. I believe I have adapted to the plastic arts some of the principles of Roussel's Poetics. But very few people in England are at all interested in this kind of experiment. The English accept Dada and Surrealism only as humour, or else as valuable historical documentary evidence concerning the aberrations of modern art in foreign countries. Even now, with the Urvater Collection being exhibited at the Tate Gallery, most of the critics here have evaded the real issues involved and dismissed all of Dada and Surrealist art as if it were merely old-hat.

E.R.: I happen to have just published, in the New York *Arts* annual, a long study of nineteenth-century fantastic art, and it occurred to me, as I was writing it, that fantastic art and literature are acceptable to the English only if they are apocalyptic and religious, as in the works of William Blake, or if they can be laughed off as wonderful nonsense, invented by some whimsically learned Lewis Carroll or Edward Lear for the amusement of children and, quite incidentally, of grown-ups too. The Dada and Surrealist movements seem to have acquired in England an almost unavoidable flavour of the church-vestry or of the nursery. The Surrealist poetry of David Gascoyne, for instance, was doomed from the start to become, in the long run, either maudlin and religious, which was the course that he finally adopted, or coyly humorous.

PAOLOZZI: That is why I feel that I am utterly alien among English sculptors. I am a Raymond Roussel rather than an Edward Lear or a Lewis Carroll, and nobody here seems to be interested in the problems that I am trying to solve seriously. If I could only fool myself into believing that my own work is whimsical, in fact that I am creating a kind of *Alice in Wonderland* for children and not for grown-ups, I am quite sure that my problems would be discussed much more seriously by English critics.

E.R.: They might then start psycho-analysing your work as they have already begun to interpret Lewis Carroll's. They hesitate to do it, however, because they feel that you may be aware of the hidden implications of some of your work, whereas it is always fun to unmask an innocent, like Lewis Carroll, and to reveal what hideous complexes are illustrated in his apparently playful fan-

tasies. But how would you define the problems that preoccupy you in your work?

PAOLOZZI: I suppose I am interested, above all, in investigating the golden ability of the artist to achieve a metamorphosis of quite ordinary things into something wonderful and extraordinary that is neither nonsensical nor morally edifying.

E.R.: Would you then agree that your own conception of the fantastic sublime tries to avoid both the portentous and the grotesque?

PAOLOZZI: Yes. It is the sublime of everyday life. I seek to stress all that is wonderful or ambiguous in the most ordinary objects, in fact often in objects that nobody stops to look at or to admire. Besides, I try to subject these objects, which are the basic materials of my sculptures, to more than one metamorphosis. Generally, I am conscious, as I work, of seeking to achieve two or at most three such changes in my materials, but sometimes I then discover that I have unconsciously achieved a fourth or even a fifth metamorphosis too. That is why I believe that an artist who works with *objets trouvés* must avoid being dominated by his materials. Wonderful as these may be, they are not endowed with a mind and cannot, as the artist often does, change their mind as they are being transformed. On the contrary, the artist must dominate his materials completely, so as fully to transform or transmute them. You have probably seen, in New York and in Paris, a lot of work by younger sculptors who, like Stankiewicz, César and I, work mainly with *objets trouvés*. Well, I often feel that if one of us chances to find a particularly nice and spooky-looking piece of junk like an old discarded boiler, he can scarcely avoid using it as the trunk or body of a figure, if only because its shape suggests a body to anyone who sets out to do this kind of assembly-work. Then one only needs to weld something smaller onto the top to suggest a head, and four limb-like bits and pieces onto the sides and the bottom to suggest arms and legs, and there you have the whole figure, which has come to life like a traditional Golem or robot . . .

E.R.: Or like the eighteenth-century French philosopher La Mettrie's mechanical man . . .

PAOLOZZI: I find such an art in a way too simple and already obsolete. It can too easily involve a sculptor in a kind of Walt Disney fantasy that simply makes materials salvaged from the

junk-yard live as in an animated cartoon, or as if cast for parts in a kind of dramatic *tableau vivant* rather than endowed with motion and life. Of course, these materials undergo a metamorphosis of sorts, but the life that they are made to assume is too often one that has been suggested to the artist by an obvious analogy which would strike a non-artist too. I really set out in my sculpture to transform the *objets trouvés* that I use to such an extent that they are no longer immediately recognizable, having become thoroughly asimilated to my own particular dream-world rather than to an ambiguous world of common optical illusion.

E.R.: When did you first become interested in this Dada or Surrealist art of *objets trouvés* and of *ready-mades*?

PAOLOZZI: When I went over to Paris in 1947, shortly after the War, and lived for three years among the artists and writers of the Left Bank. I feel I was very lucky to meet Mary Reynolds and to be able to study at ease her extensive collection of relics of the pre-war Dada and Surrealist movements, especially all her examples of the early work of Marcel Duchamp. I use the term "relics" intentionally, because so many of these objects seemed to me too fortuitous and ephemeral, somewhat dusty, pathetic and absurd, like the votive crutches and other macabre objects that the beneficiaries of miraculous cures have left in a shrine like that of Lourdes. I also became quite friendly with Tristan Tzara and spent many an evening studying his collection of modern art and of primitive sculptures. But only a few of the *objets trouvés* and *ready-mades* of the heyday of Dada and Surrealism have withstood the ravages of time, if only as materials. They soon fade or rust, and they tend to disintegrate like cheap artificial flowers left out in the wind and the rain on a grave in a French cemetery. Besides, most of these works of the early Dadaists, and of Kurt Schwitters too, seem to me to be too loud, sometimes even too infantile or silly, in their protest against serious craftsmanship and against all art. It is all a bit hysterical, like a spoiled child's tantrum of anti-art. As a matter of fact, I remain very much pro-art. You may not believe it, but I adore the British Museum, and I would be one of the first to rise up in arms if anybody threatened to burn it down as some of the early Dadaists might have suggested. I would consider any plot to destroy the Cathedral of Notre Dame as an attempt against all art, including

my own work, in fact as an attempt on my own dignity and life as an artist.

E.R.: Cocteau once told me that the idea of destroying Notre Dame and of building in its stead a gigantic old-fashioned oil-and-vinegar cruet had been discussed for the first time, as a joke, by him and Tzara. Years later, Cocteau was summoned in connection with some other business to the French police headquarters. Being capable of reading upside down, he saw, on the desk of the Sûreté official who received him and sat facing him, a file entitled "Report on the plot of Cocteau, Jean, and Tzara, Tristan, to blow up Notre Dame." Beneath this title, Cocteau also claimed to have been able to decipher the name of the informer, that of the completely innocuous and notoriously gullible Russian Dadaist Serge Charchoune, who was then the constant butt of the practical jokers of the Left Bank. But I tend to believe, as did the French political police, notorious though it is for its insistence on pursuing red herrings and wild geese while failing to prevent the occasional murder of a visiting sovereign, that some of the Paris Dadaists, though certainly not Cocteau who was never an orthodox member of this group, were quite capable of carrying out an iconoclastic outrage. A couple of years ago, the Galerie de l'Institut put on a big Dadaist retrospective exhibition that included, in the window, an object constructed long ago by Man Ray and entitled: *Objet à détruire*. A group of young anti-Dadaist vandals of a rival neo-Dadaist or Lettriste persuasion then entered the gallery, snatched this object from the window, and destroyed it in an improvised public ceremony in the middle of the Rue de Seine. Hoist with his own delayed-action petard, poor old Man Ray could only make a public statement, in the press, approving the behaviour of these young people who had come along twenty-five years later to carry out his own implied instructions. The whole incident seemed to me, at the time, to have been a very apt, though belated and pathetically ludicrous, comment on the anti-art nihilism of the early Dadaists. I have never been able to distinguish Dadaist intolerance and iconoclasm from the vandalism of reactionaries like the man who, one night, painted Epstein's *Rima*, in Hyde Park, with bright red paint.

PAOLOZZI: I'm like you. I cannot abide the idea of banning, forbidding, mutilating or destroying any kind of art.

E.R.: Do you spend much time in museums?

PAOLOZZI: I find a visit to a museum always profitable. Sometimes, in a shadowy show-case of a neglected provincial museum, I discover some miraculous object that seems to be greeting me with desperate signals, as if we had always been destined to meet at this mysterious tryst that would rescue it from the oblivion, the anonymity, the deprivation of any real existence or appreciation which, even in a museum show-case, is after all the same kind of thing as abandonment and devaluation on a trash-heap. Or else, I suddenly become aware of another artist's strategy, devised and applied in another age to solve problems similar to those that I set myself. In the Ashmolean in Oxford, for instance, Piero di Cosimo's extraordinary *Forest Fire* made me aware of other ways of handling my own obsession with detail. For me, as for Piero di Cosimo, detail is indeed a world within a world, and then another world within this last world, like a series of boxes in which each box, once opened, reveals in turn another box, and then again another box. In the *Forest Fire*, each detail, such as a leaf on a tree or an animal's eye, is handled with enough attention and sense of wonder to be a complete composition in itself. At the same time, all these magnificently conceived and composed details are again conceived and composed as elements of a larger whole, a tree or an animal, and these larger units, each one of them a perfect picture in itself, are again parts of a larger group of such units, until the larger groups too are orchestrated in turn within the general structure of the whole picture. I hope that one can detect the same kind of organized relationship between the whole of one of my sculptures and all the tiny statements represented in it by the many details of form which one should recognize in the structure or the surface of the bronze.

E.R.: You may find me a bit compulsive about logical distinctions and philosophical definitions, but I would now like to return to an elucidation of the function of the *objet trouvé* in your art, as distinguished from its function in the art of the earlier Dadaists and Surrealists. We agreed a few minutes ago that there is something distressingly ephemeral or transitory about most of their trash-heap compositions. This is perhaps because the artist has neglected to impose on his salvaged materials any material unity as a work of art. These materials remain too valueless and fragile; they then deteriorate and disintegrate too easily. The piece of newspaper in a collage, for instance, becomes within twenty years

as dark as brown packing-paper, so that the print no longer stands out clearly and the colour-harmonies of the whole collage are no longer those that had originally been intended. The postage-stamp too, or the perforated metro-ticket, may become detached and lost, and then a whole series of problems arises if one tries to restore the collage. Was the lost postage-stamp originally a used or an unused one, an English or a foreign one, a penny pink or a twopenny-halfpenny brown, or was it a stamp of an entirely different and quite obsolete series? Often it becomes impossible to restore faded and damaged Dadaist works, and only their documentary value survives when their materials, aesthetically speaking, tend to regress to the trash-heap from which they had been but temporarily salvaged. One might almost speak of a kind of inherent *nostalgie de la boue* in many of these *objets trouvés*. But the trash-heap materials, in your works, undergo a more thorough metamorphosis as sheer materials than as forms, and I feel that you thus make them far more fit for survival.

PAOLOZZI: That is why I first build up my model by cementing my salvaged *objets trouvés* together with clay, after which I make, with my assistant, a plaster cast of them, and in this cast a wax mould that is finally sent to be cast in bronze. This is what imposes, in addition to a formal metamorphosis, a material meta-morphosis on all my materials. In the finished casting, the original *objets trouvés* are no longer present at all, as they are in the Dada and Surrealist compositions of this kind. They survive in my sculp-tures only as ghosts of forms that still haunt the bronze, details of its surface or its actual structure.

E.R.: It is this material transmutation of the *objet trouvé*, of course, that will prevent your art from ever suggesting the same kind of transitory flimsiness as so many of the faded or damaged documents of the golden age of Dada and of Surrealism. Besides, you also achieve a greater harmony of the parts, a more complete synthesis of your elements, by having your models cast in bronze.

PAOLOZZI: I am anxious that my works should have a perman-ent quality and not be subject to unnecessary change, except in so far as they may acquire with time the normal patina of a matured bronze. Nothing would disturb me more than to see, a few years after completing one of my sculptures, that some of the *objets trouvés* of the epidermis, insignificant though they may seem as details, had become detached and lost, like the postage-

stamp from a Schwitters collage. Many people believe erroneously that these details, in my work, are a kind of superimposed decoration, like accessories or even gags that are not essential to the appearance or the meaning of the whole sculpture. But this whole must owe its fantastic, magical or haunting appearance to the very variety and accumulation of its crowded details. These are essential to the whole, like the choice of tattooings on a man's body, clues to an understanding of his biography or of the compulsive nature of his urge to modify his own appearance and to exhibit in public his private dream-world.

E.R.: They also remind me, in your work, of the books that add up to an Arcimboldo portrait of a librarian, or again of the *objets trouvés*, very ordinary screws and nails and bits of mirror, that a primitive African sculptor uses to decorate his carving of a deity, because these bits and pieces borrowed from our own alien world of mass-produced artifacts, ordinary or valueless in our eyes, seem wonderful and rare enough, to an African, to adorn a sacred image.

PAOLOZZI: That is what I would call the revaluation of the otherwise valueless *objet trouvé*. By reconstructing a portrait out of books or out of apples and pears, or even the roots of trees, Arcimboldo imposes on these elements a new meaning, a new value which is also what the African sculptor achieves when he uses our discarded artifacts in order to suggest the precious or wonderful quality of his deity. All these details or elements thus become tiny statements which should have a cumulative impact, perceptible only in the whole sculpture. In most sculpture, the artist limits his task to a relatively simple procedure of metamorphosis. He takes a block of wood or of stone and sets out to turn it into something that suggests a human form, or he models this form in plaster, wax or clay that may then be cast in bronze. He may even go so far as to finish the surface of his materials, as Henry Moore often does, in such a manner as to give the illusion of a kind of epidermis, suggesting the texture and the consistency of flesh. But I try to go further and to suggest that matter itself is constantly undergoing some metamorphosis or evolution of its own. Everything consists of atoms or molecules or cells or fragments of other things and materials that have ceased to exist as separate entities or that are already in the process of coming into being as separate entities. When we create a work of art, we try

to arrest this flux, to perpetuate a single moment in this endless metamorphosis of matter, much as Joshua, in the Bible, prayed that God should stop the sun in its course. The details of my sculptures try to suggest such a pause in the evolution of their materials, and the spare parts and the junk that the metal may once have been and may well become again are an allegory of the materials of which the bodies of living animals and human beings are likewise constructed. I suppose that this is why my sculptures have a kind of busy or crowded appearance, as opposed to the more reposeful or spacious mood of a Maillol. But I am obsessed with detail and always prefer a busy or a crowded sculpture, whether a tiny Byzantine or Gothic ivory relief or the huge bronze *Porte de l'Enfer* of Rodin. . . .

E.R.: The kind of busy or crowded sculpture that you prefer is nearly always indoor sculpture, as opposed to the open-air sculpture that one sees in parks or gardens or public squares. The more introspective kind of sculpture, such as Rodin's *Porte de l'Enfer* or your own work, is rarely at its best, I feel, if it is set in the surroundings of nature. But it would be just as correct to suggest that nature, or the outside world, isn't at its best as a setting for this kind of vision of the artist's inner world.

PAOLOZZI: I actually prefer each one of my sculptures to be exhibited by itself, alone in a room with white walls. My work is perhaps too personal to be seen as part of a garden or a park, or as an ornament to a building, I mean as an element of some larger aesthetic scheme.

E.R.: Besides, these larger aesthetic schemes are nearly always organized according to entirely different and more traditional principles, I mean those classical principles of "Nature improved by art". The work of an artist who has set out to "improve" a natural stone by endowing it with a human form will of course fit more easily in a landscaped park like that of Versailles, where Lenôtre has "improved" nature according to similar principles. But your work follows different principles: instead of "improving" natural materials, you salvage and revaluate manufactured materials, and the relationship of a construction of *objets trouvés* to natural surroundings such as those of the park of Versailles is not at all the same as that of a traditional sculpture. Perhaps the only appropriate "natural" surroundings, for one of your sculptures, would be a deserted square in the heart of a

disastrously bombed city, surrounded by acres and acres of ruins and rubble, all veritable gold-mines of *objets trouvés*. But I think we have now worked out a fairly complete aesthetics of the *objet trouvé*, and my last remarks might lead us too far, since they suggest a metaphysics and an anthropology of the *objet trouvé* too.

PAOLOZZI: There is still one point, I feel, that should be stressed, if you want an aesthetics of the *objet trouvé*, and that would be the relationship of my kind of sculpture to action painting and to some of the more recent developments in abstract expressionism. It is always difficult for a sculptor to suggest, in his work, the same kind of spontaneity as one appreciates in much of modern painting. A sculptor's task is much more slow and laborious than that of a painter. But the use of *objets trouvés* as the raw materials of sculpture makes it possible to suggest a kind of spontaneity that is of the same nature as that of much modern painting, even if, in my case, this spontaneity turns out to be, after all, an illusion. There is of course a real spontaneity in the model that I put together with the aid of clay, but this model is perishable or expendable and the finished bronze, once cast, remains the fruit of a very slow, deliberate and laborious process. Still, the *objets trouvés* that are recognizable in the finished bronze can suggest some of the spontaneity of the creation of the expended model. That is the only point that I still wanted to make. . . .

*We had begun our discussion in slightly Neronian pomp, both of us seated, one afternoon, in throne-like gilded Regency armchairs in Erica Brausen's office, in the basement of the Hanover Gallery. We had then continued it, after a while, in a near-by Mayfair Espresso coffee-bar, where the élite of London's art-market, mainly antique-dealers and decorators, hobnobs with the higher échelons of the gown and mantle trade. Interrupted for a few days while I prepared a first draft of my notes, our discussion had reached its conclusion in Paolozzi's Essex home, a relatively common example of the aesthetics of* objets trouvés *as they are daily and unconsciously applied in the fields of real estate and of building.*

*Paolozzi lives in a fairly deserted landscape, on the shores of an estuary near Harwich. Across the waters, in the evening, one can see the clustered lights of the harbour from which ships sail*

daily for the North Sea ports of the Continent. The sculptor's house consists of a group of three converted cottages in a row of small houses that had been built, over a hundred years ago, as lodgings for coast-guards. These cottages were later abandoned, for a long while, and had fallen into disrepair. A few years ago they were then converted and restored as country homes for urban sophisticates. In a civilization that finds it quite normal to salvage and convert old houses, it seems slightly illogical that the aesthetics of objets trouvés should cause, in the fine arts, so much scandal.

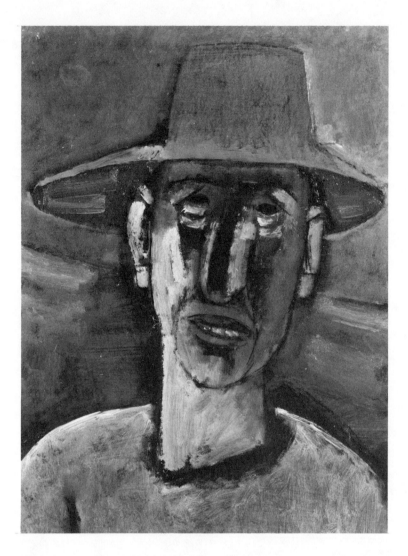

JOSEF HERMAN
*Peasant with Hat*

# Josef Herman

*The circumstances of my first acquaintance with the work of Josef Herman were particularly felicitous. Though I had lived several years in London before the Second World War, I had ceased, by 1955, to feel the immediate impact of developments in British literary or artistic life, unless their repercussions spread to the Continent and to America too. When I was commissioned by the Massadah publishing-firm in Israel to write a detailed historical survey of the contribution of Jewish painters of the Diaspora to the modern movement in all countries except France, the latter field having been assigned to another writer, I decided to spend a couple of weeks in England. This would enable me to refresh my memories of the work of such outstanding Anglo-Jewish artists as Mark Gertler and, at the same time, to become acquainted with the later painting of my old friend Yankel Adler, none of whose work I had seen since we had parted in Paris in 1936. Friends in London then communicated to me the names of a number of younger Jewish painters who had come to the fore in post-war Britain, and I thus heard of Josef Herman, who had been, during the war-years in Glasgow, a close friend and associate of Yankel Adler.*

*Herman's London dealers, Messrs Roland, Browse and Delbanco, went to considerable trouble to satisfy my curiosity by showing me a great number of Herman's paintings and drawings. I was immediately impressed by the monumental and at the same time painterly qualities of his oils, by the almost sculptural solidity of his draughtsmanship; even more, by the humanism that characterizes his approach to what seemed to be his favourite subject, men at work. In a decade that generally eschewed figurative representation, Herman's world, which had been that of Jean-François*

171

*Millet, Jozef Israels, Gustave Courbet and Camille Pissarro in the nineteenth century, had been now abandoned almost exclusively to the Communist devotees of Socialist Realism.*

*My discovery of Herman's work was all the more important to me because, in my analysis of the various trends prevalent in the emancipation of Eastern European Jewish painters from the traditional religious ban on "graven images" and, by extension, on nearly all figurative art, I had already come to the conclusion that the folkloristic "yiddish" humour and pathos of Chagall and other more famous Jewish painters of Russian or Polish origin represented but a picturesquely National aspiration, of the same general nature as the one which, in literature, had given us Sholem Aleichem's Tevya the Milkman and, in the theatre, the antics of all those Jewish comedians whose fantasy has culminated in the Hollywood "nuttiness" of Harpo Marx. To the devotees of modern art in Western Europe and America, all this seemed delightfully irrational, colourful and poetic, often suggesting, in its poignant mixture of fantasy, humour and pathos, a kind of Jewish analogue of Petrouchka. But there also existed, I felt, another trend among Eastern European Jewish painters, less particularistic or exotic in its folklore, more consciously humanistic in the universal application of its inherent Socialism. It had failed, however, to enjoy, in the Western world, the same popularity as Chagall's more cheerful and colourful memories of his childhood in Vitebsk or as Issachar Ryback's elegiac vignettes of life in an old-fashioned Ukrainian Shtettl. Yet this other trend had inspired Lasar Segall's infinitely more stark and tragic series of lithographed memories of his native Vilna as well as the work of numerous Jewish artists who had emigrated from Poland or Russia to France, England or America.*

*Here in London, in the paintings and drawings of Josef Herman, I now found an unexpected and eloquent illustration of my theory which was still based, to a great extent, on memories of earlier works of Yankel Adler that I had seen in Central European collections before 1934 but could no longer trace, and on an acquaintance with the art of a few Paris artists, such as Isaac Pailes and Simon Segal, whose reputations were not yet established on a sufficiently international basis to lend authority to my argument. I understood at once that Josef Herman was one of the four or five more important living artists among the two or three*

*hundred Jewish painters whose work I would discuss in the sur-*
*vey that I planned to publish in Israel. With the help of his*
*London dealers, I assembled enough notes on Herman's work to*
*satisfy my immediate needs. A few months later, on the occasion*
*of another visit to London, I decided to see more of Herman's*
*work and to write an article about it for the Brussels* Journal des
Beaux Arts *whose Belgian readers, I felt, should know more about*
*this rare foreign disciple of the great Flemish Expressionist master*
*Constant Permeke. Thanks to Messrs Roland, Browse and Del-*
*banco, I was then able to visit Herman in the basement studio*
*that he occupied in a late-Victorian red-brick private house on a*
*side-street near Swiss Cottage. We spent several hours together,*
*before lunching in a near-by restaurant. Though I had not yet*
*considered embarking on my project of interviewing a number of*
*contemporary artists, the notes that I took, as we talked, were so*
*ample that I was still able, with some additional help from*
*Herman, to write the present dialogue four years later.*

*Herman's London studio was a convenient place to work rather*
*than a home which might express his tastes and personality. He*
*already spent most of the year in Ystradgynlais, the mining-village*
*in South Wales that has come to mean so much to him, or travel-*
*ling on the Continent, generally in France, in Italy or in Spain.*
*From the windows of Herman's Swiss Cottage studio, one looked*
*out onto a rather desolate and abandoned back-garden. In spite*
*of the many paintings and drawings that were framed on the*
*walls, placed on easels or stacked at random against the furniture,*
*the room itself was as typically middle-class English, as imper-*
*sonal as any large furnished room in an old-fashioned suburban*
*or provincial house that had obviously seen better days.*

*Josef Herman himself might well puzzle anyone who meets him*
*for the first time without knowing much about his background.*
*For a relatively recent immigrant he speaks remarkably fluent*
*and correct English, though with a recognizable Polish or Polish-*
*Jewish accent, that of a man whose mother-tongue was Yiddish*
*rather than a Slavic language. His fair skin and light-coloured*
*hair, the structure of his cheekbones, his features and his short*
*stocky build, however, are more Slavic than Jewish. His manner,*
*besides, is that of a provincial rather than of a Londoner, and*
*one feels at once that he would be more at ease among working-*
*class Polish Socialist intellectuals than among the more sophisti-*

*cated francophile intelligentisa of pre-war Warsaw, in Antwerp
or Brussels rather than in the literary and artistic salons of Paris,
and in Glasgow or Wales rather than among the glittering celebri-
ties of a London art-patron's cocktail-party.*

*I began by questioning Herman about his childhood.*

HERMAN: I was born in Warsaw, in 1911, the eldest of three
children. My father was a cobbler; my mother, just a typical
Polish-Jewish mother. I can only say of my childhood that it was
happy, in spite of its drab surroundings and of the poverty of my
parents. It was an ordinary Eastern European urban working-class
childhood. My parents were kept busy trying to make both ends
meet and I was left very much to myself. But I was never lonely.
Even if I was alone, everything came to life in my company, and
anyone who had enough patience to chat with me became at once
my friend. Though I was never shy, I was quiet and generally
waited for others to make the first advances. The lives of chil-
dren who are brought up in the crowded slums of big cities are
often rather quiet, scarcely bright in a technicolor sense.

In contrast to my childhood, my youth was more eventful and
adventurous, though my adventures were mainly in the twilight
realms of literature. I was a voracious reader. After completing
my elementary schooling, I began studying for matriculation and,
perhaps, for admission to the university. Besides, I read for my
pleasure, and soon became acquainted with most of the major
classics. Dostoievsky and Walt Whitman, Tolstoy and Balzac
were among my favourites. One of my mother's secret ambitions
was that I should become a physician. But my father was un-
decided, and my own plans remained for a long while very vague.
My passion for reading may have been one of the causes of this
indecision, for I still read somewhat indiscriminately and for a
long while I remained a very unpractical youth. I remember my
father saying, to a friend who had remarked that I was a rather
gifted boy: "Believe me, a gifted son is a curse for a poor cobbler."
Nor can I blame my poor father. In those days, I changed jobs
quite often, and my family was never sure that I would be able to
earn my keep and contribute my own share of our household
expenses. At one time, I was an apprentice compositor in a
printing-press, at another time an office boy; I also tried my luck
in a workshop in one of the metal-trades, and as assistant sales-

man in a shop that sold imported tweeds and soon went bankrupt. When I look back on those unsettled days of my youth, I seem to see a starless night. . . .

E.R.: When did you first feel the urge to paint?

HERMAN: It began to dawn on me when I was eighteen that I wanted to draw and to paint. I was already earning a precarious kind of living and began slowly to buy all the art-magazines that I could find, which was something that I had never done before. I also began to attend, in the evenings, lectures that were given in Warsaw by the spokesmen of the various modern movements which were being widely discussed and that the Polish press still tended to lump together under a single denomination as "Futurists". I thus came to accept one theory after another, swallowing each in turn as if it were gospel truth. Not that I was too shy to criticize anything that I heard, but I still allowed myself to be rather easily convinced by the sheer eloquence of an argument and, in the heat of the discussions that often followed these lectures, I soon learned to throw in a few arguments of my own. But all this was still very innocent, mere nonsense and chatter. Many a painter who made his first steps as an artist in the late twenties of our century underwent similar experiences, and very few of them indeed have ever recovered from this feverish and often unhealthy passion for argument and theory.

E.R.: But when did you actually start to paint?

HERMAN: Well, I had already begun to try my hand a bit at drawing and even at painting during this first period when I was so busily attending lectures and discussions about modern art in my spare time. But the first man from whom I got something that might be called artistic training or schooling was, surprisingly enough, an old academic painter, a tall old Polish gentleman with a long white beard, a Mr. Slupski. In his youth, he had studied art in the nineteenth-century academies of Munich and, when he took his first look at my drawings, he seemed actually shocked. All he could do was to murmur: "Nonsense. . . . But all this is very bad. . . . Still, young man, you can draw, but what you need is discipline. . . ." Again and again, in the course of his instruction, he repeated to me a long story about the nineteenth-century German painter Adolf von Menzel who, he insisted, had never ceased, even at the peak of his career, to draw from plaster casts of Greek statuary, so as never to relax from this precious discipline. . . .

E.R.: It is a quite apocryphal legend about Menzel, who was one of the great draughtsmen of his age, an artist of much the same calibre as Ingres or Degas. Actually, Menzel nearly always had a sketch-book in his pocket, when he went out on his errands in the streets of Berlin, and often stopped in the middle of a busy thoroughfare to sketch some person or incident that caught his fancy. The great German Realist cartoonist Zille was a pupil of old Menzel, and many of the early drawings of Käthe Kollwitz also reveal his influence. But academic painters like your old teacher Slupski would only remember, of course, that Menzel drew or painted, in his old age, a few scenes of corners of his studio, where he still had the plaster casts that had been part of the furnishings of the studio of any painter in his generation.

HERMAN: Old Slupski never mentioned to me Menzel's sketching of street-scenes, and I finally gave in to his precious arguments about discipline. He impressed me so much with his talk about "solidity" and "the science of composition" and especially about the art of Raphael, that it took me some time to realize that all he really meant was a kind of routine. Anyhow, I went on drawing systematically and, a year later, when I at last enrolled in the official Warsaw art-school, I already knew at least what to avoid, including the advice of old men with white beards. I had also learned to differentiate between brilliant and provocative theory and the humble crumbs of real knowledge that can be gained only through hard work and experience. But these years of schooling as an artist were a hard struggle. I had to earn my living meanwhile as a designer of posters, of book-jackets, or as the paid assistant of more successful commercial artists.

E.R.: When did you first exhibit any of your work?

HERMAN: I had my first one-man show in Warsaw in 1932, in the shop of a small frame-maker who was also a bit of an art-dealer on the side. There were only two art-dealers, at that time, who had galleries in Warsaw. One of these expected painters to pay for their exhibitions and was very expensive; the other was willing to risk his own money on the artist. Of course, I chose the frame-maker who took risks.

E.R.: What kind of paintings did you exhibit in this first one-man show?

HERMAN: Most of them were large-sized water-colours, painted in sombre blues and browns, with rare flashes of red. My subjects

were mainly derived from the life of Polish peasants, and my style was a vague kind of expressionism. This style was indeed my only claim to originality, as most of the younger Polish painters were still under the spell of Bonnard's post-impressionist palette, and of his bourgeois interiors. But I was already beginning to feel the urgency of what the great Norwegian painter Edvard Munch had written in his diary, when he first began to revolt against the style of the later French Impressionists: "No more painting of interiors with men reading and women knitting! They must be living people who breathe, feel, suffer and love. I will paint a series of such pictures, in which people will have to recognize the holy element and bare their heads before it, as though in church." I remember repeating this exhortation again and again to my Warsaw colleagues.

E.R.: It is interesting that you should have instinctively chosen, as basic principle for your art, an idea that had been formulated by Munch. Several of the younger German painters who were later destined to become leaders of the Expressionist movement had already begun, around 1900, to prefer the work of Munch, together with that of Van Gogh, Gauguin and Lautrec, to the more established and typically French and bourgeois styles of the older Impressionists, such as Manet, the earlier Monet, Pissarro and Sisley. These German painters, especially Emil Nolde, were anxious to express a more specifically Germanic or Nordic personality in their work, and a more deeply rooted revolt against the values of an urban middle-class culture. It seems to me that you have also felt, from the very start, a need to emancipate yourself from the metropolitan and bourgeois tastes of Paris, and to formulate a style that would be more consistent with the climate and the society in which you lived, whether in Poland, in Belgium or in England. I mean that you have always been much closer to the Expressionist painters of Central and Northern Europe than to the Impressionist and post-Impressionist painters of Paris.

HERMAN: This is all so very true that, in 1936, I established in Warsaw, with an older Polish painter, Zygmunt Bobovsky, a group of artists, called "The Phrygian Cap", which deliberately set out to portray, in a style that was more expressionistic than post-impressionist, scenes of the everyday life of working people rather than of the middle class. The more active members of our group spent all their summers in the Carpathian mountains,

among the peasants whom we portrayed in monumental and poster-like forms, but in sombre colours. Three years later, however, I left Poland to study in Belgium. Not only was I attracted to that country by the Realism of some of its great painters, especially Breughel, but I also felt oppressed in Poland, under its Fascist régime, both as a Liberal and as a Jew.

E.R.: Did you find it difficult to establish yourself as an artist in Belgium?

HERMAN: Not at all. I settled in Brussels and soon became acquainted with the work of the Flemish Expressionists. I was particularly impressed by the paintings of Constant Permeke and Fritz Vandenberghe, though my closer contacts were mainly with a lesser-known member of this group, with Fernand Shirren. The year of my arrival in Belgium, I was already able to exhibit there a selection of my more serious or ambitious efforts. Though I met with some response and anticipated staying happily in Belgium, I was forced to flee to France in 1940, when the Germans invaded Belgium, and from France I then escaped, in June, to Britain. Later, freed from the Polish Army, I settled down for about two and a half years in Glasgow, where I exhibited, for the first time in Britain, in 1942, which was also the year of my marriage. A year later, I exhibited in London and settled there with my Scottish wife.

E.R.: In these first exhibitions, in Scotland and in London, did you already show paintings that depicted mainly characters and scenes drawn from the British working-class?

HERMAN: No. Most of my pictures of that period were fantasies based on childhood memories, and they were painted generally in rather dreamy harmonies of blue. I was obsessed for a long while, during my first years in England, with images of the Polish-Jewish world which was then being so ruthlessly destroyed by the Nazis. I knew that it was a doomed world, one that would never survive the disaster that had overtaken it, and I was drawn to depict all that I could remember of it, as faithfully as a chronicler, though always in colours and scenes that also expressed my own nostalgia for a vanishing past and my deep sense of sympathy for the millions of Jews who had remained in Eastern Europe and who were then being systematically starved, humiliated and exterminated. Many critics, of course, came at once to the conclusion that I was something of a lesser Chagall. Perhaps I may be

allowed now to pay my humble tribute to an artist who, almost single-handed, discovered our folklore, the lore of the Yiddish-speaking Jew. I said "almost", for I believe that it was largely an effort of a generation and that each artist came with his own, perhaps smaller but nevertheless quite genuine, contribution. Folk-singers care very little whether they are absolutely or only slightly original.

E.R.: Your compositions such as *My family and I* seem to me to be far more elegiac or tragic than Chagall's joyfully lyrical memories of Vitebsk. I would rather be tempted to compare your works on Jewish themes to those that Lasar Segall painted when he revisited Vilna in 1916, during the German occupation of his native city in the First World War, or else to Issachar Ryback's lithographed memories of his native Elisavetgrad, which he designed after the pogrom in which a band of Cossacks had murdered his father, or to certain paintings on Jewish themes of Yankel Adler....

HERMAN: You are probably right. Adler was my closest friend and he influenced me at one time, in 1936, after we first met. But not in the way in which the word "influenced" is usually understood. I never had much sympathy with Adler's artistic self-consciousness, his preoccupation with style, his wilfully modern trend of mind. How often he used this phrase: "We must be of our time." We took long walks along the banks of the Vistula, this wonderful river flowing through golden sands and silver birches. During these walks, talk would carry us sometimes into the rose hours of the morning. Adler's voice was pleasant to listen to. Unlike my young self, he never hurried his thoughts; they seemed to follow the accompaniment of the river. And just at a time when I needed it most, he made me realize that studying is not a one-time business and done with, and that a true painter proves himself by his capacity for assimilating new ideas. Talking of ideas, he would explain that they do not mean at all the same thing to a painter as to a metaphysician. To a painter "idea" means an image in its totality and not a thought squeezed into an image. "Thus painting"—I would add as though continuing his line of thought—"involves a continuous process of visualizing."—"Yes," Adler would say, "but not only.... The picture I saw this morning on your easel, think of it, the colour is good, but is this really all that one can get out of the material?" And I would be worried.

You must admit that all this was very stimulating for a beginner. When we met again in Glasgow, it was a different story and my turning to Jewish themes had nothing, as far as I can see, to do with my personal contact with Adler. It came to me as a shock, when I found myself doing the first set of drawings of a subject I had never touched before or, I should add, since. It may perhaps have been, as a psycho-analyst friend at the time suggested, that I felt lost in this new environment and was looking for an imaginary home. Perhaps. The nostalgia for my background, a background from which I had at an earlier stage run away, was driving me almost mad. The nights were anxious, with the air-raid terrors of an up-to-date reality. But in daytime and at the easel, I dreamed pleasantly. The pictures came as a torrent. In any case, thinking of them in terms of artistic development, you may be right, they were perhaps an effort to link up with a national tendency rather than with a single artist.

E.R.: Still, you might easily, as many other Jewish painters, have whiled away most of your life as an artist in such dreams and memories of your childhood in Eastern Europe. What made you suddenly shift to an entirely different kind of subject?

HERMAN: Well, whenever I stopped dreaming, I also stopped painting dreams. Besides, the realties of the war-years were not exactly conducive to dreaming, and a crisis then occurred in my work, as I longed for something more constructive, less dependent on individual moods, on memories of a vanished past. It was not an easy time to solve so purely personal a crisis. The more the earth was shaken by the convulsions of warfare, the more a voice seemed to cry out within me for a new belief in human dignity. For me, art and morality have never seemed very far apart. Then, in 1944, chance led me to this mining village of Ystradgynlais, in South Wales. The serene simplicity of its life, the constructive grandeur of the landscape, above all the monumental dignity of its men and women, all these at once set my imagination to work. For almost three years, I worked there for my next exhibition, which took place in 1946, in the London gallery that still handles all my work.

E.R.: I have been particularly interested in reading again the reactions of the Marxist critics to your exhibitions of recent years. The Communist *Daily Worker*, in one mood, wrote that it was "great proletarian art"; but, in another mood, their art-critic was

more aggressive and admitted that he had "many grumbles with Mr. Herman", who failed "to see here the tremendous individuality of the miners, their wit, homeliness and courage". As a Communist this critic was "bothered" by your "feeling of depression", which, he felt, is "foreign to the majority of Welsh miners and to the spirit of the valleys". Well, you said a few minutes ago that art and morality are always closely associated in your mind, and in the words of this particular Communist critic we see morality, or rather the absolute dictatorship of an official optimistic view about certain aspects of life, trying to override art completely. The Marxist critic John Berger, in *The New Statesman and Nation*, was a bit more intelligently explicit when he objected to what he calls, in your work, "a repetitive passivity, a certain sense of hopeless endurance". As I read Berger's article, I felt that he allows no scope for the virtue of fortitude in his aesthetics of Socialist Realism. His main objection, however, seems to have been, to quote him, that you paint miners "as if they were peasants instead of one of the most lively and militant sections of the proletariat. . . . For him, as for Millet, the symbol of the strength of labour is the peasant. . . . But miners need leaders, not consolation." It seems to me that we have here, in these few remarks of John Berger, the basis for a very lively discussion of your views on Marxist Socialist Realism.

HERMAN: Of course, I have always been interested in depicting men at work, and that is why, when I was still a beginner in Poland, I joined Zygmunt Bobovsky's "Phrygian Cap" school of art and spent my summers, with the other painters of this group, among the peasants of the Carpathian mountains. Later, when I was in Belgium, I likewise spent some time painting in the Borinage mining country, where Van Gogh and the Socialist sculptor Constantin Meunier had already worked. All this was part of my revolt against the sheltered *intimisme* of the leisured classes which was derived from Bonnard and Vuillard and seemed to dominate most of Polish painting between the two wars. But I had also been brought up in an urban Jewish working-class home, in an atmosphere of constant discussion of Socialism, Anarchism, Communism and Zionism, so that my approach to my subject-matter, I mean that of men at work, is quite naturally tinged to some extent by my original background, that of a nation which was not yet fully industrialized, where peasants and artisans still repre-

sented the majority of the workers. The French painter Millet once wrote: "I want the people I represent to look as if they belonged to their station and as if their imaginations could not conceive of their ever being anything else." Well, what Millet then wrote in a letter to a friend expresses perfectly what I feel about my own work, and I have probably chosen to paint miners, rather than factory-workers, because miners, like peasants, have this deep attachment to their work and its surroundings. Although at first sight like many other types of worker, the miner seems to me to be more impressive and singular, like a walking monument of labour. Unlike many factory-workers, he rarely thinks of changing his job or his surroundings, I mean of moving to another part of the country where he might find easier and more remunerative work. That is why a crisis in the coal industry is always such a tragedy; if a pit closes down, a migration of its miners and their families, and their resettlement in another part of the country and in other jobs, even under the best conditions, poses almost insoluble problems. In our generation, the miners of South Wales, except in brief periods of prosperity, have lived under the constant threat of such migrations and resettlement projects, but this is not to explain the "gloomy" aspects of my work to which some Marxist critics have taken exception. I do not think my pictures gloomy, but I do think that sadness plays an inherent part in serious feeling, and I feel only revulsion in front of Stalin-Prize-winning pictures depicting smirking miners in spotless and hygienic mines, in what might well be called an optimistic style of petty-bourgeois academism that tries to flatter the workers. Nor am I particularly impressed with the bright colours and Ecole de Paris formalizations with which some Italian Socialist Realists try to cheer themselves up. Neither of these two styles of Communist art is in any way progressive or deserving of serious consideration, whether in its artistic or its political aspirations. It may be true that miners need leaders rather than consolation, but no serious painter is out to supply either. Human labour is not a trifling matter. We are conditioned to labour. We have no choice. This is the tragic aspect of it. And to express this aspect, this inevitability of a fate that leaves us no choice, it does not matter whether one uses as a symbol a peasant or a worker, an archaic ox or a modern tractor. However, I do not like to engage in a dispute with the priests of Socialist Realism. My main objection is to the

gospel itself. By invoking Courbet but following Meissonier, by employing words such as "decadence" and "imperialist style" as insults rather than as terms embodying critical precision, Socialist Realism has put itself outside the broader humanist trend which obtained a new meaning in the arts since the nineteenth century and which is as much present in Courbet as in Cézanne, in Millet as in Rouault. In any case, some miners have better instincts than doctrinaires would grant them.

E.R.: And how do your neighbours in South Wales react to these paintings?

HERMAN: You have probably read that I set up my studio in Ystradgynlais, to begin with, in a room of an old local pub which I have converted. My neighbours soon acquired a habit of dropping in there to see me and to chat with me, and many of them enjoy posing for me in their spare time as models. Most of them seem to understand, far more readily than "arty" people, what I have set out to achieve. Looking at a portrait of a miner called Mike, one of them thus said: "You want to paint not only the portrait of one Mike, but of all the Mikes." And that is exactly what I want to do. I want my studies of miners to be more real than portraits. I am not trying to convey, as in some of Wystan Auden's early poems, the abstraction of derelict pits and the wasted face of an industrialized landscape, but a synthesis of the pride of human labour and of the fortitude, the calm force, that promise to guard its dignity. All this I have felt and have tried to convey in my work. I like the miners and I like living among them. In their warm humanity and their expressive occupational poses, the way they squat, the way they walk and hold themselves, I find the embodiment of labour as a human rather than a merely industrial force, in fact the basic humanity that I have always sought and tried to express. The miner has thus become, for me, both incidental and symbolical. Incidental, in that I am not interested in him merely as a representative of a particular industry; symbolic, in that I see, in his monumental appearance, the very drama as well as the dignity of human labour. I believe that I now face, in my work, no other formal problems than those implied in achieving an adequate plastic expression of this idea. Technical problems, of course, are an entirely different matter, and I don't enjoy discussing the recipes of this kind of "cuisine" of art. I just sort them out, these technical problems, as they come along.

E.R.: Would you include colour among technical problems?

HERMAN: Yes, to a certain extent, except in so far as colour also conveys atmosphere and mood, the quality of the world depicted and the reactions of the artist to this world. For this, however, the Pre-Renaissance way of colouring rather than the naturalistic way of painting suits my purpose. Also I am an ardent admirer of the Icon painters. By this I do not mean to suggest that I am interested in their decorative achievements, as the Fauves were, but in their use of colour to give fuller meaning to the expressiveness of the form. Of all contemporary painters, Rouault and perhaps Permeke seem to me to have something of this austerity and grandeur, though they too are sometimes disturbed by the histrionic ambition to paint rather than to colour. Actually I rely a great deal on drawing. I would like to add that I have no hard and fast theory of differentiation between a black and white drawing and a painting. The idea matters above all. Colour thus remains, for me, a means of making my message more intense. But I view the whole art of making pictures as a moral responsibility, a kind of rhetoric rather than an aesthetics. It should be true to experience and to the will to communicate this experience rather than to detailed observation, description and taste. To be truly relevant, art must provoke thought and stimulate feeling rather than delight the senses. I think that today an independent artist, free of the aesthetic self-consciousness of the abstract movement and the bureaucratic narrowness of the Socialist Realists, finds himself inevitably a middle-of-the-road man. I do not mind my work, in the context of our contemporary scene, being viewed as such.

*Later, as I went through my notes and drafted a first version of my discussion with Josef Herman, I was reminded, by much that he had said, of the social philosophy of several of the greatest Jewish painters of the past hundred years, I mean of the letters of Camille Pissarro to his son and the opinions expressed by Jozef Israels, whose paintings of men at work, little though they may now be appreciated by the snobs of the art-world, once influenced Van Gogh so profoundly. John Berger, in discussing Herman's work, had detected in his early ink-drawings the influence of Rembrandt, but had failed to understand that Rembrandt had indeed haunted a whole school of Jewish artists of the past hundred*

*years, ever since Israels first reverted to his sombre chiaroscuro technique and to his habit of painting portraits of his neighbours in the old Jewish quarter of Amsterdam. After Israels, Jewish painters throughout Eastern Europe became interested both in Rembrandt's technique and in his inherent Humanism. Israels, Millet, Courbet and Pissarro remain indeed powerful influences among those rare artists, in our age, who are interested in moral rather than aesthetic problems. They were among the very first painters, in the nineteenth century, to approach the theme of men at work in a spirit of Populist Humanism, if not yet of Socialism, and to purge this whole range of subject-matter of the sentimentalism of all those* petits maîtres *who, since the age of Diderot, of Greuze, of Morland and Sir David Wilkie, had degraded it to a happy hunting-ground for painters of mere genre-scenes.*

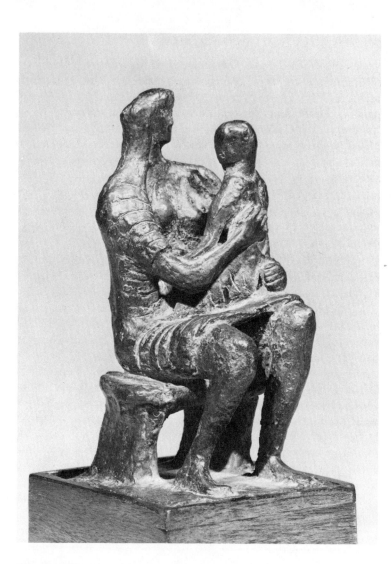

HENRY MOORE
*Madonna and Child*

# Henry Moore

*If art, in our age, has followed an evolution similar to that of in-dustry and concentrated power or prestige in the hands of an oligarchy of "captains", then Henry Moore deserves, with Picasso and one or two other painters and sculptors, to be called indeed a "captain of art". Though friendly and accessible by nature, in fact unaffected and sociable as most of the Yorkshiremen whose literary spokesman J. B. Priestley has long been, Henry Moore has found himself involved, in the past few years, in such a multitude of activities that it required weeks, if not months, to obtain the necessary audiences with him, between a trip to Poland where he had been invited to join an international jury to select the prize-winning project for a monument to be erected on the site of the former Nazi extermination camp in Auschwitz, and the numerous trips he also had to make to Paris, in order to complete his assign-ment for the new Unesco building, or to Italy where some of his figures were being cast. Throughout Europe, all available foundries seemed to be busy casting bronzes for Henry Moore; bottle-necks in this production again and again called for his "executive action", and Moore's forthcoming New York exhibition even had to be postponed in order to allow more time for its multiple and complex preparations. When, in the course of our interviews, I casually mentioned a small West Berlin foundry that had once worked for Gerhardt Marks, its name was promptly noted by Moore's secretary, who was instructed to find out if it could still accept orders.*

*I had already been impressed by this tremendous activity in the course of the phone calls and correspondence that had pre-pared the way for our actual meeting; this impression was only strengthened by my two visits to Henry Moore's home and his*

*studio in Perry Green, near Bishop's Stortford, in Hertfordshire. The sculptor's efficient and devoted secretary works full time answering his voluminous mail, filing new photographs of him and his work, selecting them out of these files for forthcoming publications, while Mrs. Moore runs the large house equally efficiently. Whether Moore is at home or away on one of his trips, his secretary continues to work, while his own production continues unabated, with the help of assistants either in the indoor studio that is a separate building next to the house or in a large semi-outdoor studio that one reaches, beyond the bottom of the garden, after crossing an expanse of meadow that is dotted with occasional works of the master. As one wanders around the meadows that Moore is gradually transforming, all around his house, into a new kind of park, one encounters quite a number of these sculptures, set among the lawns and the trees according to principles that seem more intuitional than rational, as if Henry Moore, whether consciously or unconsciously, were emulating the Zen landscape-gardeners of classical Japan rather than the kind of jardin à la française that Lenôtre devised for the royal parks of Versailles, Saint-Germain-en-Laye, Marly, Saint Cloud, the Tuileries and the Luxembourg, or the less formal achievements of Capability Brown in the Duke of Devonshire's park at Chatsworth Hall.*

*When I was at last fortunate enough, between my own other occupations and the sculptor's numerous trips abroad, to arrange for an interview, Moore had just returned from a trip to Paris, and we began discussing his figure for the new Unesco building. He admired the latter for its spatial conception of architecture and its monumental quality:*

MOORE: It's a good building—it's perhaps the only really modern building in Paris.

E.R.: I would hesitate to make so sweeping a statement. Paris actually has, here and there, quite a number of modern buildings, mainly tucked away in residential or industrial suburbs. The city owes most of them, however, to private enterprise. The Unesco building is one of the French capital's few major examples of modern architecture that have been built for a public body; because the mills of the bureaucratic gods grind so very slowly, it has come to us, I feel, too late to be at all daring. Had it been

built in 1925, I would have considered it a great artistic achieve-
ment; today, it seems to me no longer very original or experi-
mental. But the London press has in recent weeks quoted or mis-
quoted you very widely and stated that, before starting work on
your Unesco assignment, you spent three or four months meditat-
ing the meaning of Unesco. Some years ago, when I obtained
my first assignment as a free-lance interpreter for Unesco, my
mother was surprised that a Rumanian violinist should require
the services of a full-time interpreter. I hope you began your
meditations on the meaning of Unesco more auspiciously than
my mother. . . .

MOORE: The press has very much exaggerated this aspect of
my approach to the Unesco assignment. My friend Julian Huxley,
the first Director General of Unesco, told me what he considered
to be the purpose and meaning of Unesco, and this was, of course,
a help to me in first formulating my thoughts on the subject.

E.R.: To me, it all sounds like a nineteenth-century assignment
to design an allegorical group to be set above the main entrance
of the building. I mean something like: "The United Nations co-
ordinating the efforts of Education, Science and Culture and
guiding Mankind in its search for Peace." I'm quite surprised that
you didn't finally plump for a draped figure with a lantern held
high, at arm's length, above its head.

MOORE: Eventually, after discarding many preliminary studies
I decided on a reclining figure that seeks to tell no story at all. I
wanted to avoid any kind of allegorical interpretation that is now
trite. This particular reclining figure has perhaps turned out to be
one of those that Sir Philip Hendy has called "wild ones".

E.R.: How would you define your "wild ones"?

MOORE: Well, they are sculptures which are inspired by general
considerations of nature, but which are less dominated by repre-
sentational considerations, and in which I use forms and their
relationships quite freely.

E.R.: Your "wild ones" are in a way what Goethe might have
called your more "dionysiac" sculptures.

MOORE: I suppose so. I enjoy working in the open air, and I
have always regarded sculpture as an "outdoor" art. That is why
I make most of my larger sculptures in the open, and often set
them up in the garden, so that I may also judge them from various
distances. It is difficult to imagine, in the more or less artificial

light of a well-planned studio, what outdoor light can do to a sculpture. A dull cloudy day with a diffused light demands a contrast in direction and size of masses and planes in a sculpture, all the more so since details and relief effects will hardly show. In England, in particular, where we have so many sunless days, this is, for outdoor sculpture, a primary consideration. But it only means that sculpture is three-dimensional, and such principles apply to smaller works too, though they will perhaps be seen only indoors. Besides, a piece of sculpture that looks well in a poor light will aways look better in a good light. I generally work on my smaller figures in the studio near the house. It's a converted stables-building, and I also use it for patinating and finishing some of my larger works, and for storing unfinished projects. The larger outdoor studio is more convenient for work on major projects.

E.R.: With so much work on hand, you must keep several assistants busy.

Moore: I have only one full-time permanent assistant, but right now I'm also employing a student from the Slade School for the duration of his holidays and two others as well on a temporary basis.

*As we spoke, Moore led me out of the house into the smaller studio. Though crowded with examples of his work of the past few decades, with unfinished projects and sketches, with all sorts of odds and ends, it was surprisingly tidy. On a series of shelves, for instance, there was a strange assortment of curiously formed pebbles, bones of animals, odd pieces of driftwood. Henry Moore picked one up absent-mindedly and began to finger and feel it; obviously, the curves of these smooth surfaces shaped by nature fascinate him and such natural objects are to be counted among his sources of inspiration. On a table, a number of photographs of his work were scattered. He selected a few of them and began to show them to me.*

Moore: Here you can see what I mean when I say that I enjoy working in the open air and creating figures that are intended to be placed in natural lighting and natural surroundings. This is a picture of my *King and Queen* group as it has been set on a moor near Dumfries, by a Scottish collector. The figures are standing on a natural rock base. The same collector also has my larger *Cross* and several other monumental figures, all out on the moors that surround his Dumfriesshire farm. Such open-air sculptures

must be understood as three-dimensional forms, in terms of changing lights and shadows on their surfaces, and not solely as outlines standing out against the sky, though of course the silhouette also matters.

E.R.: But don't you find it difficult to work all through the year, in the British climate, in an open-air studio?

MOORE: Adrian Stokes once wrote to me in a letter that I am the sculptor who has come to terms with the English weather.…

E.R.: In that respect, you're a bit like the legendary Hassidic Rabbi who decided, contrary to all the prescriptions of the Jewish faith, to travel on a Sabbath; to his left and to his right, it was Sabbath; ahead of him, it was Sabbath too; behind him, it was again Sabbath. But he managed to walk ahead in a tiny sphere of non-Sabbath that he had miraculously created around himself. I suppose you achieve a similar miracle and create a tiny world of weather that isn't English, like a cocoon of sunshine around your open-air studio.

MOORE: On the contrary—I work out of doors throughout the whole year and never attempt to ignore the English weather, but rather to use it. Here you can see the model of the figures of the *Four Elements* that I did for the Time and Life building in Bond Street. In this model, they are movable. I had planned to place them on pivots, so that they could be turned every once in a while, which would have allowed them to be seen from changing aspects, thus emphasizing their three-dimensional quality. But the London County Council seemed to think that this was dangerous. They objected that the figures might fall on passers-by, so they were finally made immovable.

*We had already wandered out of the studio, across the garden and into the meadows, where Moore has placed several of his larger sculptures. We paused in a kind of bower, where his huge bronze nude, entitled* Seated Woman, *is surrounded by young trees and shrubs. Henry Moore caressed the back of the bronze figure, almost absent-mindedly or ritualistically:*

MOORE: You know, whenever I see this figure I am reminded of a boyhood experience that contributed towards the conception of its form. I was a Yorkshire miner's son, the youngest of seven, and my mother was no longer so very young. She suffered from bad rheumatism in the back and would often say to me in winter,

when I came home from school: "Henry, boy, come and rub my back." Then I would massage her back with liniment. When I came to model this figure which represents a fully mature woman, I found that I was unconsciously giving to its back the long-forgotten shape of the one that I had so often rubbed as a boy.

E.R.: It is a phenomenon of tactile memory very much like the remembered taste of the *madeleine* dunked in tea that inspired Marcel Proust's *Remembrance of Things Past.*

MOORE: Tactile experience is very important as an aesthetic dimension in sculpture. Our knowledge of shape and form remains, in general, a mixture of visual and of tactile experiences. A child learns to judge distance by touching things, and our sense of sight is always closely associated with our sense of touch. That is why a blind man learns to rely more exclusively on the use of his hands. A child learns about roundness from handling a ball far more than from looking at it. Even if we touch things with less immediate curiosity, as we grow older, our sense of sight remains closely allied to our sense of touch.

E.R.: I used to know a German Orientalist, the late Professor Erwin Rumpf of Berlin, who was reputed to be one of the very rare Westerners to have an instinctively true appreciation of Japanese Art. He once explained to me that the aesthetics of the Japanese Netzuke figures—those little carved ivories that were used as buttons—required that the whole object be understood or read by feeling as explicitly as by seeing, and that Japanese art-lovers fondle them and comprehend the whole sculpture with the use of one hand.

MOORE: Blind persons have been known to model sculptures which are visually exciting. Still, there are limitations to the proportions of a blind artist's sculpture. Size would pose a great problem, and it would be almost impossible to conceive a very large figure, with a proper integration of the relationships of its masses as parts, without ever being able to have recourse to one's sight. Some people, misunderstanding the nature of tactile values, and perhaps wishing to be fashionable, will often say: "I love touching sculptures." That can be nonsense. One simply prefers to touch smooth forms rather than rough ones, whether these forms be natural or created by art. Nobody can seriously claim to enjoy touching a rough-cast sculpture, with its unpleasantly prickly surface that may be nonetheless good sculpture. No one likes touch-

ing cold and wet objects for example. A sculpture may thus be excellent according to quite a number of different criteria and still unpleasant to touch. But the tactile element remains of primary importance in the actual creation of most sculpture.

E.R.: Berenson has already discussed at great length the tactile qualities of a certain kind of painting, especially of the more sculptural art of Piero della Francesca or of Mantegna. But painting can suggest a whole range of tactile qualities, not only of sculptural awareness of roundness or relief that is suggested by Mantegna and Piero della Francesca, but also the awareness of texture that is suggested in a Courbet still-life, where the feathers of a pheasant and the fur of a hare can almost make your fingers tingle. . . .

MOORE: But these last tactile qualities of painting can also degenerate into a kind of cheap illusion, like that of a performing magician. They exist, in a way, in sculpture too, for instance when a marble or bronze suggests the silky texture and the softness of human flesh. Actually, this is fairly easy to achieve, and many an outstanding sculptor is popularly admired for the finish that his assistants have given to his works.

E.R.: I have often been struck by the essentially tactile nature of certain distortions of the human form in your sculpture. It has seemed to me that these are sometimes inspired by tactile illusions of feeling, as opposed to the optical illusions that inspire most distortions in art.

MOORE: You are right. I believe that there can be distortions, tactile rather than visual in origin, which can make a sculpture much more exciting, though they may give an impression of awkwardness and disjointedness to an art-lover who is more accustomed to the distortions of painting. Sculpture with such tactile exaggerations can be so much more exciting than the smooth and merely pictorial ease that characterizes most bad nineteenth-century sculpture.

E.R.: I have often felt that only Carpeaux, Rodin and Medardo Rosso, in the whole second half of the nineteenth century, really understood the purposes and the principles of sculpture.

MOORE: Rodin of course knew what sculpture is: he once said that sculpture is the science of the bump and the hollow.

E.R.: I was interested to observe, when I visited recently the great retrospective show of works of Jacques Lipschitz in Munich,

that this one-time master of Cubist sculpture seems now to have reverted to a style in which I could feel a profound sympathy with Rodin.

MOORE: Lipschitz is, of course, a good sculptor. I would include some of his Cubist works among the best sculptures of his generation.

E.R.: To me, Cubist sculpture has always seemed a bit illogical. After all, the great innovation, in Cubist painting, consisted in introducing certain sculptural effects and principles into the two-dimensional world of the canvas. In borrowing this sculptural style from painting, Cubist sculpture becomes a kind of *reductio ad absurdum*. Lipschitz seems to have been aware of this when he created his bronze still-life panels that are like paintings deprived of colour. . . . But I would like to ask you now what you think of the so-called Renaissance of sculpture in England today. It has been frequently observed that England has never had so many outstanding sculptors, and that Italy and England, since 1945, are the only European nations to have a "native" School of Sculpture. A few weeks ago a Yorkshire museum was even able to organize an exhibition of five contemporary Yorkshire sculptors that included you, Barbara Hepworth and Armitage. . . .

MOORE: I suppose that the success of one sculptor may inspire others. One young sculptor told me that he was planning to be a doctor when he chanced upon an article about me and changed his mind. When Epstein and I achieved a certain international reputation, I suppose this fact encouraged some young people to turn to sculpture. After all, it's in a way like tennis-playing or dancing. If a local boy makes good, then all the ambitious local mothers want their boy to make the same career, and then you suddenly have a local tradition or a local school of art. Nevertheless, I believe that Yorkshiremen also have a very direct and realistic attitude towards life that can be useful to a sculptor. A sculptor must be practical. All day he is handling materials and tools that require truly practical skills. He must also be able to supervise the casting and handling of his works. Coping with this Unesco assignment was thus a major physical undertaking. It made me realize that the great Renaissance painters and sculptors were often men of terrific power and energy as sheer workmen. Some were builders, designing whole rooms before decorating them with murals. Besides, they had to make and mix all their own

colours, and the physical effort of working on high scaffoldings, to paint vaulted ceilings, must have been tremendous.

E.R.: The physical effort required of a sculptor may explain why, in the past, there have been so few famous sculptresses. Chana Orloff was probably the first important non-amateur woman sculptor. This reminds me of one of Humbert Wolfe's poems:

> "Queen Victoria's
> Portrait is
> The work of her daughter
> Beatrice . . ."

I think this sculpture, by a Royal amateur, still stands in Kensington Gardens. But what do you consider the most important aspect of sculpture?

MOORE: Sculpture, for me, must have life in it, vitality. It must have a feeling for organic form, a certain pathos and warmth. Purely abstract sculpture seems to me to be an activity that would be better fulfilled in another art, such as architecture. That is why I have never been tempted to remain a purely abstract sculptor. Abstract sculptures are too often but models for monuments that are never carried out, and the works of many abstract or "constructivist" sculptors suffer from this frustration in that the artist never gets around to finding the real material solution to his problems. But sculpture is different from architecture. It creates organisms that must be complete in themselves. An architect has to deal with practical considerations, such as comfort, costs and so on, which remain alien to an artist, very real problems that are different from those which a sculptor has to face.

E.R.: I once read in a history of ancient art that the pyramids were originally conceived as artificial mountains by a race that had migrated from a mountainous area, where it performed its religious ceremonies on mountain-tops, into a region of plains. Even the most abstract or least practical kind of architecture, it seems, was originally conceived for a practical purpose.

MOORE: Yes, some architecture may be an imitation of non-living nature, whereas sculpture derives from living nature. Even my most abstract forms, my stringed figures of 1938, are based on living creatures. This one, for instance, has a head and a tail. It's basically a bird.

E.R.: What other qualities do you require of a sculpture?

MOORE: A sculpture must have its own life. Rather than give the impression of a smaller object carved out of a bigger block, it should make the observer feel that what he is seeing contains within itself its own organic energy thrusting outwards—if a work of sculpture has its own life and form, it will be alive and expansive, seeming larger than the stone or wood from which it is carved. It should always give the impression, whether carved or modelled, of having grown organically, created by pressure from within.

*It was already dark as we returned from the outdoor studio to the house. I had ordered a cab to take me back to the station in time for my train to London. The cab was there. We parted rather hurriedly. In the train, I thought that few artists, in our age, are as completely conscious of their aims as Henry Moore, as naturally explicit.*

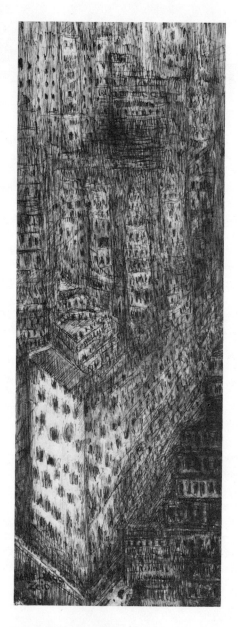

FAHR-EL-NISSA ZEID
*Vision of New York*

198

# Fahr-el-Nissa Zeid

*Fahr-el-Nissa Zeid is the first major contemporary painter from the Moslem world whose works have been extensively exhibited in Paris, London and America. She has achieved this distinction in spite of the traditional limitations imposed, in public life, on her sex. Her work thus illustrates a double emancipation: on the one hand, from traditional Islamic art, on the other, from the retirement from which, even in her native Turkey, a woman of talent and ambition can emerge only at the cost of great efforts.*

*Though generally non-figurative, the paintings of Fahr-el-Nissa Zeid reveal her emancipation from the centuries-old Moslem ban on nearly all art that does not limit its scope to the decorating and illustrating of books. There is indeed a monumental quality in many of her canvases, which no longer have much in common with the traditional miniatures of Turkish, Persian or Moghul art. As a woman, besides, she has never hesitated to create precedents by appearing in public life as a pioneer in her field. When she held her first public exhibition in 1945 in Istanbul, there were no art-galleries in the former Ottoman capital; she therefore decided to show her pictures in her own home, to which she freely admitted the crowds of curious strangers that responded to her unprecedented publicity. Later, in London, as the wife of His Royal Highness Prince Zeid al Hussein, great-uncle of the late King of Iraq and Royal Iraqi Ambassador to the Court of St James until the 1958 Baghdad revolution brutally relieved him of his duties, Fahr-el-Nissa may at times have caused some embarrassment, in the conformist diplomatic community, by exhibiting abstract canvases in some of the British capital's most controversial art-galleries. She admits that she then felt almost guilty, though the exquisite manners of many of those who visited*

199

*her shows out of sheer politeness prevented them from ever expressing any dismay or disapproval; on the contrary, Fahr-el-Nissa was immediately encouraged on all sides. Today, relieved of dynastic or diplomatic responsibilities, she can at last devote all her time and her boundless energy, whether in London, in Paris or on the island of Ischia, to her painting.*

*Our first meeting had occurred during a formal reception at the Royal Iraqi Embassy in London, a few weeks before the tragic events of the Baghdad revolution. Many ties of friendship had existed, over three generations or more, between her family and mine, in Istanbul. Common memories and friendships thus provided at once a fertile ground for an understanding which soon became very firm. We met again after the 1958 revolution, in less formal circumstances, and were then able to discuss more freely her problems and beliefs as a painter. In her bewilderment, her enthusiastic dedication to self-expression, Fahr-el-Nissa Zeid can be overwhelmingly articulate. Somewhat paradoxically, she often says so much that she may contradict herself unwittingly and, in the long run, achieve the same effect as if she were quite inarticulate. Like many action-painters, she is aware of a great emotional or spiritual turmoil within herself as she works, but remains most of the time unable or unwilling to analyse or define it in terms of a formal and consistent philosophy. Like the prophetess in Paul Valéry's poem* La Pythie, *she is content to remain an instrument of this turmoil, without seeking to understand or to master it. Often she relies, in her explanation of this process, on random analogies, on anecdotes that are almost parables. As she speaks, each image in turn casts some light on the mystery of her creative impulses, without ever explaining it fully. At first, she complained to me that, as a consequence of the shock of the Baghdad revolution, she could no longer paint:*

FAHR-EL-NISSA: I can no longer work as in the past. I have never been able to lie or to simulate in my work, and I no longer feel any magic in it, any enchantment around me or within me. It is as if I had suddenly become afraid of colours and of life. Instead of the brilliant kaleidoscope that once seemed to surround me, I can only perceive, all around me, a winding labyrinth of hard and heavy black lines. I feel lost among them, unable to emerge from the maze of my sorrow and my mourning. At most, in rare

moments of composure and courage, in the last few weeks, I have been able to draw a little, to sketch for instance a quite realistic portrait of my son. It is as if I had been brutally brought back to the very start of my career as an artist and were now forced to test again the validity of every device that I have ever used.

E.R.: I feel confident, however, that you will soon overcome this great spiritual crisis. A woman of your talent and vitality soon finds that even great misfortunes can enrich her emotional and spiritual experience. For an artist, it is sometimes useful to mark time for a while, to make a critical inventory of one's achievements and devices before setting forth on a new creative adventure. But it would interest me now to know whether, in your work of the past few years, you have ever been aware of illustrating any specifically oriental or Islamic conceptions or traditions.

FAHR-EL-NISSA: I have never really been a student of Moslem art, though I was brought up in a family where each of us sought, with more or less success, to achieve a personal synthesis of the cultures of the East and of the West. My father, Shakir Pasha, for instance, was descended from an ancient family of Turkmenian nomads that had migrated, at the head of its tribe, many centuries ago, from Central Asia to Anatolia. This tribe then became sedentary in the region of Afyon Karahissar, which means "the opium-black citadel", in Central Anatolia, where my ancestors continued for many generations to rule their vassals and to live on their feudal estates. Only in the past hundred years did a number of members of my family begin to settle in the capital of the Ottoman Empire and to play a prominent part in its cultural and political life, later too in that of the Turkish Republic.

E.R.: I have been told that there are several artists and writers in your family.

FAHR-EL-NISSA: My maternal grandmother already came of a family of famous calligraphers, and my mother had achieved at the age of thirteen some distinction as a painter. Her father, on the other hand, had been a well-known classical poet, teaching Turkish literature to the ruling families of Crete, some ninety years ago, when it was still Turkish. His interest in archaeology, besides, was so great that he made frequent trips to Egypt, where he first married.

E.R.: It is interesting to hear that you come of a family of calli-

graphers. In the Western world, calligraphic art has suffered from the development of a style of composition in which *chiaroscuro* and perspective play an important role. Only in recent years have a number of artists, among whom Klee was a pioneer, developed a new interest in the techniques of calligraphy on which Oriental art has so often relied.

FAHR-EL-NISSA: In the Moslem world, figurative art was generally eschewed by the more devout, and calligraphy thus became a complete form of self-expression.

E.R.: One can observe a similar phenomenon in the masoretic illustrations to medieval Hebrew manuscripts, where the text is organized in figurative compositions, like the calligrams of the poet Guillaume Apollinaire. But this ban on figurative art has been less rigorously or universally applied, in the Moslem world, than among the orthodox Jews.

FAHR-EL-NISSA: The Shi'ah Mohammedans of Persia were more liberal in their interpretation of the ban on graven images. Miniatures, they felt, could scarcely be interpreted as idols, and the art of the great Persian miniaturists thus spread to Turkey and to the Moghul Empire. At the same time, we also had, in Turkey, a firmly established tradition of purely calligraphic and non-figurative art; those Turkish artists who preferred to refrain from realistic representation of living forms thus became calligraphers and expressed the intensity of their emotions in an entirely abstract medium.

E.R.: I have seen some surprisingly complex and beautiful examples of Moslem calligraphic art in the collections of the former Imperial palace of Top Kapou in Istanbul. To me, Turkish calligraphy appeared to follow principles that are diametrically opposed to those of the art, more widely known in the West, of the Chinese and Japanese calligraphers. Whereas the artists of the Far East, especially those of the Zen school of philosophy, have reduced their calligraphic medium of expression to a bare minimum of significant brush-strokes and thus seem to grant almost more importance to empty space than to the details of drawing, the Turkish calligraphers crowd their compositions with details and sometimes leave only tiny open spaces, like those of embroidery or of lace.

FAHR-EL-NISSA: The Far Eastern calligraphers, I feel, are more contemplative or static, in their approach to their art, less dionysiac

or dynamic than their Turkish colleagues. The Turkish calligraphers of the past, in their directly creative attack on empty space, have formulated a style of abstraction that is almost the same as that of the Western action-painters of today.

E.R.: Yet both schools of calligraphy, the Far Eastern as well as the Islamic, seem to me to be founded on a mystical approach to art and to the universe. The calligrapher of China or of Japan is a contemplative who withdraws from the world of action and refrains from any activity in the outside world. The Turkish calligrapher, on the other hand, is a mystic who joyfully seeks to lose his individual identity in the infinite variety of the manifestations of the world of human activity. The one rejects action, the other drowns himself in activity. And this might also explain the intricate complexity of your own art, in terms of Western painting too, as opposed to the more reticent or contemplative "Chinese writing" of Hartung, among painters of the School of Paris, or of Franz Kline, among the Americans.

FAHR-EL-NISSA: You are probably right. The calligraphers of my mother's family were all mystics, members of a sect of dervishes founded in the Middle Ages by Mevlana in Konya, the former capital of the Seljuk Turkish Empire.

E.R.: Is it true that these dervishes were hashish-addicts and generally wrote their poems or painted their calligraphic compositions only when they were *hashash*, in a state of ecstasy induced by the drug? Far from achieving a sensation of withdrawal from the world, they sought, I have been told, an awareness of communion with all things.

FAHR-EL-NISSA: Perhaps some of them were hashish-addicts, but these were a minority. Their true doctrine required that the love of God be their real drug, and only those whose mystical passion and communion proved insufficient would then rely on merely material aids and disciplines to induce their ecstatic communion, I mean their songs and their dancing. I myself, when I am painting, am always aware of a kind of communion with all living things, I mean with the universe as the sum total of the infinitely varied manifestations of being. I then cease to be myself in order to become part of an impersonal creative process that throws out these paintings much as an erupting volcano throws out rocks and lava. Often, I am aware of what I have painted only when the canvas is at last finished. Sometimes, I'm almost shocked by the

N

alien quality of one of my paintings, or by the sheer mass and variety of my works. If I return to my studio after a long absence abroad, I find so many pictures that I no longer remember having painted that I sometimes ask myself how I can possibly have produced so much work.

E.R.: It sounds as if you work in a kind of trance.

FAHR-EL-NISSA: Yes, time goes by, the pictures come into being, and I stop working only when I'm interrupted, or too exhausted to continue. Nor am I ever able to describe beforehand what I plan to paint. On the contrary, I'm almost greedy for the surprises that I'm about to experience, when my work begins to play tricks on me, or when I play tricks on myself. It is like playing hide-and-seek with myself, concealing myself from myself but also finding myself, pouncing on myself like a wily cat on an unsuspecting mouse. There is fun in this game, but cruelty too. Often, I find myself doing what I had least expected to do. In my bewilderment, I then tell myself to abandon all pretence so as to follow this guidance, this inspiration of the moment, which alone can lead to truth, I mean to the utter sincerity of self-expression. All the rest, I feel, is illusion, pretence, lies. If I have a plan, when I start working, I inevitably find that I cannot follow it. Things happen to me and to my pictures as I paint, and the pictures come into being independently of whatever I may have set out to do. Only in moments of great distress, as in recent months, have I been able to follow a preconceived plan, but then I also feel that I am forcing myself to work and am able to follow a plan only because there is no joy in my work and nothing really urging me to paint except my will to forget my distress in my work.

E.R.: Have you always worked in this manner?

FAHR-EL-NISSA: No, for many years I was still a traditional art-student, then a more or less traditionally figurative painter as I continued to feel my way towards a style that might be my own, or a kind of art that might suit my particular temperament. Even now, I sometimes draw figurative sketches of views or of faces that I want to remember. When I was in New York, for instance, I sketched from my hotel-window a view of the Central Park skyline, but I transformed the yellow cabs in the streets below into a flock of patches of yellow that rose like birds into the blue sky.

E.R.: I hear that there are other modern painters in your family.

Do you all have a common style, I mean a kind of family resemblance, like Pissarro and his sons?

FAHR-EL-NISSA: I doubt it. On the contrary, each one of us seems to have developed along different lines. My father, Shakir Pasha, had been educated at the Military Academy in Istanbul and attained high rank in the Turkish army and diplomatic service. But he was also a writer, when his duties allowed him the necessary leisure, and it had been his ambition to contribute towards the birth of a modern Turkish dramatic literature. He is remembered, however, mainly as a historian of the Ottoman Empire, both for the books that he published and for the courses in Turkish history that he taught in Istanbul's best school for boys, at Galata Sarai. His brother, Djevat Pasha, was also a scholar of distinction, but died young, shortly after becoming Grand Vizir of the Empire. Djevat Pasha was mainly a historian, the author of a great scholarly work on the history of the Janissaries; he also owned a fabulous library, now the property of the Turkish Government in Ankara, and a famous collection of rare old Turkish ceramics. Besides, he had been a pioneer photographer and had tried his hand at reviving the art of ceramics, baking his experimental modern ceramics in a special kiln constructed in his garden. Another one of his hobbies was a publishing-house which he founded in Bab-Ali, where most of the Istanbul publishers have now established themselves, following his initiative. I myself was the sixth of seven children. One of my brothers, Djevat Shakir, is today a well-known Turkish novelist and essayist. A great scholar of ancient mythology and of comparative religion, he has specialized in the folklore of the Aegean Coast and publishes his works under a pseudonym, Halikarnas Balikçisi, which means "The Fisherman from Halicarnassus". My sister, Aliye Berger, is one of the best-known modern artists in Istanbul; she was married to a Hungarian musician, a very fine artist indeed. One of my nieces, Fureya, has carried on the research started by my uncle and is today the most outstanding modern Turkish ceramist. She has truly revived the art of the old Turkish craftsmen and was granted a Rockefeller Fellowship to pursue her research. My daughter Shirin, besides, is an actress in New York. As you see, our interests are varied, and each one of us has followed a very individualistic path.

E.R.: When you first began to paint, I suppose you met with no opposition from your family.

FAHR-EL-NISSA: None at all, though there had never been any
women artists, in the modern sense, in Turkey. At first, I attended
the Academy of Fine Arts in Istanbul, where I studied under Namik
Ismail, a pupil of the French Impressionists. Later, I exhibited for
the first time with a group of young Turkish painters, the "D
Group", in Istanbul. We were considered dangerous innovators
and revolutionaries because we insisted on showing our work to
the masses, not only to the educated élite, as all painters of the
past had done; besides, we attached as much importance to the
critical remarks of illiterate workers as to opinions expressed by
sophisticated intellectuals.

E.R.: Were the painters of the D Group committed to any
specifically political doctrine?

FAHR-EL-NISSA: I myself was never politically "engagée", but
many other members of the group were. I shared their enthusiasm
for an art that would no longer appeal exclusively to the well-to-do
bourgeoisie which, in Istanbul, displays in any case but a limited
interest, in general, in the efforts of a local *avant-garde*. In Turkey,
as in many countries that still lack a tradition of encouraging
experimental literature and art, the more privileged classes are
on the whole content to follow, with more or less of a lag, the fads
and fashions that reach them from Paris, London or New York.
I believe that our D Group was thus the first group of modern
Turkish painters to achieve any prestige in Istanbul. Still, it was
only after the Second World War that I began to feel at my ease
as a painter. In 1946, shortly after my second show in Istanbul, I
moved to Western Europe and soon began to exhibit in Paris
and London too. As long as I had still lived and worked in Turkey,
I had seemed to distrust my own artistic initiatives. I was too iso-
lated, too unsure of myself. Now I feel that I am at last under-
stood and accepted, whether in London or in Paris, as an artist
rather than as a kind of freak, I mean as a Kabaagatchli, a lady of
the Turkish feudal nobility who has thrown her yashmak over
the nearest windmill and set her heart, Allah alone knows why,
on becoming the first woman painter of her country much as other
emancipated women of her generation have become politicians,
physicians or lawyers. Actually, I've never been a militant femin-
ist and I hate to think of my paintings as expressions of a faith of
this kind. They are both too personal and too impersonal to be
interpreted as public statements. On the contrary, they surge

within me from depths that lie far beyond peculiarities of sex, race or religion. You have probably seen some of those Persian rugs from Tabriz that represent the Tree of Life, with every kind of creature, birds, animals and even human beings, nesting in its branches. Well, when I paint, I feel as if the sap were rising from the very roots of this Tree of Life to one of its topmost branches, where I happen or try to be, and then surging through me to transform itself into forms and colours on my canvas. It is as if I were but a kind of medium, capturing or transmitting the vibrations of all that is, or that is not, in the world.

E.R.: This is indeed action-painting, but explained more clearly than by any of the younger American action-painters whom I have known. Most of these explain their art in terms of Far Eastern mysticism, all claiming to be adepts of Zen philosophy. But I was always disturbed, in the case of Jackson Pollock for instance, by the obvious contradiction between the crowded design of his compositions and the empty spaces which characterize the works of Zen artists of the Far East. I was similarly shocked by the addiction of so many American action-painters to alcohol or to marihuana, whereas the abstemious Zen artists of the Far East trained themselves to subsist on the simplest and least intoxicating diet. Your own explanation of action-painting seems to me far more logical. I now see that it has far more in common with the more active trances of a Moslem dervish than with the contemplative withdrawal from the world of a Zen mystic. A whirling dervish, for instance, achieves his ecstatic condition through his own motion, whereas the Zen mystic achieves it through his immobility. At the same time, the crowded details of your compositions have far more in common with the designs of the abstract miniatures of certain Turkish mystics, than with the quintessential calligraphy of the draughtsmen of China and Japan.

FAHR-EL-NISSA: Yet I have never been particularly conscious of being an artist in this specifically Turkish tradition. Of course, I was brought up in this tradition and, in my childhood, attended the great annual ceremonies of the dervishes in the century-old *tekke* or monastery which was that of our particular clan or sect. These early experiences may indeed have helped form my particular attitude to the mystery of artistic creation, which I now tend to interpret quite naturally in terms of the familiar mysteries of the spiritual traditions of my country rather than in terms of an alien tradition.

But I've also been conscious, at all times, of being an artist of the same generally "abstract" school as many of my American, French or English friends and colleagues, I mean a painter of the "Ecole de Paris" rather than of any more specifically national school. . . .

*We then discussed for a while Fahr-el-Nissa Zeid's plans for the immediate future. Free to devote, for the first time in many years, all her energies to her work, she spoke almost like a prophetess of her will to transcend the recent blows of fate by devoting her time exclusively to painting. A handsome woman with a truly regal presence and the eyes, like still and deep pools, of an Oriental visionary, she described her work with an intensity that one encounters but rarely among the more despondent or jaded action-painters of the West. She faces the future with the confidence of an artist who finds only in her work the justification of her existence.*